WALKER EVANS DECADE BY DECADE

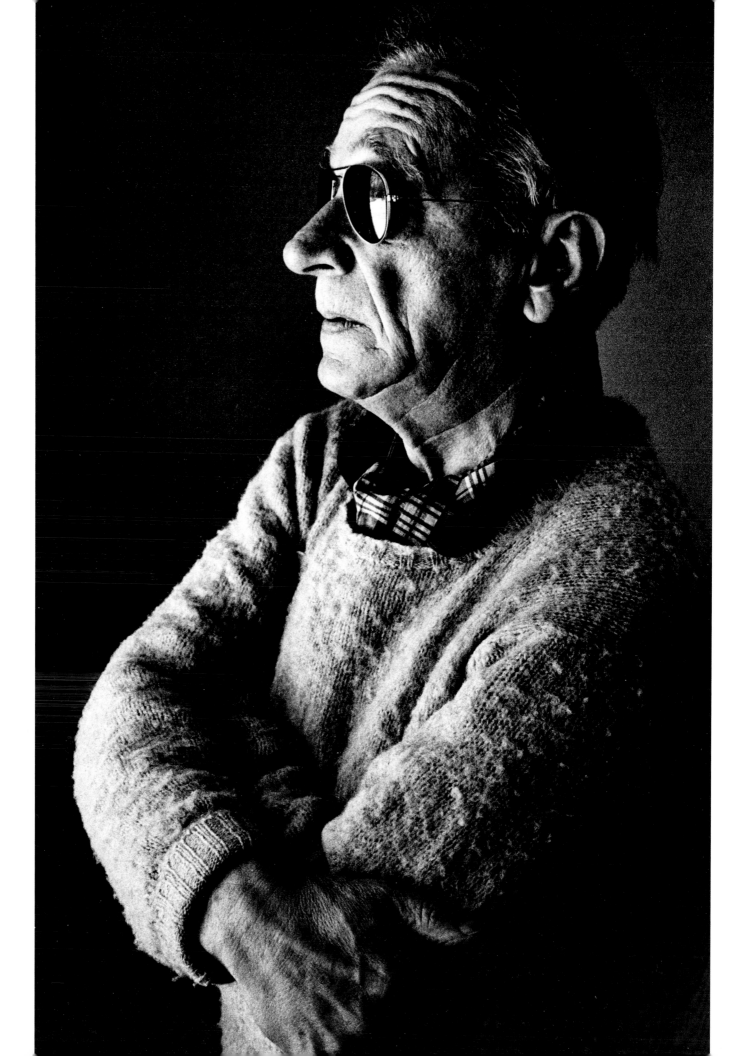

WALKER EVANS
DECADE BY DECADE

James Crump

HATJE
CANTZ

cincinnati ✳ art museum

CONTENTS

FOREWORD

That Walker Evans was one of America's greatest photographers is a fact beyond much doubt. What kind of photographer he was, and why he was so important, is a matter about which there is cause for renewed debate. The image of Walker Evans, as well as the nature of his images, came into focus in the 1930s and has not changed much since then. This exhibition and catalogue will show us that Walker Evans had a forty-six-year career that spanned many different subjects, attitudes, and modes of expression. It is curator James Crump's great contribution to the contemporary history of photography that he has wrested Evans's image from a hagiography that, certainly as pertains Evans's later career, is in need of revision.

It is important to realize that artistic careers do not just appear out of nowhere. However brilliant an artist may be, he or she must show their work somewhere. Art museums and galleries construct the meaning and worth of artwork in collaboration with, or sometimes in contradiction to, the artist. Critics pick up this task by either elaborating what the themes and messages of an artwork might be, or by constructing their own meanings through and over the images. This is not to say that the system of art presentation and interpretation necessarily corrupts art, but that what is said about a work of art plays as large a role in our understanding of a powerful image as the actual figure the artist creates.

Walker Evans first came to the public's attention through his portrayal of the poverty he found in the American heartland during the Great Depression. For the next forty years, until his death in 1975, Evans produced thousands and thousands of images, many of them as part of his work for *Fortune* magazine. Most of this work has never been seen and this exhibition, by showing a small fraction of this output, seeks to readjust our notions of what Evans was about as an artist.

That in itself is an effort of presentation and criticism. James Crump here presents a small and selective survey of Evan's work across almost five decades. In so doing, he also reevaluates the relationship that Walker Evans had with critics, galleries, and museums, and in particular with the high temple of modernism, the Museum of Modern Art in New York. It is important to point out, as Crump does in his essay in this catalogue, that Evans was not only defined by that institution, but also helped to define, through his relationship with MoMA's curator, John Szarkowski, what we think of today as American photography. This exhibition will forever change not only what we think of Walker Evans, but how Evans's work defines that particular kind of art.

We are very grateful to the Walker Evans Archive at the Metropolitan Museum of Art, New York, the Image Library at the Metropolitan Museum of Art, and the Museum of Modern Art Archives. We are particularly indebted to Clark and Joan Worswick, who most generously lent a significant portion of their collection of vintage Walker Evans photographs. We are also grateful to the Andrea Rosen Gallery, New York; Rodger Kingston; and the publisher Hatje Cantz, Ostfildern, Germany.

At the Cincinnati Art Museum we are particularly grateful to James Crump, curator of photography, for assembling and interpreting this collection. Scott Hisey offered his technical expertise in reproducing Evans's photographs. Jay Pattison was a most expert and professional registrar who helped to organize the shipment of these valuable prints. Susan Hudson, our exhibitions manager, was extremely diligent in her oversight of this project. Finally, we would like to thank Stephen Jaycox for his installation concepts.

Aaron Betsky
Director
Cincinnati Art Museum

INTRODUCTION
WALKER EVANS: DECADE BY DECADE

Walker Evans is probably the single greatest American photographer ever to have worked in the twentieth century. Certainly he is the most influential, considering the medium's subsequent trajectory, and the proliferation of documentary-based artwork that followed from the 1970s onward. In a career that spanned five decades (1928–74), Evans radically altered the collective American consciousness, if not also the country's collective memory; his photographs changed the way Americans viewed their country and themselves. Drawn chiefly from a largely unseen private collection, the Cincinnati Art Museum's revisionist exhibition and this sumptuously illustrated companion volume present a surprising number of photographs heretofore inaccessible to the public.

The exhibition includes iconic images of Evans's southern work (1935–36), but also his rarely exhibited Victorian House survey series, begun in 1931 in order to preserve a neglected American architecture. *Decade by Decade* also features rare prints from Evans's trip to Tahiti in 1932, as well as the work the artist made in pre-revolutionary Cuba in 1933 and a select sampling of photographs he created for the Museum of Modern Art's 1935 exhibition African Negro Art. Rounding out the early portion of Evans's career are many well-known portraits, including ones of Lincoln Kirstein, James Agee, and Hart Crane, but also of lesser-known persons, as well as portrait series of African Americans and women.

Before his now legendary and highly influential Museum of Modern Art exhibition and book, *American Photographs* (1938), Evans had started to define and refine his particular vision, which deviated from the reportage made possible by smaller cameras. The documentary style Evans evolved dealt in facts and actual events, but only as raw visual material for his increasingly disinterested aesthetic

viewpoint. Though he was critical of America, the modern age, and the dehumanization wrought by capitalism, Evans was not interested in social commentary or "concerned" photography. He rather composed his work with searing irony and pictorial tension, reducing each image to its most basic elements. Economy, democratic scrutiny of the everyday, themes derived from the commonplace, word play and poetry cast from the mundane—these are the hallmarks of Evans's work that influenced a veritable who's who that followed: Andy Warhol, Stephen Shore, Ed Ruscha, Robert Frank, Garry Winogrand, William Eggleston, Dan Graham, Lee Friedlander, and Diane Arbus. Without Evans, the present worldwide landscape of contemporary photo-based art would look very different today.

His earliest photographs came to define Evans, notwithstanding an active career that continued into the 1970s. While the Cincinnati Art Museum's exhibition includes many of the 1930s pictures, it will nevertheless be the very first monographic presentation to examine Evans's work from every decade of his activity, with shared emphasis placed on the 1940s, '50s and '60s. Evans returned again and again to the classic, evocative, and psychologically intense subjects that mattered most to him. In this exhibition we are able to see, for the first time, how these repeated treatments of such subjects provided great depth to Evans's vision, while allowing him to represent the changing American culture and landscape around him. The exhibition ends with the last photographs that Evans made using the new Polaroid SX-70 camera in the early 1970s. Like in the swansongs of André Kertész and Carlo Mollino, Evans was obsessed with a technology that allowed him to continue making pictures at the very brink of his own death.

Decade by Decade rewrites the story of Evans's expansive career by offering a new, more inclusive view that takes into account the years that followed his triumphant appearance in the late 1930s. Most important, it charts Evans's re-ascendancy in the 1970s as the most important photographic artist of the twentieth century. The worldwide reach of Evans's photographic aesthetic is today regularly cited by contemporary artists and curators as a profoundly dominant focal point for American twentieth-century art in general and contemporary photography in particular. The exhibition and this publication prove that it is impossible to overstate the extent to which Evans's oeuvre helped form a modern camera vision that continues to resonate to this very day.

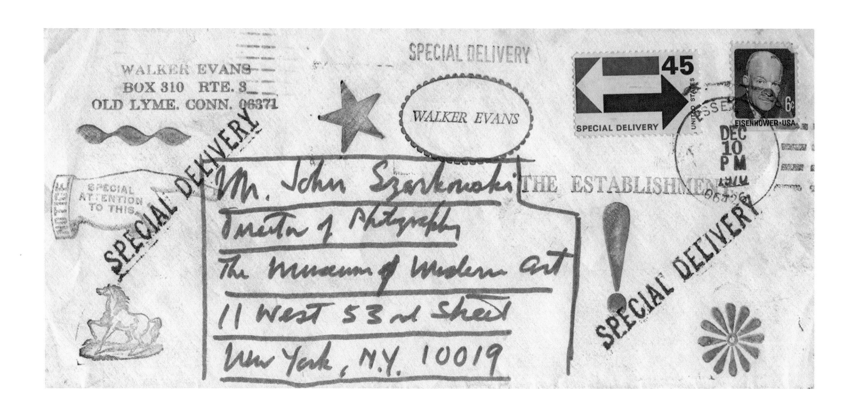

J.S. + W.E.—RETRIEVAL

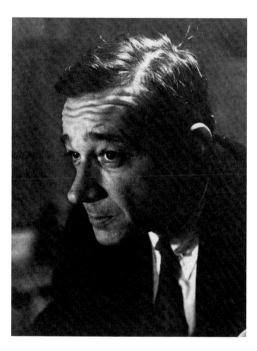

WALKER EVANS, c. 1955

A PHONE CALL

It was a sunny day in Manhattan in 1955. People were gliding down Fifth Avenue, ignoring the din of the traffic. The well-dressed greeted and nodded to each other, gracefully slipping into Checker cabs as others stumbled back to the office after the classic two-martini lunch. A thirty-year-old photographer from Wisconsin was enjoying the spectacle. But he had something else on his mind. He slipped into a phone booth, put in a dime, and dialed. He was not sure why he was calling. "May I speak to Walker Evans?"[1]

The caller was John Szarkowski, for whom Walker Evans was someone near to a god. Szarkowski was a photographer, passionate about American architecture and architects such as Louis Sullivan; he regarded Evans's *American Photographs* of 1938 as a hallowed masterpiece. Its chaste, ordered aesthetic completely paralleled Szarkowski's own. More than this, he believed that Evans's work of genius contributed to his own formation as an artist.[2] Surveying the big city, Szarkowski thought about the great man and wanted to meet him. If he was lucky, Evans would look at his photographs and maybe even find him some employment. Most importantly, for the younger man, finding and meeting Walker Evans was nothing less than a devout pilgrim's journey to Mecca.

The Walker Evans whom Szarkowski was telephoning was a far cry from the hero he had imagined. In 1955 the fifty-two-year-old Evans was "in disguise,"[3] a corporate "suit" at Time Inc., photographing and producing stories for *Fortune* magazine. He was ashamed of the connection and mildly desperate. Out of favor with the art world that had so enthusiastically embraced him two decades earlier, Evans was a shade of the man he had once been. Despite the fact that his

years at *Fortune* have been immensely productive, he was all but invisible to art dealers, curators, and collectors.

Much to his chagrin, Evans was also at odds with the Museum of Modern Art, which during the 1930s had launched his career. Evans had been a fixture at MoMA. Now with Edward Steichen leading the museum's photography department—his tenure began after the war—Evans lost his privileged status. In Steichen's eyes, he was persona non grata. Evans has only himself to blame. After all, he had boldly written of Steichen as "photography off its track." He had all but called the "Captain" an advertising hack.[4]

In 1955 Evans had no reason to believe his reputation would improve. He deplored Steichen's triumphal exhibition *The Family of Man,* later characterizing it, in an outburst of spleen, as "'photo sentiments' about human family-hood,"[5] which had only exacerbated his new role as a pariah. Estranged, periodically broke, and suffering from intensifying alcoholism, Evans was in a constant state of physical and moral malaise. He was divided: part of him enjoyed the reporter's disguise as the lowly outcast.[6] Yet he wanted to distance himself from any perception that he was working for hire for any corporation and did his best to disappear. In his own mind, he would never be anything but part of the earlier avant-garde, which unfortunately, had marched into history without him.

"This is Walker Evans," he replied to Szarkowski.[7] "Of course, I'd be delighted to see [you]."[8] Szarkowski ambled from the street corner and began his ascent to Evans's office at *Fortune.* The contrast between the two men could not have been greater. Szarkowski, a Polish American, Roman Catholic in rumpled blazer and soft-soled shoes, was shocked to encounter not the great man whom he had imagined would resemble a movie star playing Abraham Lincoln. Instead, he saw a diminutive day-commuter with the attire and airs of the English gentry.[9] Evans offered Szarkowski tea. He began to examine the young man's dummy book containing photographs of Louis Sullivan's buildings. The meeting became a master class of sorts, with Evans playing the mentor, flipping through Szarkowski's pictures, pausing only to consider the best photographs and to offer sage words of encouragement. It turned into a lovely afternoon. "What are you going to do now?" Evans sternly inquired. Szarkowski asked his idol if he might help him find similar work photographing architecture in New York. "No, I won't do that," Evans, visibly recoils. "This magazine is not the kind of place for people like *you* and *me.*"[10]

The story of Walker Evans's retrieval—how he returned to public awareness, how his work came to represent the essence of America—begins with the "you and me" acquaintance struck up this day in 1955. This essay will show that it marked a turning point in both men's lives. Szarkowski did not think that their paths would cross again. Evans knew they would.

NEW BLOOD

The mythology of the history of photography suggests that Szarkowski was "Captain," Edward Steichen's heir apparent, that he was "invited" to take over MoMA's photography department in 1962.[11] It wasn't that simple. Since its inception, MoMA had been a leader in recognizing photography's artistic merits and its rightful place in art museum collections alongside works in other media. In 1961 MoMA was in the early planning stages to create the Steichen Photography Center. In a $25 million campaign to double the size of the museum, as much as $600,000 was allocated for photography, an astronomical sum at this time, which reveals the medium's new status in relation to the other arts. Selecting Szarkowski to lead, however, took place in an atmosphere of great uncertainty and hand wringing about the department's future. The atmosphere invites scrutiny, not only about how a relatively unknown young photographer from Wisconsin with little or no museum experience got the job. It also reveals the beginning of Evans's subsequent re-ascendancy as the preeminent American photographer of the twentieth century.

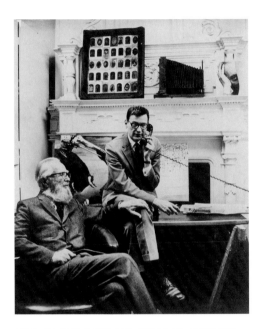

EDWARD STEICHEN AND JOHN SZARKOWSKI, 1962

Steichen's unambiguous first choice to take his place was photographer Wayne Miller, his chief assistant on *The Family of Man*. Miller rebuffed MoMA. He said he needed to earn more than the meager wages of a curator.[12] The remaining candidates were a curious mix that ranged from renowned historians of photography, such as Fritz Gruber and Helmut Gernsheim, to younger and lesser-known contenders, such as Van Deren Coke, who, like Szarkowski, was an ambitious photographer and art historian. There was also Ralph Hattersley, a teacher at the Rochester Institute of Technology, and a large assortment of picture editors, including Rick Fredericks of the *New York Times* and Ben Schultz of *Sports Illustrated.* The list amply reflected Steichen's populist approach to the medium, which had always infuriated Walker Evans. Glorifying the aesthetics of

the picture magazines, Steichen's *Family of Man* startled the public with aggressive, hard-sell theatrics in overly designed rooms jam-packed with photographs. Following Steichen's directives, MoMA named Alexey Brodovitch, legendary creative director of *Harper's Bazaar* and founder of the Design Laboratory, along with Swiss-born photographer and graphic designer Herbert Matter, as consultants in finding the right successor to the "Captain."

Museum life in New York in the 1960s was still a clubby affair, fraught with politics, nepotism, and insider relationships that originated with MoMA's opening in 1929. The search for Steichen's successor was conducted in a Byzantine manner with other candidates, secretly considered, that were a better fit with the prerogatives of MoMA's director, René d'Harnoncourt. With Monroe Wheeler, MoMA's director of exhibitions and publications, d'Harnoncourt pursued an agenda that did not always agree with Steichen's. D'Harnoncourt favored hiring a museum person. His first choice was the Art Institute of Chicago's very able curator of prints and drawings, Hugh Edwards. An unlikely candidate to succeed in stylish New York art circles, Edwards—from Paducah, Kentucky—spoke with a pronounced drawl, wore inexpensive suits usually in need of cleaning, and visibly suffered from Giles Smith syndrome, the menacing condition of clubfoot, which forced him to wear special shoes and to navigate on a wooden crutch.

More than likely, d'Harnoncourt quietly tendered the position to Edwards during the summer of 1961. On July 5, Edwards replied, "I am happy indeed to have had this new association with your museum," but lamented, "I have come to the conclusion that, in any case, I shall stay in Chicago."[13] D'Harnoncourt was too late. Besides, Edwards had his own agenda. A little more than a year earlier, on May 23, 1960, Edwards wrote to Robert Frank proposing Frank's first one-man exhibition to be held at the Art Institute. "I have not forgotten that you said you might be interested in a show and my experiences with *The Americans* have been so many," Edwards wrote.[14] Under Edwards's stewardship, something had already "been begun in Chicago," with the Art Institute's "plans for enlarging the collection and . . . a new gallery" for photography. Edwards, in fact, was a remarkable visionary whose impact on American photography has yet to be defined and appreciated. Giving early support to Frank, he also championed Danny Lyon, Duane Michals, and numerous others before most curators recognized them. He recognized Szarkowski's talent, too, showing his work in 1961. Szarkowski recalled

George Platt Lynes
MONROE WHEELER, c. 1950

he "wanted to get in the ring with big boys," knowing in 1961 that Edwards was a maverick in the field in his bold and speculative choices as a curator.[15] Edwards's deep commitment to Walker Evans, first planted in 1938, remained steadfast throughout Evans's lifetime. It is tempting to consider what the MoMA's department of photography might have looked like under Edwards's direction, for he had vast experience, having virtually dedicated himself to museum life in Chicago for nearly a quarter of a century.

Szarkowski, on the other hand, possessed no experience running a museum department, let alone curating photographic exhibitions. Only after Edwards rejected d'Harnoncourt's offer to take over in New York did Wheeler write to Szarkowski on July 11, 1961. "You may have heard," he wrote, "that the Museum of Modern Art is planning as part of its new building, a new Photography Center, to be named after Edward Steichen . . . It occurred to us that you might like to talk with us about our future and perhaps yours."[16] Szarkowski was a somewhat reluctant candidate compared with others, like Coke, who was more than eager to ascend to Steichen's throne. During the summer of 1961, Szarkowski waited more than two weeks to respond to Wheeler's second letter of invitation to visit New York in order to meet d'Harnoncourt. Using a letterhead that boldly proclaimed his status as "PHOTOGRAPHER," Szarkowski explained his delay, saying he had been documenting the Quetico-Superior wilderness area, which overlaps the border separating Minnesota and Canada, near Lake Superior.[17] The statement clearly spelled out his priorities.

Ironically, the photographer/curator duality in a candidate troubled Steichen even though he was himself a photographer, who had landed at MoMA as a patriotic celebrity following World War II. Earlier in 1961, Steichen wrote in a memo to d'Harnoncourt that he was "worried about the caliber of the men who have been suggested for the department" and proposed that "photographers be ruled out (unless we find someone willing to give up photographing) and perhaps canvas the art field."[18]

Monroe Wheeler was the epitome of decorum and style. One could hardly refuse him. In retrospect it is difficult to determine whether Szarkowski's disinterested counter replies were calculated in advance, acts of naïveté, or outright disrespect. At this moment, did Szarkowski genuinely want the position in New York? He seemed to be suggesting that his own photography took prece-

dence over everything else. Did he realize what Wheeler's offer of a photography curatorship meant in 1961? Did he care? And when asked, would he give up photographing as Steichen had proposed?

Wheeler facilitated Szarkowki's initial interaction with MoMA. He maneuvered among the various political factions weighing in on his choice for the appointment. By late 1961, MoMA had found its man and made an historic and prescient decision. On December 7, 1961, Beaumont Newhall, former MoMA curator and then director of the George Eastman House, wrote enthusiastically to Wheeler. "I am delighted with the choice of John Szarkowsky [*sic*]. He spent the weekend with me on a kind of briefing session. I was impressed with his personality, his attitude, and his eagerness. I am grateful for the privilege of sharing the confidential news of his forthcoming appointment."[19]

It is interesting to consider the role Walker Evans played in Szarkowski's hiring in 1961. Perhaps more than any other American artist, Evans was uniquely woven into MoMA's historic tapestry. Wheeler, who for all intents and purposes oversaw Szarkowski's selection at MoMA, had known Evans for years. Their paths probably crossed in the late 1920s in Villefranche-sur-Mer on the Côte d'Azur. Certainly the two met in New York in the early 1930s, when the Julien Levy Gallery paired Evans and George Platt Lynes in an exhibition.[20] Lynes was Wheeler's lover who, together, with writer Glenway Wescott, formed an impressive *ménage-à-trois* whose social set included Evans's chief patron, Lincoln Kirstein.[21]

Kirstein was among the first to recognize and promote Evans's talent. He included Evans in *Modern Photography,* a 1930 group exhibition Kirstein curated for MoMA's predecessor, the Harvard Society for Contemporary Art. The same year, Kirstein published three of Evans's pictures in *Hound & Horn,* the literary journal he had founded at Harvard. As Evans's most ardent supporter, Kirstein, more than any person, influenced MoMA's early support of Evans, initially in 1930, advising MoMA on its first acquisition of a photograph, an Evans picture of a Wilhelm Lehmbruck sculpture; and three years later with MoMA's exhibition of Evans's Victorian house survey photographs. An auspicious prelude to what followed in the Evans/MoMA relationship, Evans's thirty-nine prints in *Photographs of 19th-Century Houses* hung in the museum simultaneously with a retrospective of Edward Hopper paintings. It was MoMA's first one-person exhibition of photography and Kirstein was in the background from the very be-

Walker Evans
LINCOLN KIRSTEIN, 1931

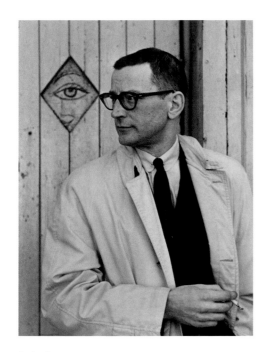

André Kertész
JOHN SZARKOWSKI, 1963

ginning. His later involvement in Evans's 1938 exhibition and book, *American Photographs,* is legendary.

As for Wheeler, himself, in the 1930s, Evans must have appeared as a kind of fellow party boy. Evans's presence on the scene left an impression of earnestness and street smarts, qualities that Wheeler also possessed and that both men found useful in the New York art world at this time. Besides, both had grown up in suburban Chicago, Evans in Kenilworth and Wheeler in Evanston. They were of the same generation; Evans was nearly five years Wheeler's junior. Thus, in seeking recommendations for Steichen's replacement, it would have been natural for Wheeler, as he surveyed the rather negligible art photography community, in 1961, to consider Evans's insight on the matter.

Much has been written about Evans's advocacy of Robert Frank for a 1955 Guggenheim Fellowship, which allowed Frank to make his famous road trip across America and led to what later became *The Americans* of 1959 (published first in France by Robert Delpire as *Les Américains,* 1958). Szarkowski had not known this, but Evans had done the same for him. Through Evans's endorsements, Szarkowski received two Guggenheim Fellowships, in 1954 and 1961. Why Evans never disclosed this remains a mystery. Evans, the consummate gentleman, was not above flagrant opportunism in his professional relationships. As with many struggling artists, a system of exchange always helped advance his particular agendas. This had begun with Kirstein in the early 1930s. Evans's secrecy reveals another side of his knotty relationships with rivals and those he considered possessed of talent or power. Szarkowski noted later that it was a matter of Evans's "style— not a word ever . . . no hint that he ever had known anything about me or my project."[22] By 1962, with Szarkowski having learned of Evans's support, the two men became friends. "I came to the museum in 1962," Szarkowski recalled. "I got to know Walker and saw him quite a bit, you know, he'd come to dinner and we'd go to lunch together and maybe around 1963 or 1964, Moe (Guggenheim Foundation president, Henry Allen) said, 'John, I'd like you to come and be referee for us at the Guggenheim. . . . Walker wants to spend more time in the country.'"[23]

Szarkowski needed Evans as much as Evans needed him, but he was correct in perceiving that the older man's professional desires outweighed his own. John began to do for Walker what Walker had quietly done for John. Szarkowski would never forget the artist who, having supported his first Guggenheim grant

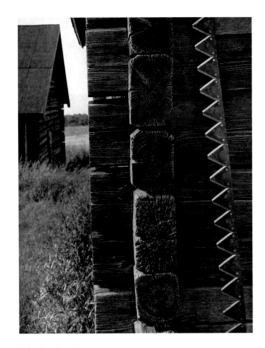

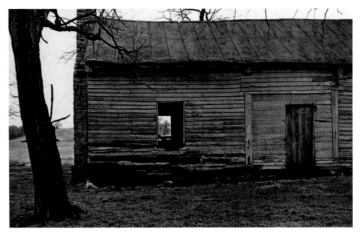

John Szarkowski
FINNISH BARN NEAR LINDEN GROVE,
Minnesota, 1957

Walker Evans
BARN, KENTUCKY, 1961

in 1954, had opened his doors to him in 1955, as if to a stranger. Szarkowski admired the subtlety, the grace of it all.

It can be said that Szarkowski, who certainly didn't look like Evans, modeled his style and intellect after those of Evans. He also emulated Evans's tendencies toward compartmentalization, discretion, and aloofness. Most importantly, each man reinforced in the other a taste that balanced the opposing forces of topographic fact collecting with rigorous formal beauty. They loved work that, in Evans's words was "literal, authoritative, and transcendent."[24] Many of Szarkowski's photographs from the 1950s onward amply show that Evans's photographs had established the standard to which the younger artist aspired.[25] "I want to make pictures possessing the qualities of poise, clarity of purpose and natural beauty," Szarkowski wrote of his own photographs in 1958.[26]

The symbiosis between Evans and Szarkowski, equal parts mutual hero-worship and identity exchange, extended beyond mutual aid. Taking what each needed from the other amounted also to a crucial aesthetic collaboration at a moment when the definition of what it meant to photograph, what a photograph was, or what it might be for future generations was up for grabs and being rewritten.

It is a fascinating coincidence that a modest seventeen-print reinstallation of Evans's 1938 exhibition *American Photographs* occurred at MoMA just days after Szarkowski began his new job. Overseen by Wheeler, who contributed a text to the reissued book, *American Photographs* enthralled a new generation of photographers eager to claim it as inspiration. In another coincidence, Robert Frank's exhibition with Harry Callahan was hanging on the walls just months before Szarkowski's first days at MoMA in 1962.

No one having studied or written about the medium has ever overestimated the ego of a photographer. It must have irked Evans to see new talents like Frank enjoying the limelight at MoMA that he had once monopolized himself.[27] During his long dry spell with the museum, Evans had been evolving much grander, if seemingly delusional, designs for MoMA than the piddling rehash of his classic work it now deigned to give him.

Evans was sitting on an archive of work that he had published in *Fortune* but never exhibited. From the 1940s to the 1960s, working for *Fortune* kept him afloat; he had created portfolios for the magazine that demonstrated that he hadn't lost his unique way of looking at things, despite being underwritten by a prominent commercial enterprise. At *Fortune* he had continued to build diligently onto the strengths of a life's work in photography.

MoMA's diminutive reprise of *American Photographs* in 1962 showed that few were able to separate Evans from his iconic early work—and Szarkowski was no exception. Hilton Kramer had described it as literally embodying "the emotional and esthetic texture of the Depression era."[28] But Evans had greatly expanded his repertoire. *Fortune* knew it; the museums did not. It was strategic for Szarkowski to remind the public of Evans's virtues as an artist. His *American Photographs* gave historical precedent to the theoretical framework that Szarkowski embodied in his first major exhibition and publication at MoMA, *The Photographer's Eye*. The exhibition premiered on May 27, 1964, with the book publication following in 1966. But in 1961 Szarkowski outlined his plans in a confidential brief entitled "The MoMA Department of Photography—62," where he wrote, "In addition to surveying photography's important achievements, this exhibition will attempt to trace photography's growing understanding of its own nature."[29] The American Landscape, the Frame, the Invisible, and Continuity were among the project's tentative themes, the latter of which addressed photographic series, essays, and book sequences. Of these, Szarkowski wrote, "Perhaps the strongest use ever made of this potential exists in the MoMA publication *American Photographs* by Walker Evans."

The Photographer's Eye featured work by well-known artists, but also lesser-known and anonymous photographers. It favored photographs that shared Evans's aesthetic, and of course, Szarkowski's own. Evans's work was the prototype. It epitomized and announced to the world the new curator's embrace of author-

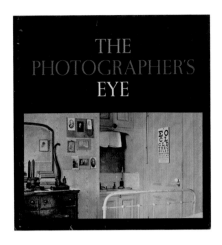

Cover of John Szarkowski's
THE PHOTOGRAPHER'S EYE
(Museum of Modern Art, 1966)

less, disinterested, and to some extent, perfectly "artless," democratic images that dissolved subjectivity in favor of purely photographic transparency. Or, as Evans later articulated to Leslie Katz in 1971, "the non-appearance of the author, the non-subjectivity" of the artist.[30]

With Szarkowski, one cannot separate the photographer from the writer/curator/public intellectual. They merge into one. Somewhat defensively, and certainly alluding to Evans, Szarkowski later retorted that "one does not choose to write about photographers who illustrate one's point of view. The process is almost the reverse: one's point of view is formed by the work one chooses to write about, because it is challenging, mysterious, worthy of study, fun."[31] Given his obvious belief in the power of *American Photographs,* in 1962 Szarkowski used Evans to bolster his newly acquired influence at MoMA. His friend, mentor, and idol would aid his nascent enterprise to redefine American photography and return it to its roots, to its own true "nature." Thus, MoMA began to forge a new status for the medium. With Szarkowski in charge, Evans had something to look forward to.

THE ARCHIVE AND THE IDEA

Evans's rise in the mid-1960s was precipitated by two publications that coincided with *The Photographer's Eye* in 1966. *Message from the Interior,* a book of Evans's photographs of interiors with an essay by Szarkowski, and *Many Are Called,* showcasing his subway portraits, underscored a surge of interest in his work. Through Szarkowski, Evans began to see the future of his legacy. He realized it rested chiefly on his early work at the expense of what had followed. But most people were unaware of the artistic value of what had followed.

To honor the publication of *Many Are Called,* Szarkowski organized *Walker Evans' Subway Photographs,* an exhibition of forty-one prints that opened on October 5, 1966. Simultaneously, Evans mounted an exhibition of prints for sale at the Robert Schoelkopf Gallery, uptown, at 825 Madison Avenue. The space, dedicated to painting and sculpture, had never before shown photography. It is difficult to ascertain how successful the print sales were—in 1966 there was virtually no photography collecting market to speak of. A truer measure of Evans's re-ascendancy at this moment came from the critical praise mounting

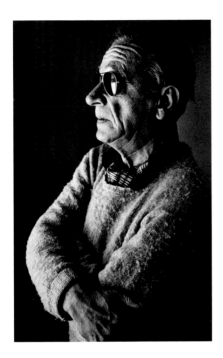

Arnold Crane
WALKER EVANS, 1969

throughout New York's cultural establishment. "Having been a distinguished photographer in our midst," *The New Yorker* magazine auspiciously proclaimed, Walker Evans is "currently being fussed over as excitedly as if he were the latest fashionable discovery."[32] Szarkowski held the banner highest, fervently advocating Evans's supremacy. Evans was certainly not blind to his efforts and gracefully, if not tactically, he complied with his curator's every directive. In a letter thanking Szarkowski for his support for *Many Are Called,* Evans wrote, "I value *that* highly [Evans's emphasis]. So, much gratitude; and I hope you'll be rewarded by me, by events on earth and in heaven. In fact I shall see to it, somehow (except in heaven, I fear)."[33]

Evans was more than ready for the attention. Shortly afterward, he initiated a campaign that sent his artistic stock skyrocketing. It culminated with Szarkowski's 1971 monographic exhibition of 202 photographs, *Walker Evans,* which, at that moment, was the second-largest exhibition that the curator had given to any single artist—an impressive fact, considering that Szarkowski had already mounted exhibitions of work by Henri Cartier-Bresson, Jacques-Henri Lartigue, Berenice Abbott, and Garry Winogrand, among numerous others.[34]

The exhibition was long in the planning. By early 1967, Evans had already engaged Szarkowski in conversations about a future retrospective. In correspondence that year, Evans made clear his desire to put the project on a fast track. He also made clear his need to keep working and earn money. In a letter dated July 2, 1967, Evans wrote:

> Dear John,
> After our conversations, I should give you some estimate of the time and money I think will be needed to produce a comprehensive exhibition of my photographs for the Museum.
> I believe the exhibition could and should be mounted in 1969.
> I believe about $15,000 need be granted. This money would be for purchasing materials and equipment; employing research and technical assistance; and, let me make it clear, employing myself.
> I shall be asking you what you think of this; you will naturally give or send some reply, and we may proceed from there. I am meeting James Dow next week. As I told you, Dow has already

qualified, in my mind, for the job of as technical assistant for such a project and has declared desire and willingness to undertake it. He may be qualified for the research work as well.
Yours faithfully,
Walker[35]

"Retrieval" is the operative word that Szarkowski attached to the project. It required that Dow, with Evans's oversight, locate the photographer's original negative files and submit them to a process of contact- and test-printing. This ambitious effort had far reaching affects, historically. Szarkowski's intention was to find the best images. But among many of the negatives he selected, there were no corresponding vintage prints, or at least any extant prints that Szarkowski deemed acceptable. It was a highly subjective process inflected by Szarkowski's puritanical craftsman's roots in photographic printing, which clashed with Evans's more casual, laissez-faire approach, not to mention his utter disdain for the darkroom.

It was clear from the Schoelkopf Gallery exhibition that Evans's photographs sometimes existed only in single prints, "the negative having been lost or destroyed."[36] Of the vintage prints in Evans's archive, Szarkowski was "unconvinced" of their quality. Szarkowski thought, "There were an awful lot of bad prints . . . They were vintage, all right. They were mustard colored, peanut-butter colored, faded . . . and here and there a pretty good print."[37] It is important to remember that Evans never considered himself to be a technician and his eccentric printing methods were uneven and "difficult for anyone else to follow." "Walker didn't care if they were old prints or new prints, as long as he felt they were good [pictures]."[38] *Time* magazine had observed in 1947 that for Evans, "the pleasure and the art of photography are in the seeing, not the doing." Evans added that "developing chemicals smell bad, and the darkroom is torture . . . Photography has nothing whatsoever to do with 'Art.' It's an art for all that."[39] Despite protestations, past and present, Evans was ready to do anything to see his MoMA retrospective realized. He submitted to Szarkowski's demands that Dow make modern prints. Besides, Evans needed the money that would surely result from the project.

The debate over Evans's prints—vintage, modern reprints, and others (e. g., recent, oversized carbon pigment examples)—has occupied collectors, dealers, critics, and scholars since this time. The argument involves aesthetic sub-

WALKER EVANS: CARBON AND SILVER
Exhibition (UBS Gallery, New York, 2006)

jectivity versus constantly revised codes of museum standards and the modern, peculiarly American cult of the "perfect" print that has become institutionalized in collecting photographs. Evans never subscribed to perfectionism, and for his entire career railed against too beautiful, arty photographs of the type that were the mainstay of modern masters as Steichen, Edward Weston, and Ansel Adams. He sometimes (haphazardly) supervised the printing of his work. This is evidenced today in the secondary market, where the range of tonalities, papers, and patinas that distinguish these concoctions have stimulated a veritable revival in photographic print connoisseurship.

Szarkowski's advocacy for newly printed photographs concurs with Christopher Phillips's observation that the curator showed "little interest in work in which the photographer's 'hand' figures prominently."[40] Nor was Szarkowski caught up in issues of rarity and authenticity. He sought to emphasize his belief in "pure photographic description,"[41] which Evans's work supremely illustrated. Besides, immaculate, new prints avoided unwanted distractions. For Szarkowski, the message *was* the medium.

The portfolio of prints that Evans produced to take advantage of the 1971 retrospective exhibition opened the floodgates of demand for subsequent re-editions of his work. Produced at the end of his life, these portfolios intro-

duced viewers to pristine, flawless, and in some instances, homogenous-looking photographs that further confused the burgeoning number of collectors interested in his work, though they sold poorly during the artist's lifetime.[42] These new prints certainly irritated the "eye club," a loosely aligned group of collectors and historians attracted to imperfect, the dog-eared, stained, faded and other eccentricities of vintage photographs. These attributes, they felt, infused photographs with the primitive magic they loved in the very first photographs.

Szarkowski disagreed. He, Evans, and Dow pressed forward on their retrieval, authorizing, if unwittingly, other, commercial editions of Evans's photographs that eventually made their way to the marketplace. Besides the debate over the quality of Evans's vintage works and modern reprints, the photographer's erratic and inconsistent habit of cropping his images, for books and exhibitions, also confused contemporary viewers. Evans was never always satisfied with cropping. He later continued this practice at *Fortune,* experimenting with crops, thus altering the emphasis he wished to make with an image, reworking prints over and over again. Writing for *Artforum* following the 1966 Schoelkopf exhibition, Sidney Tillim wondered, "which is an original or the official version?"[43]

Cash poor, Evans made matters worse by a wholesale disbursal of his archive. By 1974, he had sold all the vintage prints that he had, keeping no definitive record, so that single prints still continue to elicit surprise when they surface in galleries and auction houses. Evans made several thousand prints in his lifetime. There may be no end to the discoveries of his vintage work in years to come.[44]

Through the course of 1967 and most of 1968, Evans and Szarkowski negotiated the financial and practical terms of their collaboration as Dow began the painstaking work that it required. Files of negatives were assembled and dropped off in waves during 1969 with occasional distractions that showed Evans playing catch-up to keep the plan on schedule. From Robert Frank's and June Leaf's home in Nova Scotia, Evans wrote to Szarkowski, "John, Sir, travel is broadening. But I still remember my occupation; and that I am to arrange transfer of my negative file, complete, from the New York warehouse to your office . . . You'll have some prints won't you, of the large and small negatives I left at my last visit? Full speed ahead."[45] To begin the work, $9,500 was raised, with Evans asked to account for only $3,500 of the total. Proof prints for a "very large body of Evans's work" were made, from which Szarkowski began editing the planned exhibition.[46]

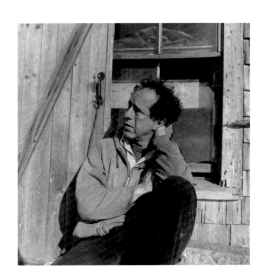

Walker Evans
ROBERT FRANK, NOVA SCOTIA, 1969–71

Walker Evans
ROBERT FRANK AND JUNE LEAF'S PROPERTY,
NOVA SCOTIA, 1969–71

Szarkowski himself was coming off a transformative year that culminated in 1967 with *New Documents,* a visionary and controversial exhibition which in many respects set the stage for all that followed in his career. *New Documents* was a testament to Evans, too, whose own work had laid the foundation of Szarkowski's theory of photography. This had been defined through the essential themes and methodology in *The Photographer's Eye,* which henceforth drove his program at MoMA. With Diane Arbus, Lee Friedlander, and Garry Winogrand, Szarkowski went much further in defining his position, exhibiting ninety-four of their prints in one of the most influential photography exhibitions ever mounted. *New Documents* anchored the future reputations of all three artists not only to Szarkowski, but also to Evans, the hidden hand, the "prophet."[47]

Evans had forcefully advocated for Friedlander and Arbus, and, as with Frank, he developed strong personal ties. All three photographers came to know Szarkowski from the moment of his tenure at MoMA. Winogrand had been one of five artists who comprised Szarkowski's *Five Unrelated Photographers* of

Installation view of
NEW DOCUMENTS (Museum of Modern Art, New York, Feb. 28 – May 16, 1967)

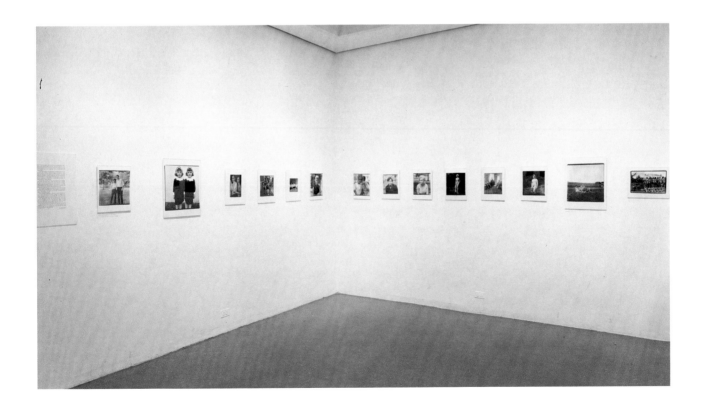

1963. With *New Documents,* by comparison, the curator shifted current conceptions regarding approaches to documentary form, from a social or "concerned" photography to deeper introspection. "In the past decade a new generation of photographers has directed the documentary approach towards more personal ends," Szarkowski wrote in the wall text for the exhibition.

> Their aim has been not to reform life, but to know it. Their
> work betrays a sympathy—almost an affection—for the imper-
> fections and the frailties of society. They like the real world, in
> spite of its terrors, as the source of all wonder and fascination
> and value—no less precious for being irrational . . . What they
> hold in common is the belief that the commonplace is really
> worth looking at, and the courage to look at it with the mini-
> mum of theorizing.[48]

The synergy and common aesthetic sensibilities that Evans and Szarkowski shared with these emerging artists marked a crossroads. *New Documents* charted the medium's new documentary direction for at least the next two decades, establishing MoMA as a crucible for a quintessentially American photography, the effects of which continue into the present. Because these younger artists collectively admired Evans's work and acknowledged its impact on their own, the senior photographer found himself back in the center of innovation. It was where he belonged.

With Evans reconnected to what was now considered new, American photography itself gained new importance. It began to inch out of its narrow confines toward representation that was more conceptual and engaged with other media. Evans's dedication to vernacular subjects was reconceived as proto-Pop art. What he had done all along, now, decades later, not only seemed fresh, it nourished the artists who sought photographic refreshment.

In the final days before the MoMA retrospective, Jim Dow was feverishly working on the new prints. He selected some images he thought "might be good," though Szarkowski somehow overlooked or dismissed them. In a letter of January 7, 1971, Dow lamented to Szarkowski, "Many of the negatives had stains, streaks and/or smears of the sort that had they been printed around would have essentially destroyed the picture."[49] Nonetheless, Szarkowski forged ahead by favoring the Depression-era photographs. Despite the existence of Evans's pictures

for *Fortune,* called the "largest single body of work he produced," Szarkowski was insecure about his picture selection and all but ignored the later photographs.[50]

The focus on Evans's pre-1940s work that persists to this day is the product of a master narrative begun much earlier. One part of this narrative suggests that Evans's later work, after the decade in which he carved out a unique identity, is meager in scope, inferior, or uninspired. "The pictures made for *Fortune* exhibit the clarity and intelligence that are the essence of the Evans style," Szarkowski wrote, damning Evans's later work with faint praise, before continuing, "It must also be said that they often lack the sense of fierce conviction that identifies his best work."[51] Szarkowski narrowed Evans's career even further. He believed that the eighteen-month period, begun in late 1935, bracketed Evans's best work, a period Szarkowski called the artist's "astonishing creative hot streak."[52]

Yet, Evans's portfolios for *Fortune* and work that followed are worth reconsidering. In 1971, Evans said his interests after the 1930s had been "amplified somewhat" but he had not "outgrown them."[53] He felt boxed in by his Depression-

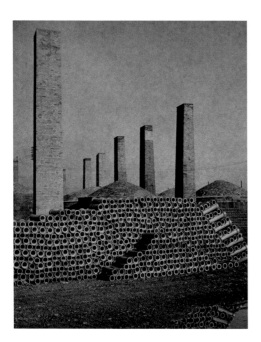

STUDY OF CLAY PLANT, OHIO, 1950
Commissioned by FORTUNE for "Clay: The Commonest Industrial Raw Material" (Jan. 1951)

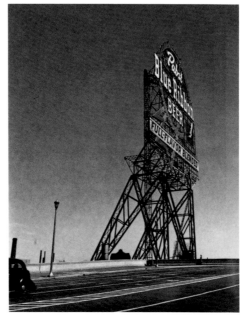

PABST BLUE RIBBON SIGN, CHICAGO, 1946
Commissioned by FORTUNE for "Chicago: A Camera Exploration" (Feb. 1947)

era photographs. He hotly resented that so many people were unaware that he was still a practicing photographer. It was a misperception, and curious in light of Evans's persistent return to classic subjects from the American vernacular, the rural southland, architectural typologies, the margins of modern urban life, and portraiture, which clearly amplified his earlier work, thematically and aesthetically.

Evans remained unwavering in his wry observations regarding the state of the American scene. The many ironies in American excesses of the 1950s and 1960s postwar consumerist culture were hardly lost on Evans, who had survived the worst years of the Depression. An obvious and cohesive visual unity runs through all of Evans's work. Yet, primarily, he continues to be known for only a fraction of images from his vast output. This was largely due to Szarkowski's preferences, as we have seen. The curator had his own reasons for defining Evans as he did. But the myopia persists forty years after the 1971 retrospective. Why?

RESTORATION

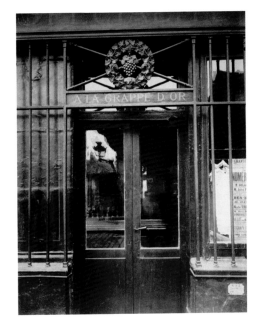

In New York intellectual circles attracted to photography in the early 1970s, Susan Sontag was an estimable presence. "It is a nostalgic time right now," Sontag wrote in her contentious collection of essays, *On Photography,* published six years after Evans's 1971 MoMA exhibition. "Photographs actively promote nostalgia," Sontag continued. "Photography is an elegiac art, a twilight art . . . The moody, intricately textured Paris of Atget and Brassaï is mostly gone. Like the dead relatives and friends preserved in the family album . . . so the photographs of neighborhoods now torn down, rural places disfigured and made barren, supply our pocket relation to the past."[54] Clearly familiar with *American Photographs* and Szarkowski's 1971 MoMA exhibition catalogue, Sontag praised Evans as the non-heroic image-maker refusing to "express himself," in favor of cool, democratic understatements.

Her summation is apt, though surprising in its refusal to mention Evans's posthumous (by 1976) status in American photography which had led contemporary viewers to regard this nostalgic, elegiac art with new eyes. Nor does she make any link to Atget, whose work was perhaps Evans's greatest inspiration. Sontag was not striving for completeness. In fact, when she was writing, she didn't actually know much about the history of photography. She based her essays on her own personal experience with photographs, but she was no fan of Szarkowski.

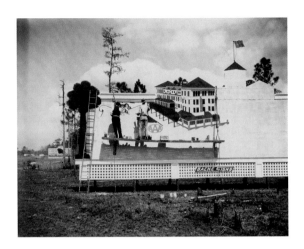

Walker Evans
BILLBOARD PAINTERS, FLORIDA, c. 1934

Her scathing critique of Arbus in *On Photography* is matched by her thinly veiled dismissal of *New Documents*, "the cooler, ruder, bleaker photography" produced in Evans's wake.

Perhaps too little time had passed since Evans's death in 1975 for Sontag to make this aesthetic leap. Her book was compiled from articles published in the *New York Review of Books* years earlier. But others, more astute, were making finer distinctions and more radical pronouncements. In 1971, Hilton Kramer distinguished Evans from the Depression-era movies that he felt induced "nostalgia." "For how many of us I wonder," Kramer wrote, "has our imagination of what the United States looked like and felt like in the nineteen-thirties been determined not by a novel or a play or a poem or a painting or even by our own memories, but by the work of a single photographer, Walker Evans?"[55] It was one of the most profound assessments of Evans's cultural impact ever written.

Nostalgia. "I hate that word," Evans seethed in a 1971 interview with his publisher, Leslie Katz. "That's not the intent at all. To be nostalgic is to be sentimental. To be interested in what you see that is passing out of history even if it's a trolley car you've found, that's not an act of nostalgia."[56] In his text for *Let Us Now Praise Famous Men,* James Agee arguably lapsed into romanticizing a "pre-technological" and "organic past," but that did not suit Evans.[57] Like Walt Whitman, in his desire to wring art from the commonplace and the extraordinary, from the unattractive and the beautiful, from the downtrodden and the respected, Evans countered Agee's sentiments. His vision, which leveled all experience into a new American beauty, was the very reason that Szarkowski needed to retrieve his work, and it was the reason for the industry in Evans scholarship that followed.

Evans's classic disinterestedness persists in the post-1940 work as well. Szarkowski knew this, but it seems that he did not want to confuse his audience. He concentrated on the work of the 1930s, perhaps because he saw his own origins in it. He was nearly four years old when the stock market crashed in 1929. Having grown up in the American heartland, he directly witnessed the social and economic fragmentation of the dispossessed throughout the 1930s. It was his own story, experienced during the most formative period of his life. It cannot be ruled out that possibly in adulthood his undying praise for Evans's classic work might have been colored by feelings about his own past as he poured over Evans's Depression-era photographs.

In his introduction to the 1971 catalogue, Szarkowski made an unusual observation. "It is difficult to know now whether Evans recorded the America of his youth or invented it," Szarkowski wrote.[58] "Beyond doubt, the accepted myth of our recent past is in some measure the creation of this photographer, whose work has persuaded us of the validity of a new set of clues and symbols bearing on the question of who we are. Whether that work and its judgment was a fact or artifice, or half of each, it is now part of our history."

The supposition recalls Hilton Kramer's by hypothesizing that what was presented as factual might be the stuff of dreams. That Evans's work was a force that could convince us about what might never had existed. Evans's 1930s photographs were like mirages, not visualizing something he had seen but what he might have made up. It was the America of a boyhood forever lost except through imperfect memories, like the little boy's sled, called Rosebud, a tender imprint on the memory of the tragic character in Orson Welles's *Citizen Kane* (1941). Yearning for irretrievable moments of one's life is something photography has always amply fulfilled. Roy Stryker, Evans's manager at the Farm Security Administration during the 1930s, recalled that he found Evans's photographs from this period "a source of reverie and nostalgia . . . I would look at pictures like that [of Edwards, Mississippi, 1936] and long for a time when the world was safer, more peaceful. I'd think back to the days before radio and television when all there was to do was to go down to the tracks and watch the flyer go through."[59]

Many others, like Hugh Edwards, had similar feelings. He arrived in Chicago as a music student in 1928, one year before the stock market crashed, and began his career as curator at the Art Institute in the 1930s. He obtained *American Photographs* in 1938. Writing to Szarkowski about the 1971 exhibition, Edwards remembered how important Evans's work had been to his own life. "When so many of us were discovering the U.S.A. and—strangely enough in one of its worst times of crisis . . . Walker Evans, more than anyone else, opened my eyes to America and revealed photography to me. It makes me very happy after all these years to realize how surely . . . his work has arrived at this stage of influence and permanence which it occupies today."[60] For Edwards, Evans and his work constituted the best "living example of what is called the American Tradition."

The desperation of the Depression lived on in collective memory, through anecdotes, photographs, motion pictures, and many tributes through the collec-

tive imagination. In this period of Evan's re-ascendancy, a potent tribute occurred in Arthur Penn's 1967 Academy Award-winning film, *Bonnie and Clyde,* where Evans's photographs were the source of Dean Tavoularis's set designs and cinematographer Burnett Guffey's visual effects. Arthur Penn, the brother of Irving Penn, another photographer whom Szarkowski favored during his tenure at MoMA, depended on Evans's photographs for the imagery through which the director could depict the failure of capitalism and the sepia-toned malaise associated with the Depression, the Dust Bowl, and the American southland. Penn had seen it represented in Evans's and Agee's *Let Us Now Praise Famous Men.*

SYMBIOSIS

Tributes like these gnaw at the fact of Evans's later work, about which the photographer was a walking contradiction. Like any artist he desired recognition for all of his work. He also calculated that he had little time left to restore a reputation, built largely on *American Photographs,* that would include everything he had accomplished during his lifetime. Evans was inclined to distort his record at *Fortune* in order to underscore his now iconic work of the 1930s.[61] But he liked what he had done at the magazine. Looking at the portfolios, for which he wrote important texts, one sees not only his own poetics applied to the images but an intense conviction regarding the presentation of text and photographs. In Evans's color work for *Fortune* and other magazines, too—another striking contradiction, given his statements about color photography being "vulgar"—his lyrical compositions challenge any lopsided judgment.[62] The color photographs he made as early as 1945 and the Polaroids he made at the end of his life show Evans's intense engagement with the present. In this work, he deftly prefigures the new American color photography gaining ground in the 1970s, the work of William Eggleston and Stephen Shore, for example, among numerous others. Szarkowski ignored this aspect of Evans's career; he played dumb to it because it simply did not fit his narrow viewpoint.[63]

Editing the 1971 exhibition, billed as Evans's "first definitive retrospective," Szarkowski solidified the master narrative once and for all. Evans, concealing the contradictory complexity of his real wishes, didn't resist. He only feigned agreement, wanting to never again fall out of MoMA's good graces. Only thirty-

Walker Evans
"Color Accidents," spread for ARCHITECTURAL FORUM (Jan. 1958)

three images, or sixteen percent of the entire exhibition, addressed work made after 1940. Although the exhibition catalogue generously reproduced the post-1940 work, the classic pictures dominated in seventy-seven of the one hundred plates. Even if one never read the catalogue, the pictures concretized a rather skewed view of Evans's forty-six years photographing.

Evans's acquiescence on the newly produced prints made by Dow was perhaps an even greater surprise, certainly to those familiar with the vintage works. "I attended the opening night reception at MoMA," photographer and collector Arnold Crane recalled. "I was horrified by what I saw, disturbingly uniform prints. It wasn't a Walker Evans exhibition, but a printer's exhibition."[64] Crane, who had wrested ownership of over one thousand Evans prints from the artist in 1968, noted that Szarkowski "was incredibly jealous, especially of other photographers that got too close to Walker." Crane continued, "I asked MoMA curator [since 1966], Peter Bunnell, 'Why did John do this when he had complete carte blanche with my collection?' Peter's response was 'John didn't want it to be another Crane exhibition'"[65]

Installation view, WALKER EVANS
(Museum of Modern Art, Jan. 27 – April 12, 1971)

The opening of Evans's MoMA retrospective on January 26, 1971 culminated in a black-tie dinner to honor the photographer. The more than ninety guests included a mélange of Evans's oldest personal friends and newest young acolytes. The event was most impressive for the crushing throng of notables who emerged from every nook and cranny of the art world to be present at what must have seemed like a royal fête. It was a rich mixture of types who clinked their glasses of champagne for Walker: photographer Lee Friedlander, modernist critic Clement Greenberg; art dealers Julien Levy and Robert Schoelkopf; Russell Lynes, critic and brother of George Platt Lynes; Leslie Katz, Evans's publisher; and MoMA's intrepid Grace Mayer, for example. The seating put Diane Arbus and art director Marvin Israel at the same table. Garry Winogrand sat next to *New Yorker* writer Brendan Gill and Mrs. Edward Steichen. Robert Frank sat opposite Peter Bunnell.

Installation view, WALKER EVANS

As the champagne flowed, Davis Pratt, Harvard University's Fogg Art Museum curator of photography, found himself ogling Arbus, who later wrote to him that he "looked very good too. At one of the most painful of the dinner moments I looked across the room at you and was cheered."[66] What had been "painful" about an event so long overdue? Pratt loved the photographer, but he

felt embarrassed. He recalled that he and Arbus "were both bored by the endless words of praise for Walker."[67] After Henry Allen Moe recited a litany of appreciation, Evans's friend, the Pulitzer prize-winning author and poet, Robert ("Red") Penn Warren (*All the King's Men,* 1946) delivered the keynote address, in which he summed up the appeal of Evans's work and, as Hugh Edwards, Hilton Kramer, and Roy Stryker had done in the past, Penn Warren cast his praise in personal terms that continued to link Evans, exclusively, to the iconography of the Depression. Warren recalled:

> The world that Walker caught so ferociously in his lens thirty
> years ago was a world I had known all my life. Facing his pic-
> tures then, I found, at first, pleasure in simple recognition, but
> as I pored over the pictures, it began to dawn on me that I had
> not known that world at all. I had walked down those roads,
> dusty or muddy according to season. I had stopped before those
> log cabins or board shacks and been barked at by the hound
> dog. I had swapped talk with those men and women, by the
> rock hearth inside or squatting on my heels under a white oak
> or a chinaberry tree, according to latitude. But staring at the
> pictures, I knew that my familiar world was a world I had never
> known. The veil of familiarity prevented my seeing it. Then,
> thirty years ago, Walker tore aside that veil; he woke me from
> the torpor of the accustomed.[68]

Warren's eloquence bore more than a passing kinship with that of William Carlos Williams, who had reviewed *American Photographs* for *The New Republic* when it opened at MoMA in 1938. Williams and Warren uncannily brought Evans full circle to the institution that had launched his career, and defined him as the great American photographer. "It is ourselves we see, ourselves lifted from a parochial setting," Williams had written, presaging Warren. "We see what we have not heretofore realized, ourselves made worthy in our anonymity."[69] Williams's choice of the word *anonymity* conveyed a painful modern beauty. It was the kind of beauty that Evans's peculiar genius discovered and validated in pictures. Anonymity, a mounting feature of the modern experience, favors the power and grace of the ordinary, of the grass-roots collective. Warren realized he had been asleep.

Evans's photographs proposed something grand in the all-too-familiar. Future viewers, increasingly ruled by what General Dwight D. Eisenhower called the military-industrial complex, by big business, bureaucracy, by consumerism run amok, and mind-boggling explosions in technology, would return to Evans's romance with anonymity, achieved as if he had photographed America through a dirty window that simplified everything, and in so doing, restored to America its true democratic spirit.

Whether Szarkowski and Evans anticipated the groundswell of praise for the exhibition that crossed the United States is hard to say. Their reputations were now inextricably bound together. Szarkowski had launched Evans on an improbable late-life trajectory that restored him to the forefront of the art world. The curator had also bolstered his own reputation. He had bet on a seeming dark horse and won.

Besides multiple stories in *The New York Times,* the exhibition was covered by the *Nashville Tennessean,* the *Knoxville News Sentinel,* the *Christian Science Monitor,* the *Pittsburgh Press,* and the Washington *Star,* to name a few among the numerous periodicals that responded to this exhibition as a decisive cultural event.[70] "In the annals of photographic art," Hilton Kramer wrote in the *Times,* "1971 is clearly going down as Walker Evans's year."[71]

In December 1971 the Yale University Art Gallery mounted its own, though smaller, retrospective of Evans's work, *Walker Evans: Forty Years.* It was a fitting homage that also acknowledged Evans's teaching contributions at Yale.[72] Yale not only joined the praise, it joined the future. It was the first time this university had produced a major photographic show. And it confronted Szarkowski's parochialism by including Evans's most recent work from Nova Scotia, notably, a haunting series devoted to Robert Frank's home near Mabou Mines. The modest yet revelatory Yale exhibition went further by including with the photographs ten framed pieces from Evans's large collection of vernacular, found objects, rusted signs and discarded printed matter and postcards which he collected for years. Yale was looking at Walker Evans whole. The regular critics were confused, but they treated the inclusion as a trick. Hilton Kramer was coy. He considered the presence of this material a sleight of hand that he called a "beguiling intellectual trap" from which theorists would "be extricating themselves from for years to come."[73] Evans's cultivation of the vernacular was a mostly concealed

passion. With Kramer conferring on it critical legitimacy, suggesting it might be part of an aesthetic theory, it was out in the open. It entered the dialogue. It was here to stay.

The Yale exhibition was Evans's last major show and marked the pinnacle of interest in the photographer's work until his death in 1975. For its part, MoMA sent an abbreviated version of its Evans retrospective abroad. The MoMA exhibition traveled to Helsinki from August 1975, less than six months after Evans's death, and closed in Brussels on December 18 that year. In a five-month period, the "marvelously successful" eighty-print exhibition had ten different installations after Helsinki.[74] This sweep of Evans's work across Europe initiated a campaign that not only asked the viewing public outside America to reexamine a quintessentially American artist. The European response converted Evans into a kind of de facto American emissary, a good will ambassador whose pictures generated familiar clichés about the young country's up-by-the-bootstraps past—from colonial oppression during the Revolutionary War to its stunning, postwar domination, politically, on the world stage. Many Europeans looked at Evans's work for the first time. He fulfilled expectations of what was American. It was in retrospect an operation that more than resembled MoMA's ideologically charged promotion of American avant-garde art in the 1940s and the Cold War 1950s.[75] In a moment befitting a patriotic motion picture, Szarkowski proclaimed, "let's bring it home!"[76] Thus a vital chapter in American art that forever married Evans

Arnold Crane
WALKER EVANS, 1969

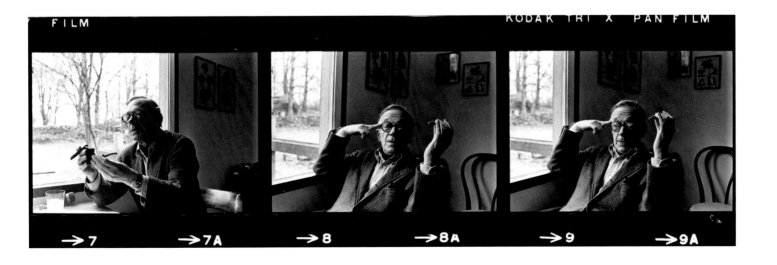

to the Depression-era 1930s, was closed. It made Szarkowski the new voice of American photography. It displaced what Leslie Katz called a "national consciousness"[77] with an international one that persists until today.

VALENTINE

In the Museum of Modern Art's curatorial files, there is a peculiar, mostly ignored souvenir. It is nothing more than a printed, legal-size envelope that Evans snatched from the Century Club in New York, an exclusive meeting place where the photographer enjoyed spending time, and it is decorated with the enthusiasm of a child. Addressed in Evans's handwriting to Szarkowski, the envelope also displays Evans's playfulness with stencils and inked stamps. Play, of course, is always serious: Evans has placed his and his curator's initials boldly across the envelope, almost as if he, like a lover, were carving them into a tree. "J. S." precedes and appears larger than "W. E." The envelope feels like the shred from a great romance. Its graphics declare the admiration, respect, gratitude, comradeship, even love that Evans felt for his curator and in sending it, knew that his feelings were reciprocated.

Evans died in 1975, but his ingenious spirit lived on in Szarkowski's choices for the next three decades, of whom to exhibit, about whom and what to write. A year before Szarkowski's own death in 2007, he solemnly recalled their relationship. Alluding to that chance moment when the young photographer/soon-to-be curator first met Evans in 1955, Szarkowski reflected "He was complex, sophisticated, secretive, unpredictable, and capable of deviousness, none of which affected his superior manners or his loyalty as a friend—although that loyalty was expressed according to a code that remained resolutely secret."[78] Evans's cryptic valentine to John Szarkowski was a code. Simply, it encompassed all the qualities the curator had observed about the photographer, except that in sending it, Walker Evans's feelings were not as resolutely secret as they might have seemed.

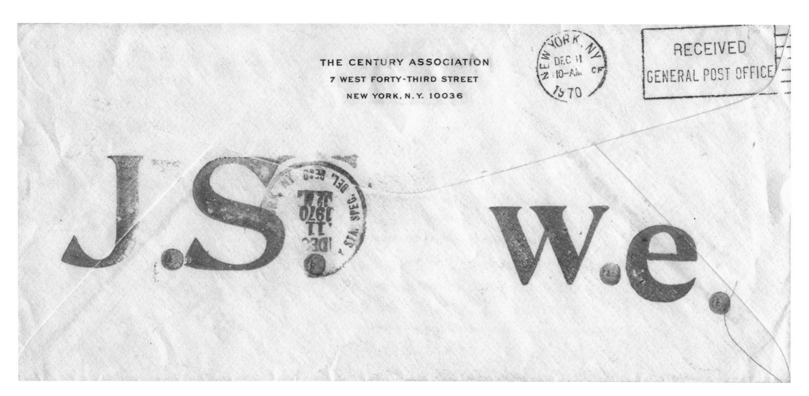

Envelope with John Szarkowski's and Walker
Evans's initials, postmarked Dec. 11, 1970

1 Doug Nickel, "John Szarkowski: An Interview," *History of Photography* 19, no. 2 (Summer 1995), p. 137.

2 The book, Szarkowski claims, only gets better with time. See Mark Haworth-Booth, "The Idea of John Szarkowski," *Art on Paper* 5, no. 3 (2001), p. 53.

3 To William Stott, Evans stated that at *Fortune* he had worked "in disguise, earning my living as a reporter." See William Stott, "Walker Evans: A Memoir and Introduction," in *Walker Evans: Photographs from the "Let Us Now Praise Famous Men" Project* (Austin: University of Texas Humanities Research Center, 1974). Noted in Lesley K. Baier, *Walker Evans at Fortune 1945–1965* Wellesley, MA: Wellesley College Museum, 1978), p. 7, note 8.

4 In his 1931 essay for Kirstein's *Hound & Horn,* "The Reappearance of Photography," Evans wrote, "Steichen is photography off its track in our own reiterated way of technical impressiveness and spiritual non-existence. In paraphrase, his general note is money, understanding of advertising values, special feeling for parvenu elegance, slick technique, over all of which is thrown a hardness and superficiality that is the hardness and superficiality of America's latter day." Walker Evans, "The Reappearance of Photography," *Hound & Horn* 15 (Oct.–Dec. 1931), p. 127.

5 In 1958, Evans's thinly veiled criticism appeared in his introduction to a portfolio of Robert Frank's work for *U.S. Camera Annual*. Walker Evans, "Robert Frank," *U.S. Camera Annual,* 1958, p. 90.

6 Stott 1974 (see note 3), p. 7.

7 Nickel 1995 (see note 1), p. 137.

8 Ibid.

9 Ibid.

10 Ibid. Emphasis is mine.

11 See Richard B. Woodward, "Picture Perfect," *Art News,* March 1985, p. 166. Also see Mark Durden, "Eyes Wide Open: John Szarkowski," *Art in America,* May 2006, p. 83.

12 On February 28, 1961, there was a meeting adjourned at MoMA whose purpose was to discuss "suggestions for someone to head the Photography Center," with attendees including the museum's director of exhibitions and publications, Monroe Wheeler; director, René d'Harnoncourt; and Edward Steichen. See typescript memorandum dated March 3, 1961 from Emily Woodruff to Monroe Wheeler, Monroe Wheeler Papers, I.55, the Museum of Modern Art Archives, New York (hereafter MW).

13 Typescript letter from Hugh Edwards to René d'Harnoncourt, dated July 5, 1961. MW, I.55.

14 Typescript letter from Hugh Edwards to Robert Frank, dated May 23, 1960. Published in *Doubletake* 1 (Summer 1996).

15 Woodward 1985 (see note 11), p. 170.

16 Typescript letter from Monroe Wheeler to John Szarkowski, dated July 11, 1961. MW, I.55.

17 Typescript letter from John Szarkowski to Monroe Wheeler, dated August 16, 1961. MW, I.55. Szarkowski was responding to Wheeler's letter to him dated July 31, 1961. MW, I.55.

18 Typescript memorandum from Elizabeth Shaw to René d'Harnoncourt, dated April 27, 1961. MW, I.61.

19 Typescript letter from Beaumont Newhall to Monroe Wheeler, dated December 7, 1961. MW, I.99.

20 "Walker Evans and George Platt Lynes," Feb. 1–19, 1932. See Julien Levy, *Memoirs of an Art Gallery* (New York: G.P. Putnam, 1977).

21 On these relationships, see Anotole Pohorilenko and James Crump, *When We Were Three: The Travel Albums of George Platt Lynes, Monroe Wheeler and Glenway Wescott* (Santa Fe: Arena Editions, 1998).

22 Nickel 1995 (see note 1), p. 137.

23 Ibid.

24 John Szarkowski, *Walker Evans* (New York: Museum of Modern Art, 1971), p. 13.

25 Perhaps a sign of artistic insecurity, later in life, Szarkowski neatly distanced himself from the sway of Evans's timeless masterpiece, noting that it was in fact *Fifty Photographs by Edward Weston* that "had a much more immediate effect" on his aesthetic and maturating positions on photography. See Haworth-Booth 2001 (see note 2), p. 53.

26 John Szarkowski, *The Face of Minnesota* (Minneapolis: University of Minnesota Press, 1958). In its presentation of photographs, many of the book's spreads shared more than a passing relationship with *American Photographs.*

27 As a mentor and advisor, Evans was active in the community of photographers seeking to advance their work with support from the Guggenheim Foundation. In addition to writing in support of Frank, Evans did the same for Diane Arbus and Lee Friedlander.

28 Hilton Kramer, "An Era Lives in Photos at Evans Show," *New York Times,* Jan. 28, 1971, p. 42.

29 Typescript brief, "The MoMA Department of Photography—62," dated Dec. 1961. MW, I.61. *The Photographer's Eye* was "a loan show of 202 photographs borrowed from public and private collections in the U.S. and abroad. The works epitomized the visual and pictorial concepts that are peculiar to the photographic medium, ranging from the way photographers make use of significant detail and the picture edge, to explorations of time and motion."

30 Leslie Katz, "Interview with Walker Evans," *Art in America* (March–April 1971), p. 84.

31 Durden 2006 (see note 11), p. 86.

32 "The Art of Seeing," *The New Yorker,* December 24, 1966. pp. 26–7.

33 Handwritten letter from Walker Evans to John Szarkowski, dated March 22, 1966. Curatorial Exhibition Files, Exh. #952, the Museum of Modern Art Archives, New York (hereafter CUR).

34 It's interesting to note that Szarkowski's 1966 Dorothea Lange retrospective was his largest single-artist exhibition to this time. In addition to those mentioned, by 1971, Szarkowski had curated one-person exhibitions of living artists Brassaï, Bill Brandt, William Gedney, Joel Meyerowitz, Ray Metzger, Jerry Uelsmann, Bruce Davidson, Marie Cosindas, Elliot Erwitt, and Ernst Haas.

35 Typescript letter from Walker Evans to John Szarkowski, dated July 2, 1967. CUR, Exh. #952.

36 *New Yorker* 1966 (see note 32), p. 27

37 Belinda Rathbone, *Walker Evans: A Biography* (New York: Houghton Mifflin Company, 2000), p. 282.

38 Ibid.

39 "Puritan Explorer," *Time* 50, no. 24 (Dec. 15, 1947), p. 73. In his 1971 interview with Katz, Evans stated, "Photography, I said before, really doesn't interest me, the technique of it either. I do know that I want to be able to do something with it, though." See Katz 1971 (see note 30), p. 87.

40 Christopher Phillips, "The Judgment Seat of Photography," *October* 22 (Autumn 1982), p. 57, note 63.

41 Ibid.

42 *Walker Evans: Fourteen Photographs* (New Haven, CT: Ives Stillman, 1971) was printed
 by Thomas Brown, and contains an introduction by Robert Penn Warren. An edition of
 100 copies was published to take advantage of the MoMA retrospective, February 15, 1971,
 it reportedly sold fewer than twelve copies in Evans's lifetime. See *Diane Arbus: Revelations*
 (San Francisco and New York: SFMoMA and Random House, 2003), p. 216, n. 500.
 The notorious dealer and ex-CIA operative, Harry H. Lunn, Jr., produced *Walker Evans I,*
 a portfolio of fifteen original photographs in an edition of seventy-five copies, with fifteen
 hors commerce (Washington, DC: Lunn Gallery/Graphics International, 1972). In 1974,
 Double Elephant Press produced *Walker Evans: Selected Photographs* (New York, 1974), a
 portfolio of fifteen original photographs, each signed by the photographer in an edition of
 seventy-five copies, with an introduction by Lionel Trilling.

43 Sidney Tillim, "Walker Evans: Photography as Representation," *Artforum,* March 1967,
 pp. 16–17.

44 Benjamin Lima has suggested that as many as 40,000 Evans prints exist. To the present
 author's knowledge, this figure is unsubstantiated. See Benjamin Lima, "The Evans File,"
 Art Journal 63, no. 3 (Autumn 2004), p. 102.

45 Handwritten postcard from Walker Evans to John Szarkowski, dated August 12, 1969.
 CUR, Exh. #952.

46 Typescript memorandum of agreement between the Museum of Modern Art and Walker
 Evans, dated October 30, 1968. CUR, Exh. #952.

47 Szarkowski 1971 (see note 24), p. 19.

48 Typescript wall label text, CUR, Exh. #821.

49 Handwritten letter from Jim Dow to John Szarkowski, dated January 7, 1971. CUR,
 Exh. #952.

50 Rathbone 2000 (see note 37), p. 283. "As Szarkowski brooded over his picture selection,
 he realized that the bulk of Evans's work since 1938 was much less impressive."

51 Szarkowski 1971 (see note 24), p. 18. Szarkowski's bias against Evans's later work has long
 helped shape the master narrative, so much so that even the most recent scholarship mimes
 its rhetoric. See Chema González, "Walker Evans and the Invention of Documentary
 Style," *Walker Evans* (Madrid: Fundación Mapfre, 2009), p. 62.

52 Ibid., p. 14.

53 Katz 1971 (see note 30), p. 88.

54 Susan Sontag, *On Photography* (New York: Farrar, Straus and Giroux, 1977), pp. 15–16.

55 Kramer 1971 (see note 28).

56 Katz 1971 (see note 30), p. 87.

57 See Peter Cosgrove, "Snapshots of the Absolute: Mediamachia in *Let Us Now Praise Famous
 Men,*" *American Literature* 67, no. 2 (June 1995), pp. 329–57.

58 Szarkowski 1971 (see note 24), p. 20.

59 John Tagg, *The Burden of Representation: Essays on Photographies and Histories* (Minneapolis:
 University of Minnesota Press, 1993), p. 182.

60 Handwritten letter from Hugh Edwards to John Szarkowski, dated Jan. 13, 1971. CUR,
 Exh. #952.

61 In his obituary for Evans, Hilton Kramer wrote that Evans sometimes "allowed his work
 to pass into the world and be praised as something he knew it was not," noting that the
 Depression-era work that had received so much fanfare cultivated "a fame somewhat out of

proportion to the place [these pictures] occupy in his work." See Kramer, "Walker Evans: A Devious Giant," *New York Times,* April 20, 1975, p. xi. Leslie K. Baier was among the first to recognize the growing misperception "that Walker Evans produced little of note after a decade of intense creativity." Baier's study of Evans's work for *Fortune* shows Evans attempting to "rewrite the past" in re-emphasizing his 1930s work out of fear of being remembered as a photojournalist. See Baier 1978 (see note 3), pp. 6–7. Nickel subsequently wrote, "Evans willingly participated in the reinvention process, even as he learned to view himself in the terms his devotees advanced." See Nickel's "*American Photographs* Revisited," *American Art* 6, no. 2 (1992), p. 95.

62 Baier 1978 (see note 3), p. 20.

63 Evans's color work for *Fortune* was not exhibited until 1978, when the Wellesley College Museum mounted the exhibition *Walker Evans at Fortune 1945–1965.* Although "many of the negatives and transparencies from important portfolios . . . especially the Fifties 2 ¼ color work, are so badly faded that prints are impossible," in 1978, the Estate of Walker Evans lent the exhibition *Fortune* color photographs made from the original transparencies in the dye-transfer process. See Baier 1978 (see note 3), p. 57.

64 Arnold Crane, interviewed by the author, Aug. 25, 2009.

65 According to Crane, he had lent a great number of photographs to *Photo-Eye of the 20s,* June 4–Sept. 8, 1970, an exhibition in MoMA's East Wing Galleries, First Floor. With Crane's help, the exhibition was organized by Beaumont Newhall, director of the George Eastman House, which collaborated with MoMA on the show. Consisting of 158 photographs, this exhibition "surveyed a critical period when the functions of all artistic media were being redefined by artists and critics alike."

66 *Diane Arbus* 2003 (see note 42), p. 216, note 495.

67 Ibid.

68 Typescript transcription of speeches, dated January 26, 1971. CUR, #952.

69 William Carlos Williams, "Sermon with a Camera" *New Republic,* Oct. 12, 1938, pp. 282–83.

70 The exhibition subsequently traveled, making stops at the University of Michigan and the Art Institute of Chicago, among other venues. CUR, Exh. #952.

71 Hilton Kramer, "Second Evans Retrospective—Smaller but Powerful," *New York Times,* Dec. 10, 1971, p. 50.

72 Beginning in 1965, Evans was professor of photography in the department of graphic design at the Yale University School of Art and Architecture.

73 Kramer 1971 (see note 71), p. 50.

74 In addition to Helsinki and Brussels, the exhibition traveled to Rotterdam, Paris, Vienna, Stockholm, Oslo, Düsseldorf, Bielefeld, and London.

75 On MoMA's role in promoting American avant-garde art abroad see Serge Guilbaut, *How New York Stole the Idea of Modern Art,* trans. Arthur Goldhammer (Chicago: University of Chicago Press, 1985).

76 Typescript memorandum to John Szarkowski, dated October 4, 1976. CUR, Exh. #952.

77 Katz 1971 (see note 30), p. 87. "People live by mythic images, by icons. Certain of [Evans] photographs have become classics, have found their way into what could be called national consciousness. They've found a permanent audience, not immediately as fashion does, but as art does, by a residual process."

78 Durden 2006 (see note 11), p. 86.

EARLY WORK: NEW YORK

1 [BUILDING FAÇADE DETAIL, NEW YORK CITY], 1928–30

2 [DETAIL OF SHIP MAST AND RIGGING, NEW YORK CITY], 1928–30

3 [SHIP RIGGING AND TACKLE DETAIL, MARKET DOCKS, NEW YORK], 1928

4 [DETAIL OF SHIP MAST AND RIGGING, NEW YORK CITY], 1928–30

5 [VIEW FROM ACROSS STREET OF EVANS'S APARTMENT HOUSE,
48 COLUMBIA HEIGHTS, BROOKLYN, NEW YORK], October 1928

6 [HANNS SKOLLE ON ROOFTOP OF APARTMENT BUILDING
AT 13 EAST 14TH STREET, NEW YORK CITY], 1928–30

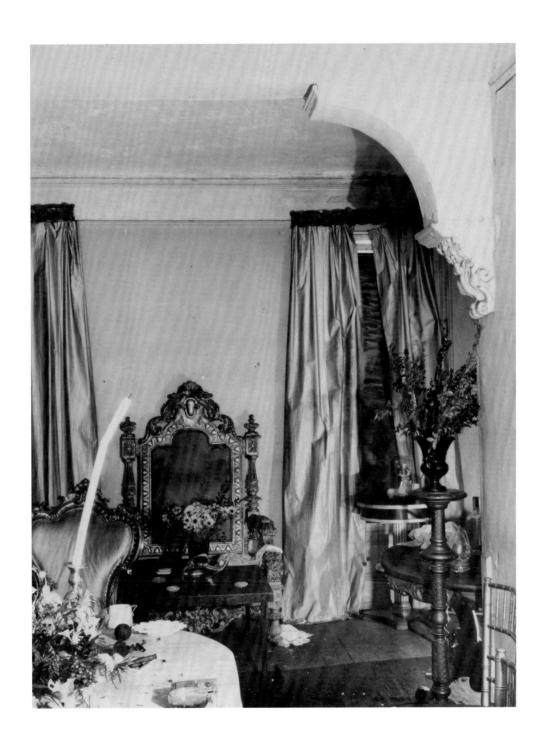

7 [TABLE SETTING AND THRONE CHAIR IN MURIEL DRAPER'S
APARTMENT, NEW YORK CITY], May 29, 1934

8 [HANNS SKOLLE], 1928–30

9 [HANNS SKOLLE], 1928–30

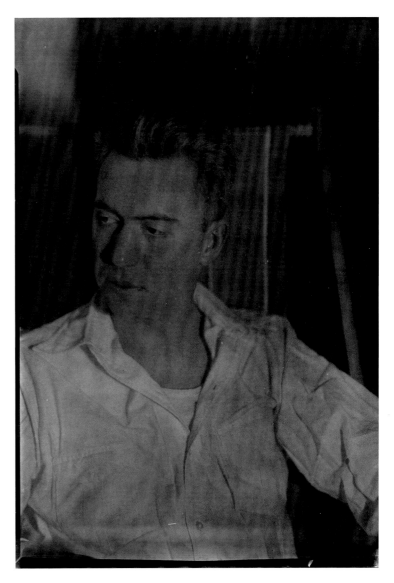

10 [HART CRANE], 1929–30

11 [HART CRANE], 1929–30

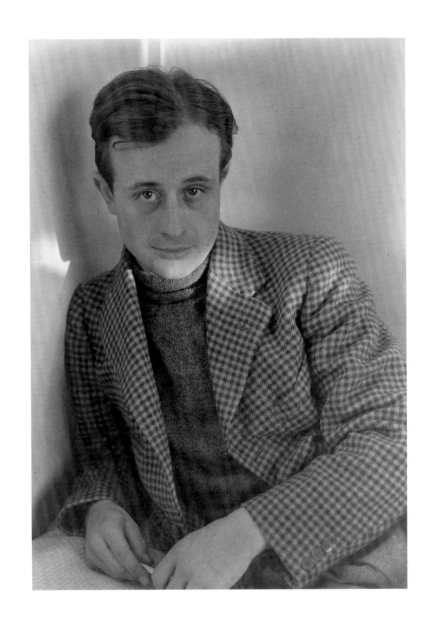

12 [HANNS SKOLLE], 1930–34

13 [UNIDENTIFIED WOMAN LEANING ON FIREPLACE MANTLE], 1930s

14 [SHIP'S PROW AND RIGGING, NEW BEDFORD,
MASSACHUSETTS], April 1931

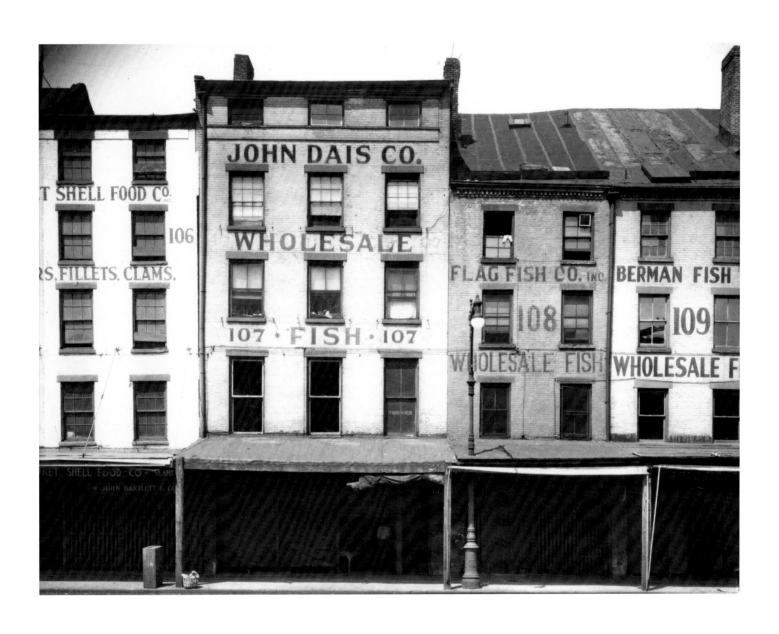

15 [WATERFRONT BRICK BUILDINGS IN FULTON MARKET,
NEW YORK CITY], 1933–34

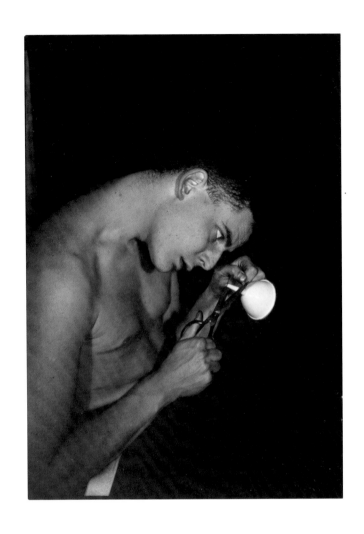

16 [LINCOLN KIRSTEIN CUTTING RUBBER FUNNEL WITH SCISSORS], 1930–31

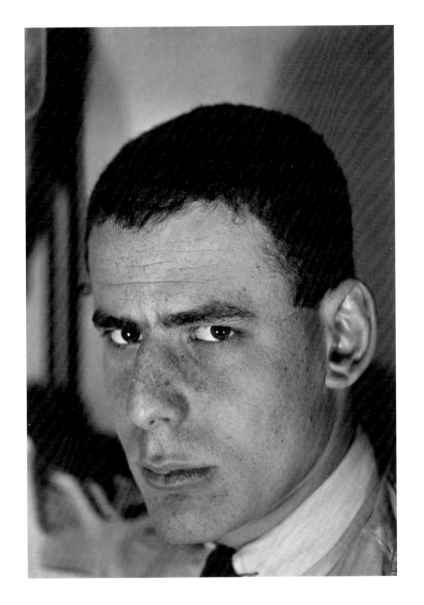
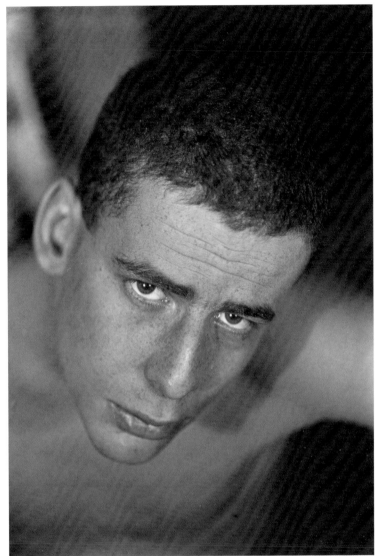

17 [LINCOLN KIRSTEIN], 1931

18 [LINCOLN KIRSTEIN], 1931

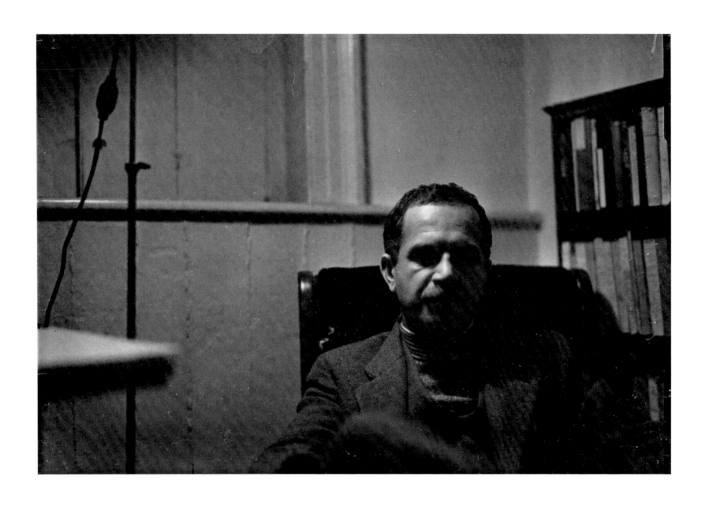

19 [BEN SHAHN AT 23 BETHUNE STREET APARTMENT,
NEW YORK CITY], 1932–33

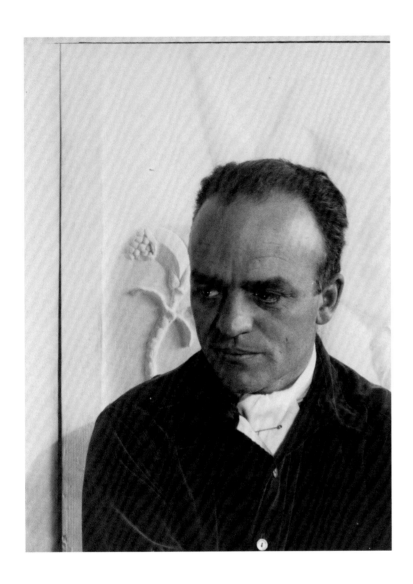

20 [CHARLES FULLER, BEDFORD, NEW YORK], 1931

21 [JANE AND JILL FULLER ON STAIRWELL, BEDFORD, NEW YORK], 1931

VICTORIAN ARCHITECTURE

22 [JIGSAW ORNAMENT DETAIL OF FOLK VICTORIAN HOUSE
AT OSSINING CAMP WOODS, NEW YORK], 1930–31

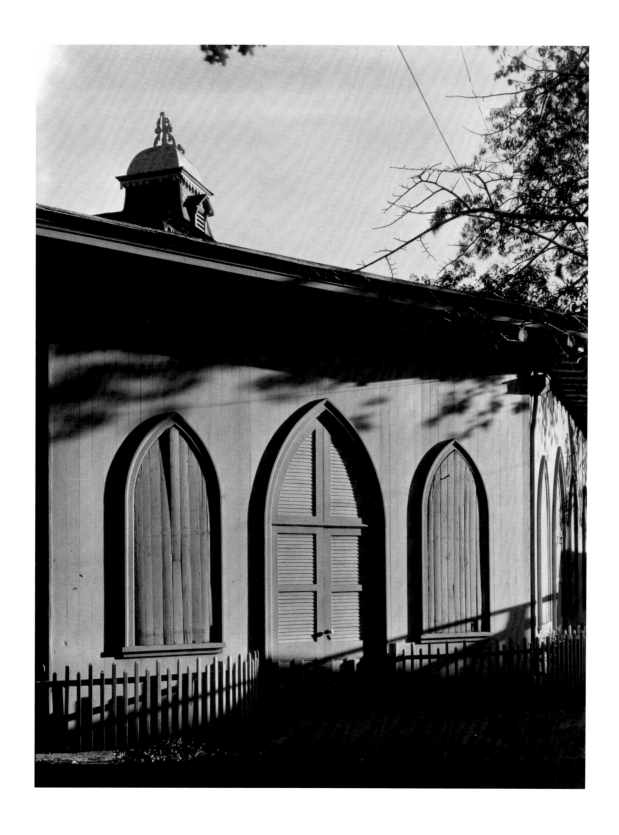

23 [COUNTRY CHURCH FAÇADE, OSSINING, NEW YORK], 1931

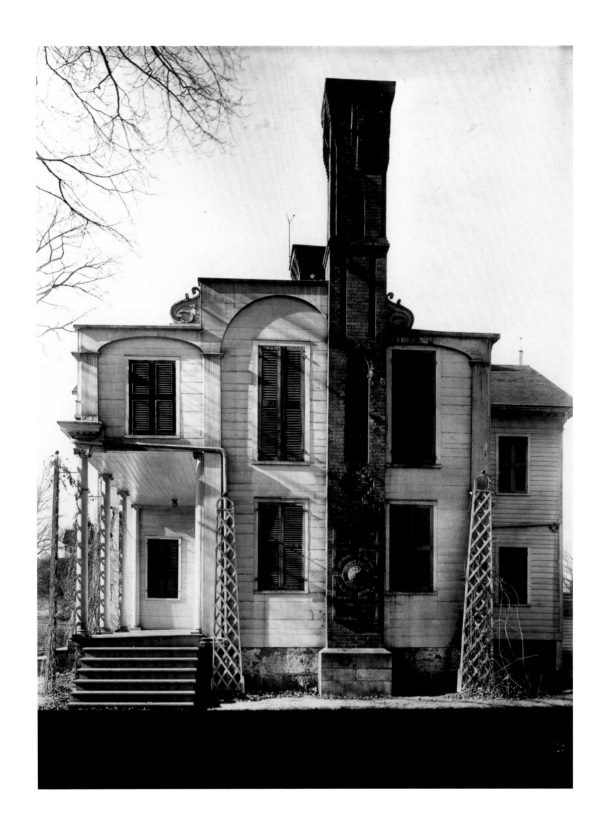

24 [LEFT WING FAÇADE OF QUEEN ANNE (?) HOUSE WITH
PATTERNED MASONRY CHIMNEY, NEW YORK], 1931

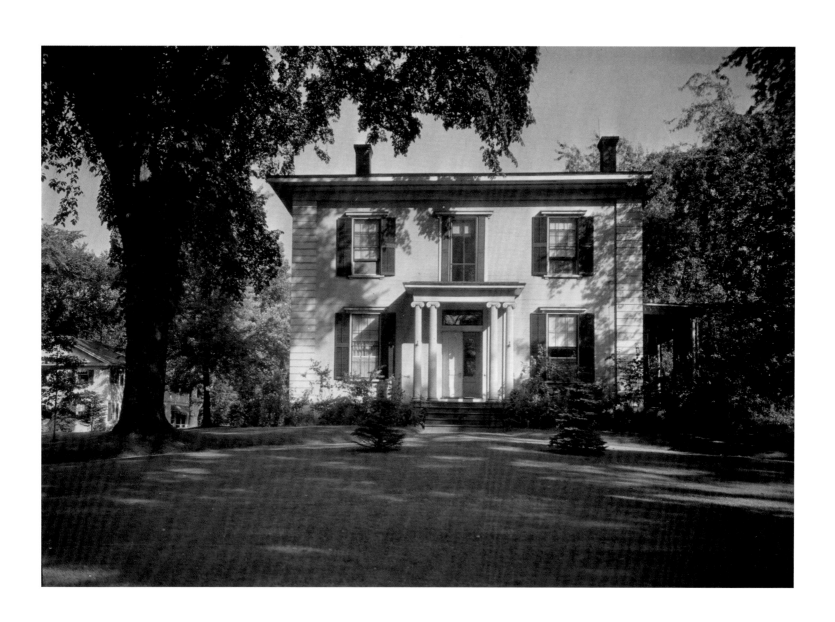

25 [GREEK REVIVAL HOUSE WITH PAIRED IONIC COLUMNS IN
ENTRY PORCH, NORTHAMPTON, MASSACHUSETTS], 1930–31

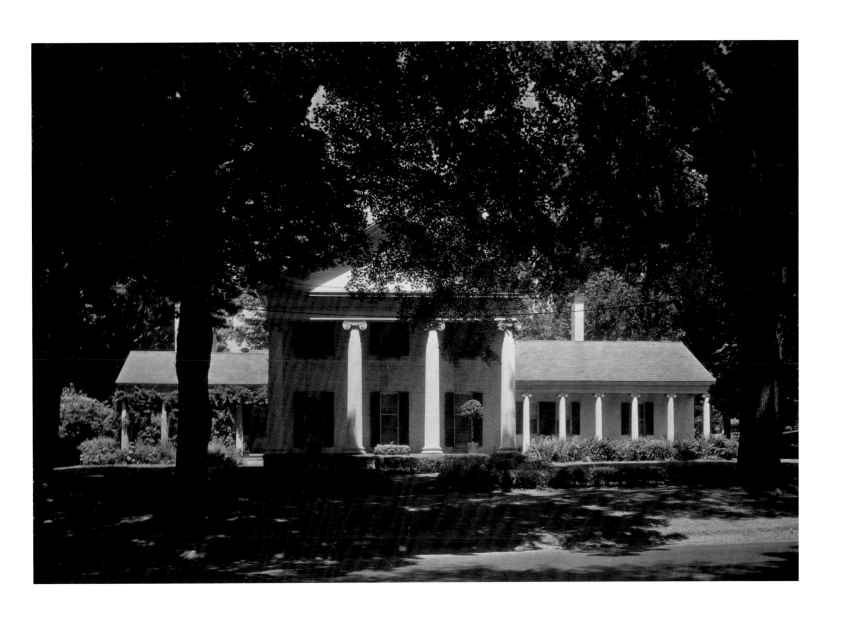

26 [GREEK REVIVAL HOUSE, GREENFIELD, MASSACHUSETTS], 1930–31

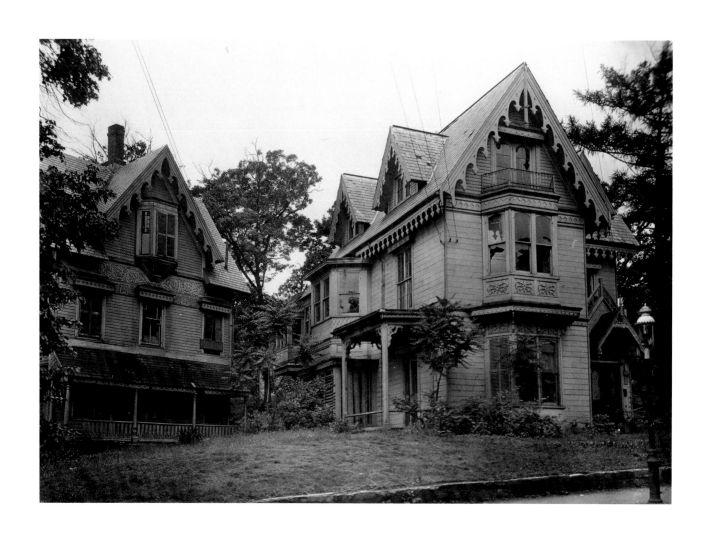

27 [TWO GOTHIC REVIVAL HOUSES WITH DECORATIVE VERGE
BOARDS IN GABLES, DORCHESTER, MASSACHUSETTS], 1930–31

28 [GREEK REVIVAL HOUSE WITH HALF-LUNETTE WINDOW
IN FULL-FAÇADE GABLE, CHERRY VALLEY, NEW YORK], November 1931

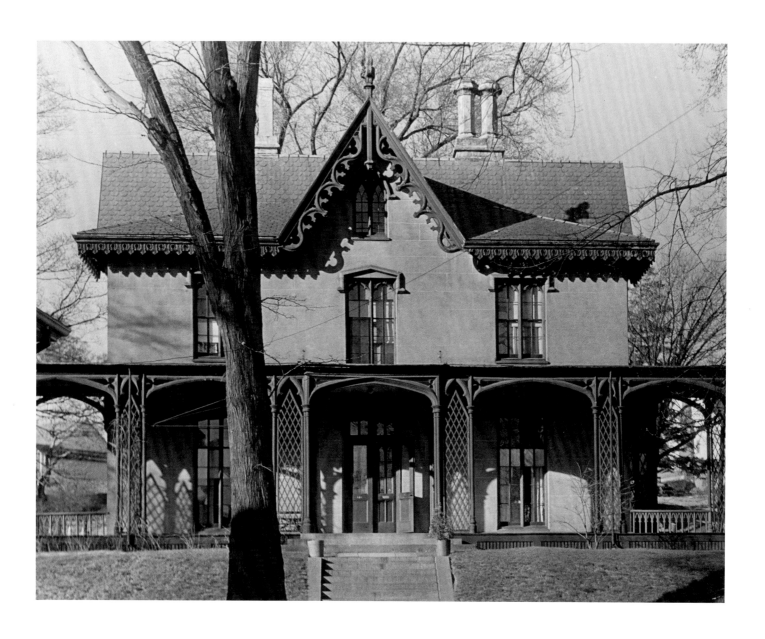

29 [GOTHIC REVIVAL HOUSE, SOMERVILLE, MASSACHUSETTS], 1930–31

30 [GOTHIC REVIVAL HOUSE WITH IRON GATE, POUGHKEEPSIE, NEW YORK], 1930–31

THE SOUTH SEAS: TAHITI

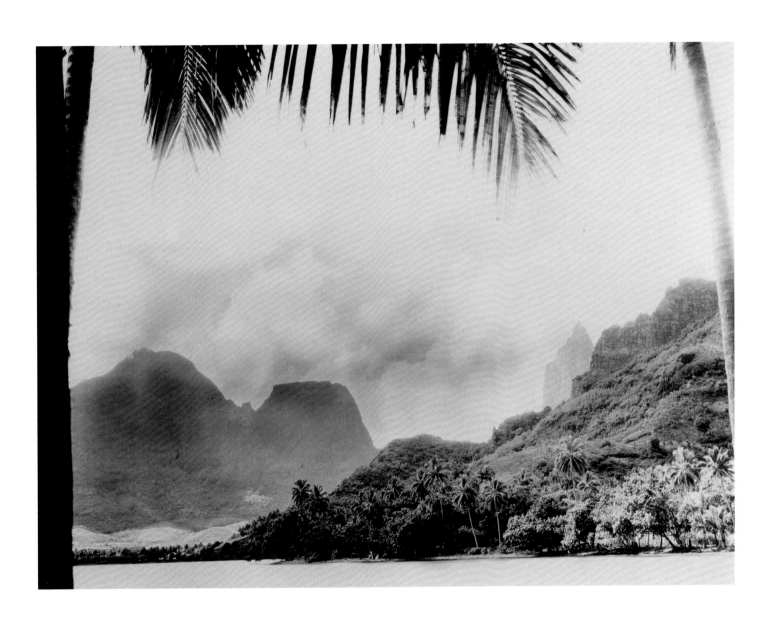

31 [SOUTH SEAS: MOUNTAINS AND SHORELINES], 1932

32 [CREW MEMBERS AT HELM OF CRESSIDA, SOUTH SEAS], 1932

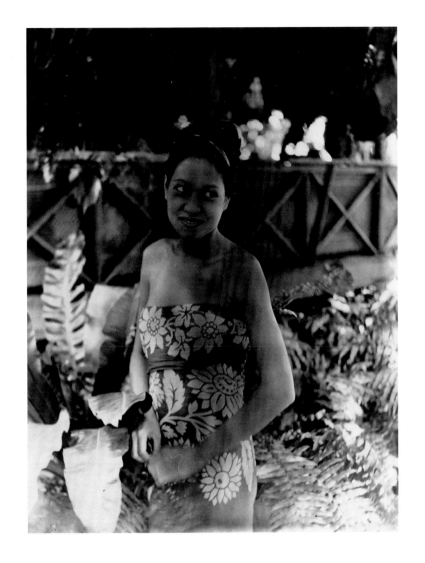

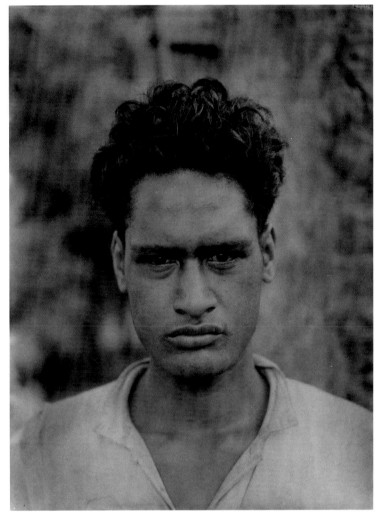

33 [WOMAN WEARING SARONG, SOUTH SEAS], 1932

34 [MALE PORTRAIT, SOUTH SEAS], 1932

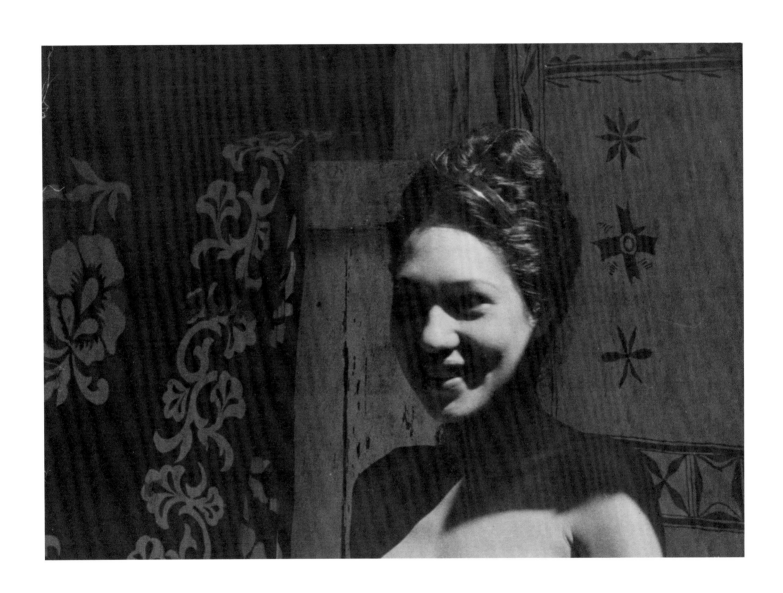

35 [FEMALE PORTRAIT, SOUTH SEAS], 1932

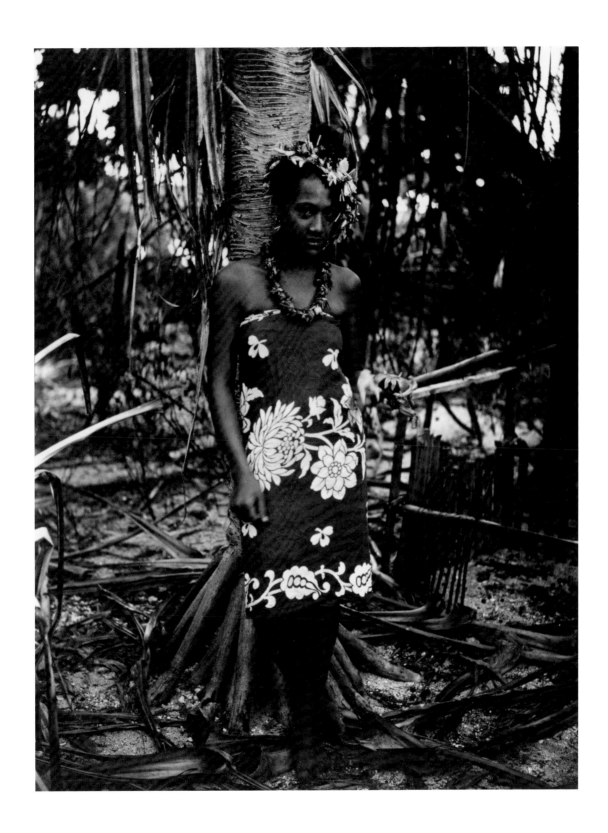

36 [FEMALE PORTRAIT, SOUTH SEAS], 1932

37 [PASSENGERS ON DECK OF CRESSIDA], 1932

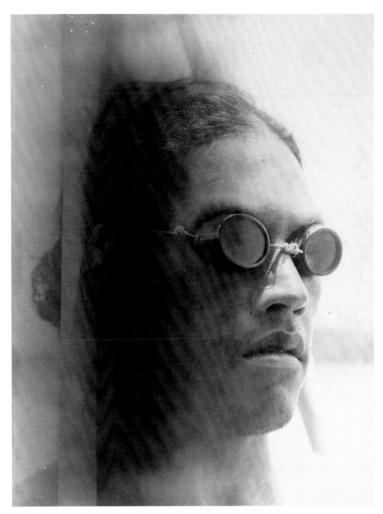

38 [SAILOR ON DECK OF CRESSIDA, SOUTH SEAS], 1932

39 [SOUTH SEAS, MAN WEARING GOGGLES], 1932

CUBA

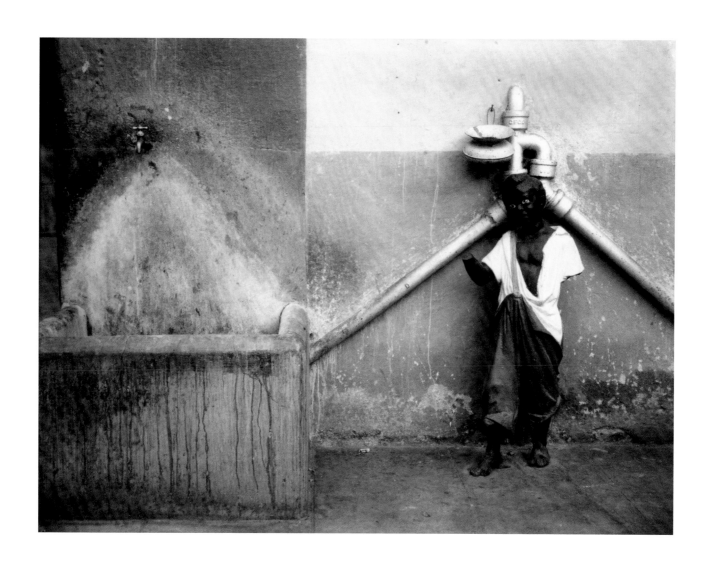

40 [STATUE AND OUTDOOR FAUCET IN COURTYARD, HAVANA], 1933

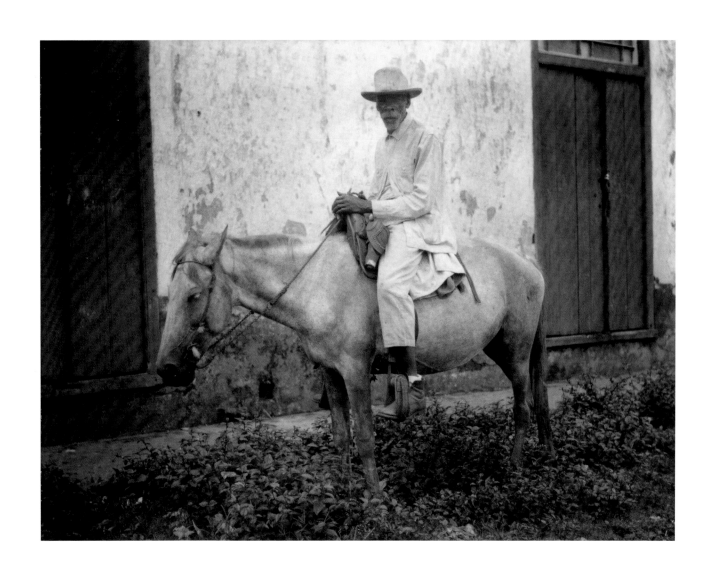

41 [MAN ON DONKEY, CUBA], 1933

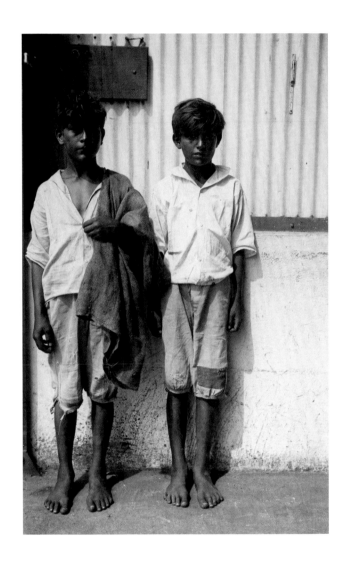
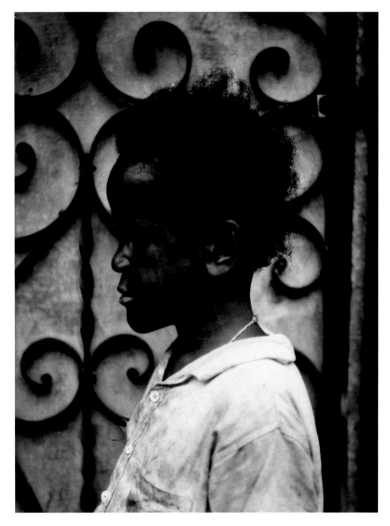

42 [TWO BAREFOOTED BOYS, HAVANA], 1933

43 [CHILD IN PROFILE BEFORE IRON GATE, HAVANA], 1933

44 [CHURCH INTERIOR WITH MADONNA AND CHILD STATUARY
IN NICHE, CUBA], 1933

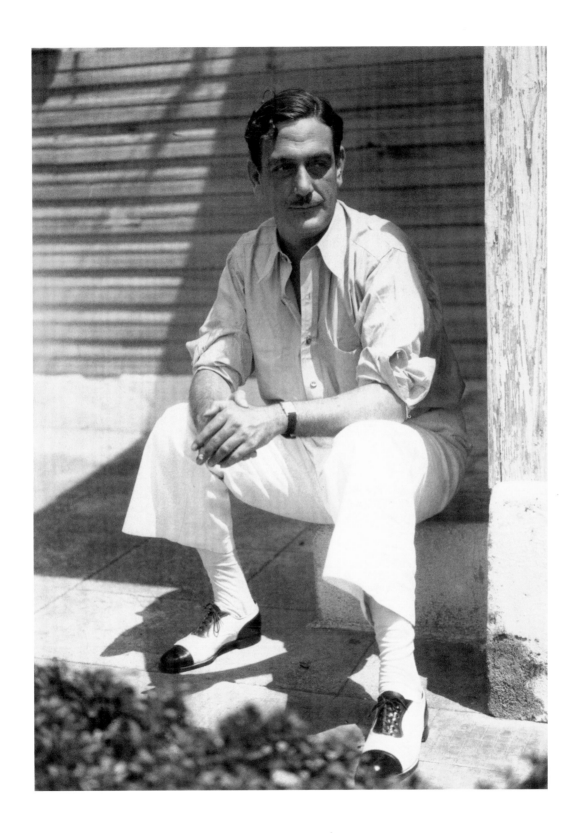

45 [JOSE ANTONIO FERNANDEZ DE CASTRO, HAVANA], 1933

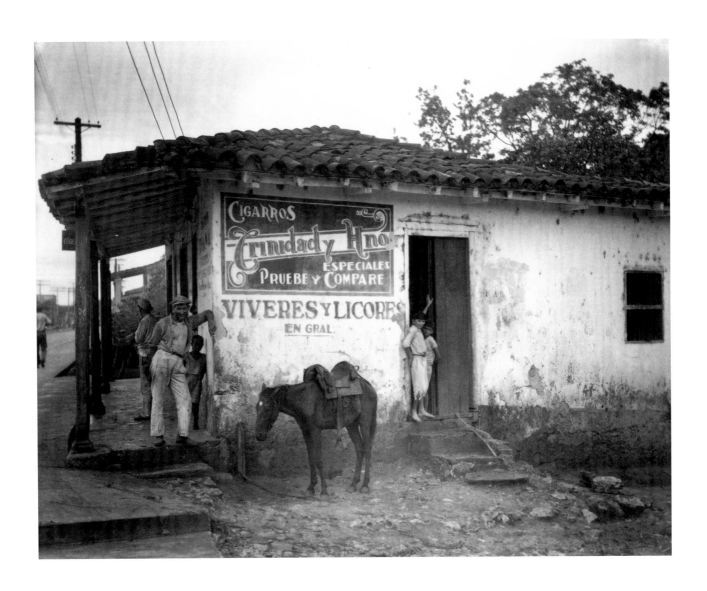

46 [GENERAL STORE WITH PEOPLE IN DOORWAY AND
PONY TIED TO POST, HAVANA OUTSKIRTS], 1933

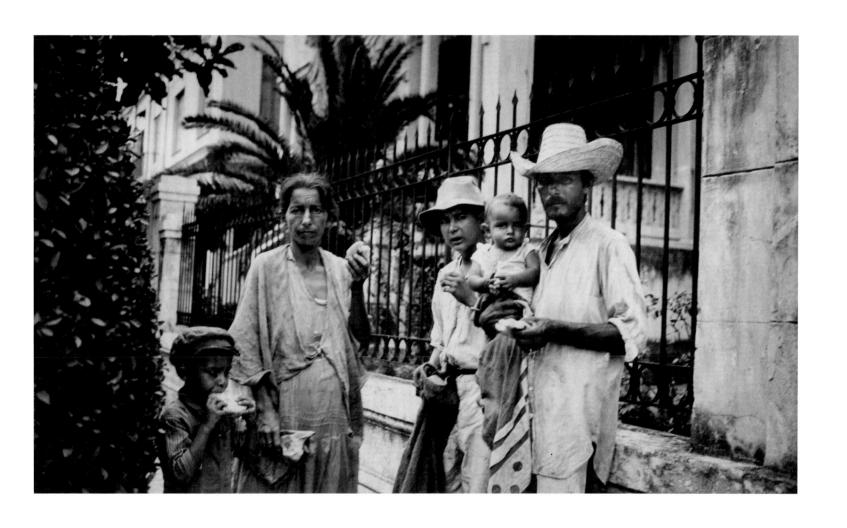

47 [COUNTRY FAMILY ON STREET IN VEDADO DISTRICT, HAVANA], 1933

48 [STAND OF EIGHT MACHETES, HAVANA], 1933

AFRICAN NEGRO ART

49 [FOUR MUSICAL INSTRUMENTS, FRENCH CONGO, LOANGO (?)], 1935

50 [MASK REPRESENTING AN ANIMAL, FRENCH SUDAN, DOGON], 1935

51 [TWO BOBBINS: IVORY COAST], 1935

92

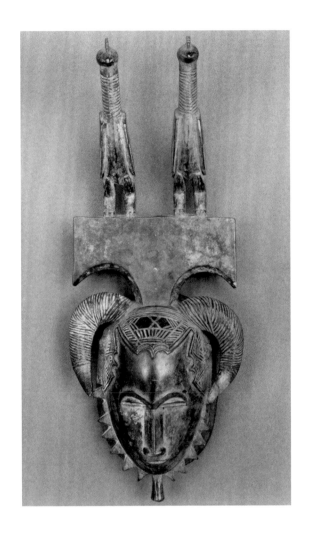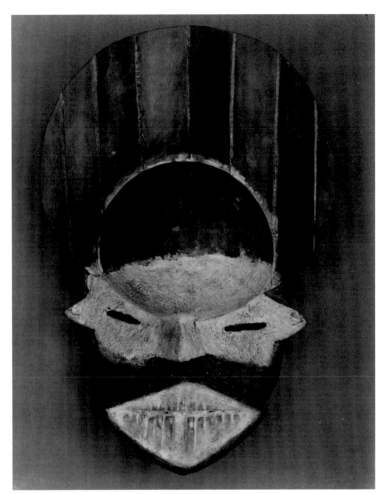

54 [MASK], 1935

55 [UNTITLED], 1935

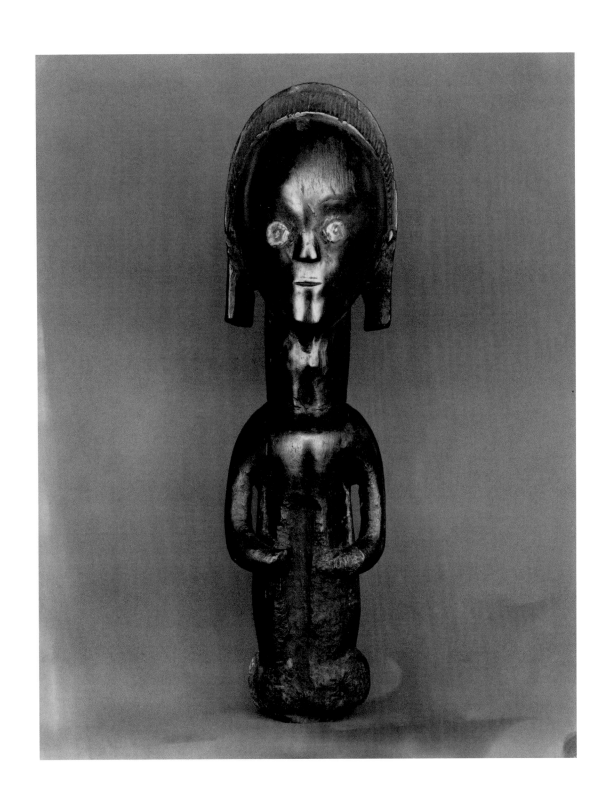

56 [UNTITLED], 1935

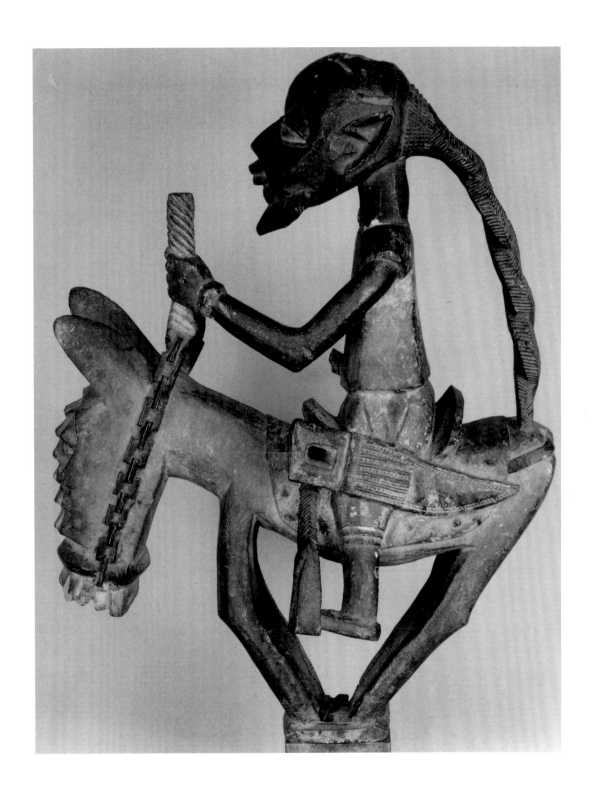

57 [EQUESTRIAN FIGURE, DAHOMEY, YORUBA], 1935

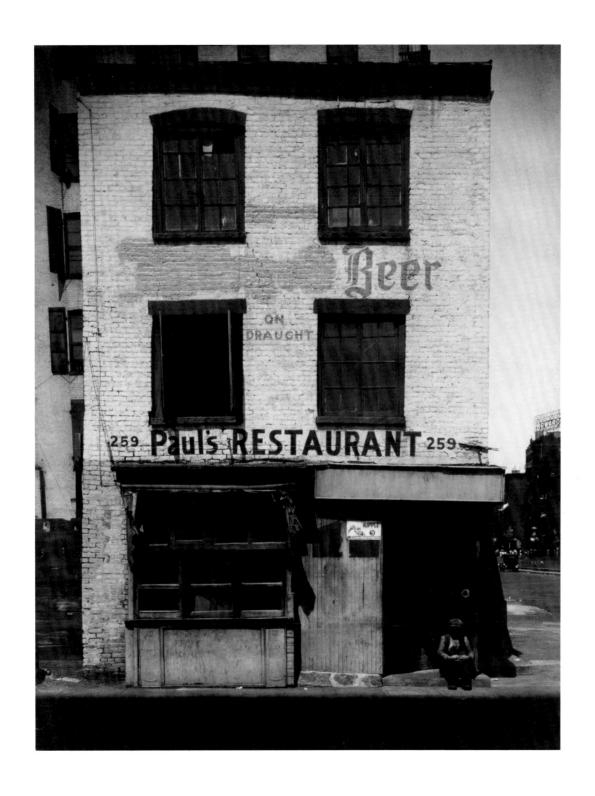

58 [BRICK BUILDING ON WATERFRONT, PAUL'S RESTAURANT, NEW YORK CITY], 1934

59 [GILDED PEDIMENT EAGLE, CHARLESTON,
SOUTH CAROLINA], March 1936

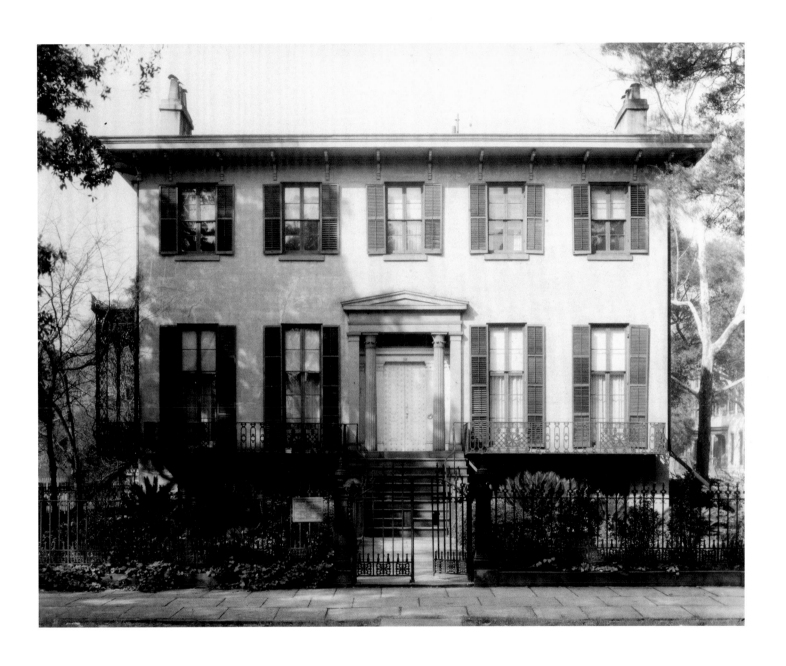

60 [GREEK REVIVAL HOUSE, 329 ABERCORN STREET, LAFAYETTE
WARD, SAVANNAH, GEORGIA], February–March 1935

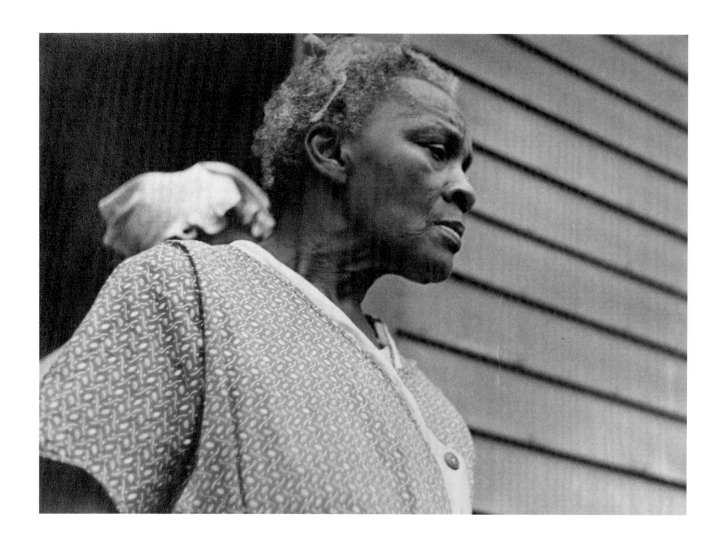

61 [TWO WOMEN, FRENCH QUARTER, NEW ORLEANS,
LOUISIANA (?)], February–March 1935

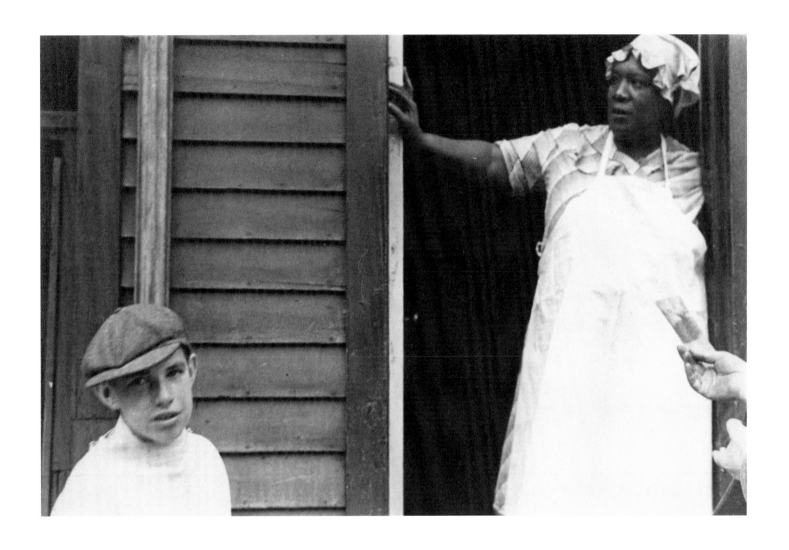

62 [BOY AND WOMAN, FRENCH QUARTER, NEW ORLEANS,
LOUISIANA (?)], February–March 1935

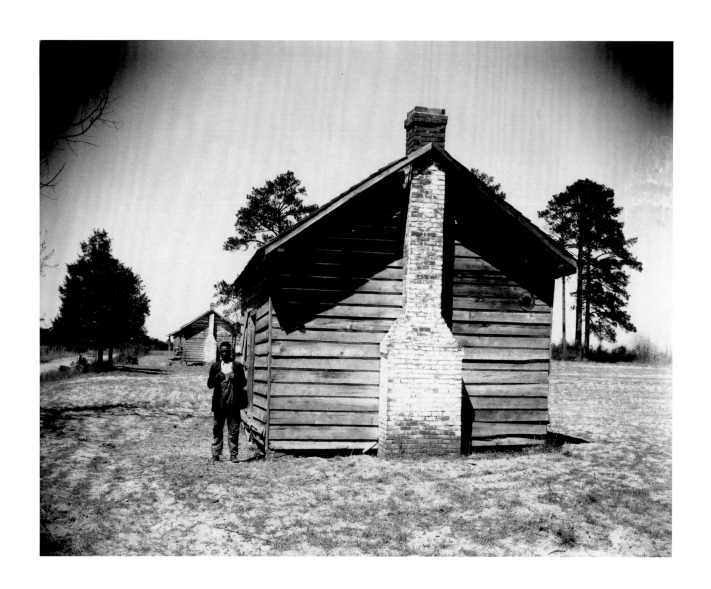

63 [MAN POSING FOR PICTURE IN FRONT OF WOODEN HOUSE], 1936

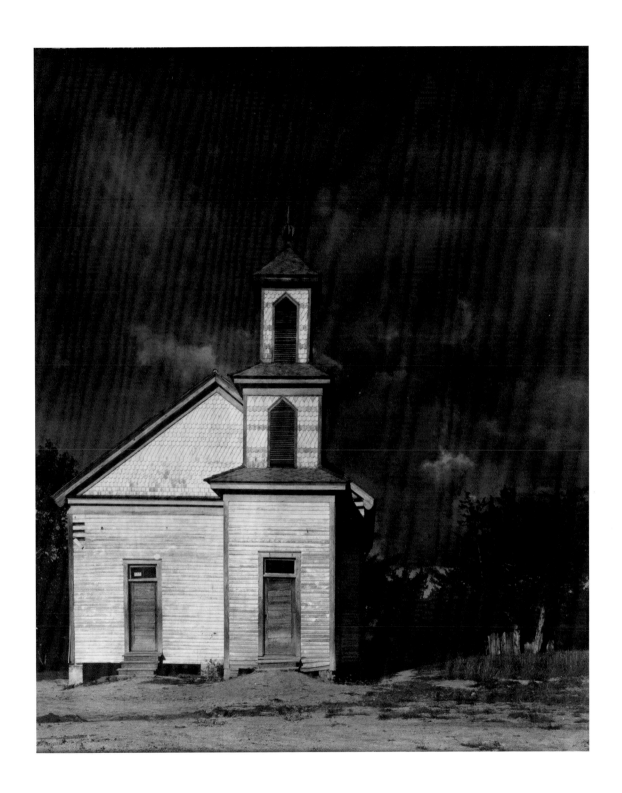

64 [WOODEN CHURCH (OR SCHOOLHOUSE?)], 1936

65 [WOOD SHINGLE DETAIL, TRURO,
MASSACHUSETTS], 1930–31

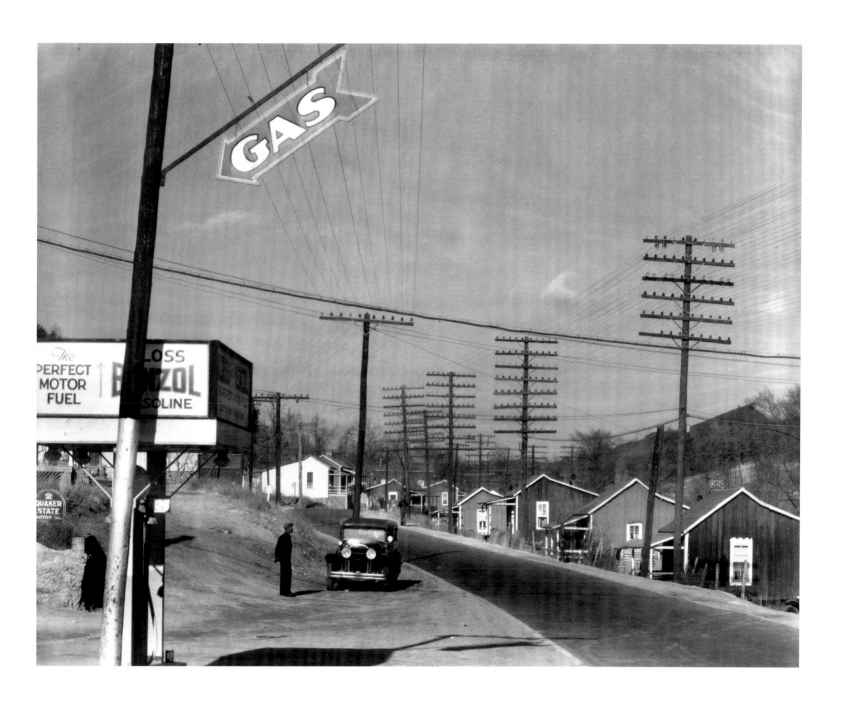

66 ROADSIDE GAS STATION WITH MINERS' HOUSES ACROSS
STREET, LEWISBURG, ALABAMA, December 17, 1935

67 [MINIATURE TOY ANIMALS NEAR ROADSIDE,
WEST VIRGINIA(?)], 1930s

68 [MINIATURE TOY ANIMALS NEAR ROADSIDE,
WEST VIRGINIA(?)], 1930s

69 [YOUNG BOY, WESTMORELAND COUNTY, PENNSYLVANIA], July 1935

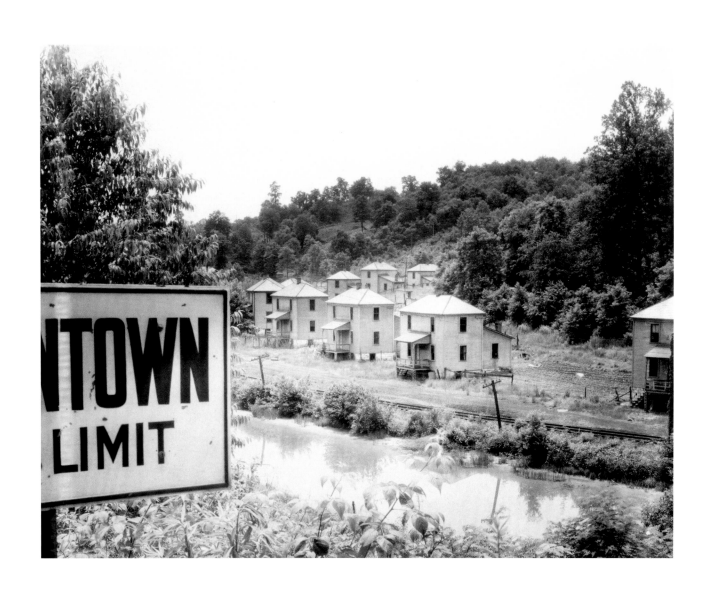

70 "COMPANY" HOUSES FOR MINERS BY TRAIN TRACKS AND CREEK
(WITH TOWN SIGN IN FOREGROUND), MASONTOWN, WEST VIRGINIA, June 1935

71 [STOREFRONT FAÇADE OF STAR PRESSING CLUB LAUNDRY,
VICKSBURG, MISSISSIPPI], February–March 1936

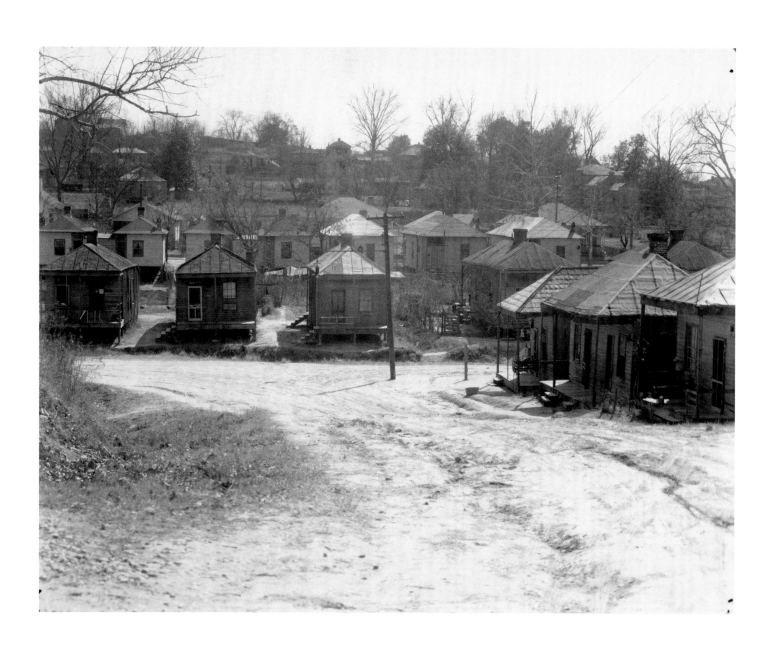

72 [HOUSES IN NEGRO QUARTER, VICKSBURG, MISSISSIPPI], March 1936

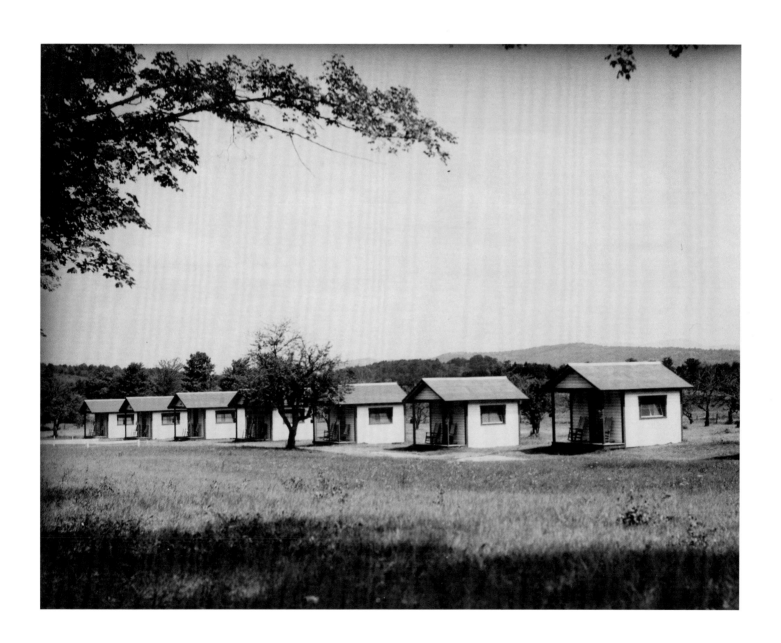

73 [WOODEN HOUSES, RURAL SOUTH], 1930s

74 INDEPENDENCE DAY, TERRA ALTA, WEST VIRGINIA, July 4, 1935

75 INDEPENDENCE DAY, TERRA ALTA, WEST VIRGINIA, July 4, 1935

76 VIEW OF BETHLEHEM, PENNSYLVANIA, November 1935

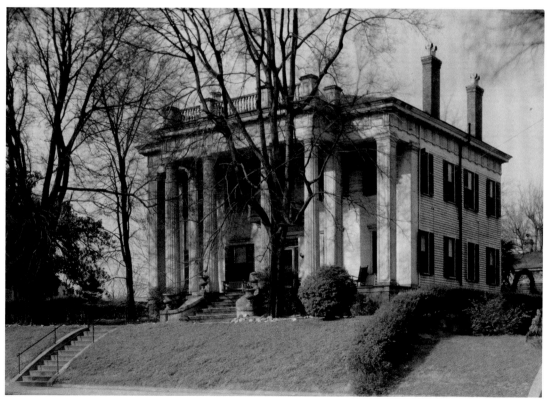

77 [CROWD IN PUBLIC SQUARE], 1930s

78 [GREEK REVIVAL HOUSE, FROM ACROSS STREET,
MACON, GEORGIA(?)], February 1935

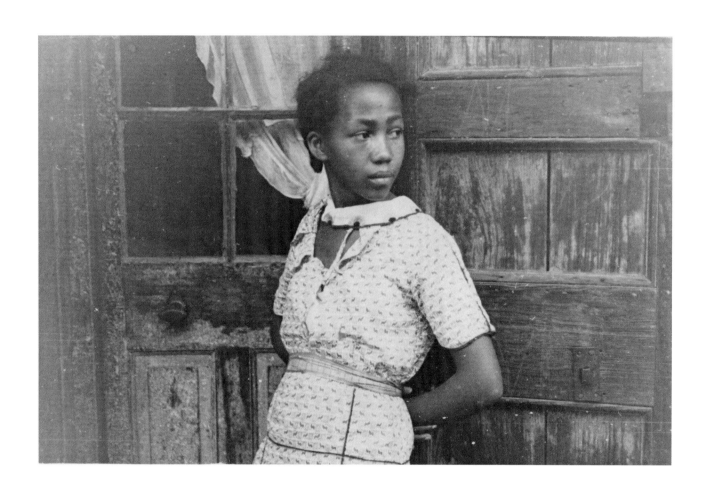

79 [GIRL IN FRENCH QUARTER, NEW ORLEANS, LOUISIANA],
February–March 1935

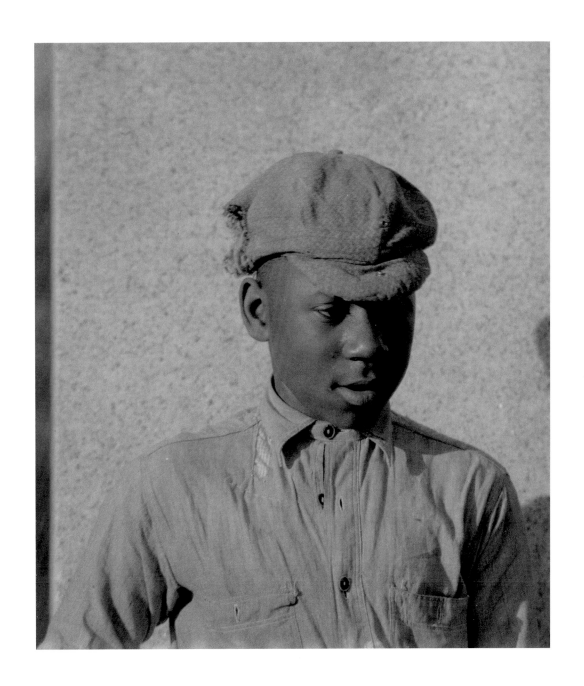

80 [BOY, RURAL SOUTH], 1930s

81 HOUSES AND GRAVEYARD, ROWLESBURG,
WEST VIRGINIA, June 1935

82 VACUUM CLEANER FACTORY, ARTHURDALE SUBSISTENCE HOMESTEAD
PROJECT, FSA, REEDSVILLE, WEST VIRGINIA, July 1935

83 BARNS ON FRANK TENGLE'S FARM, 1936

84 [TWO CHILDREN, RURAL SOUTH], 1930s

85 [WOMAN WITH FOUR CHILDREN ON HOUSE PORCH,
RURAL SOUTH], 1930s

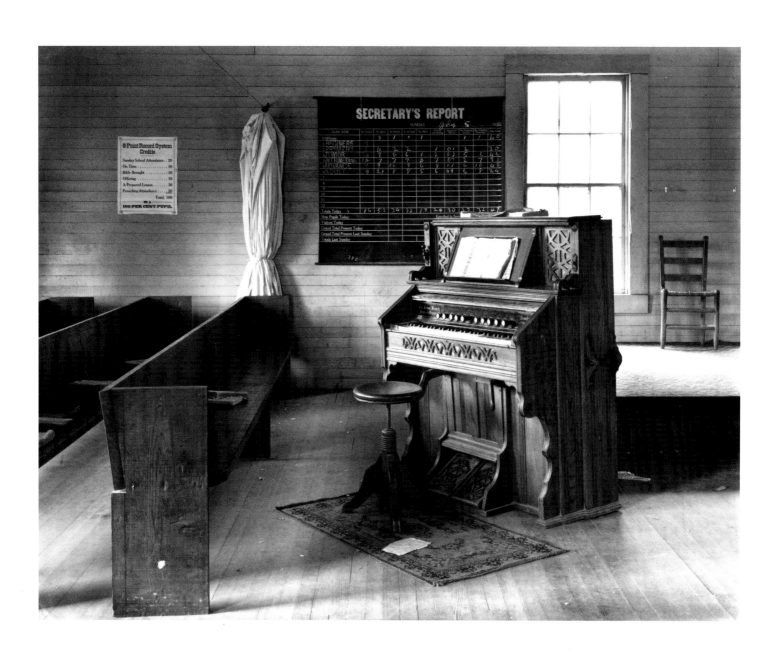

86 [CHURCH INTERIOR WITH PUMP ORGAN, ALABAMA], 1936

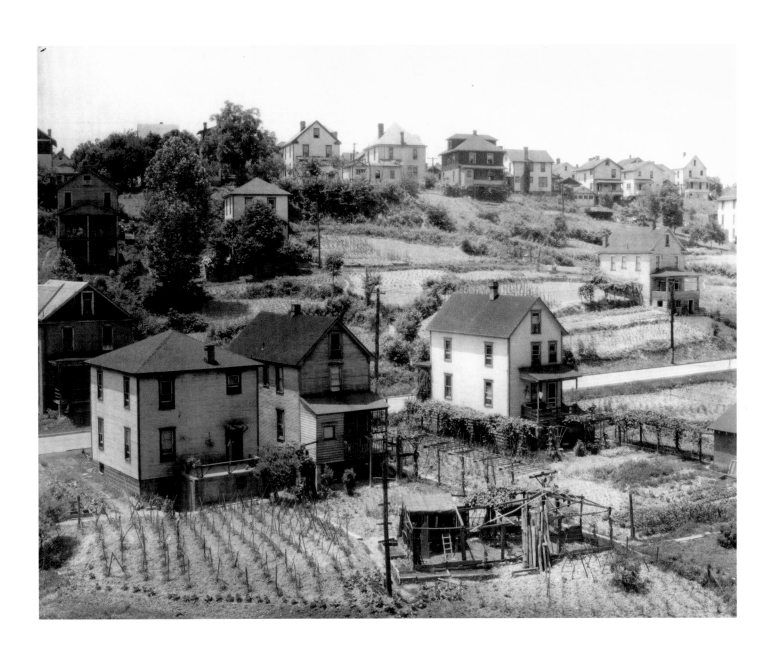

87 RESIDENTIAL AREA, MORGANTOWN, WEST VIRGINIA, June 1935

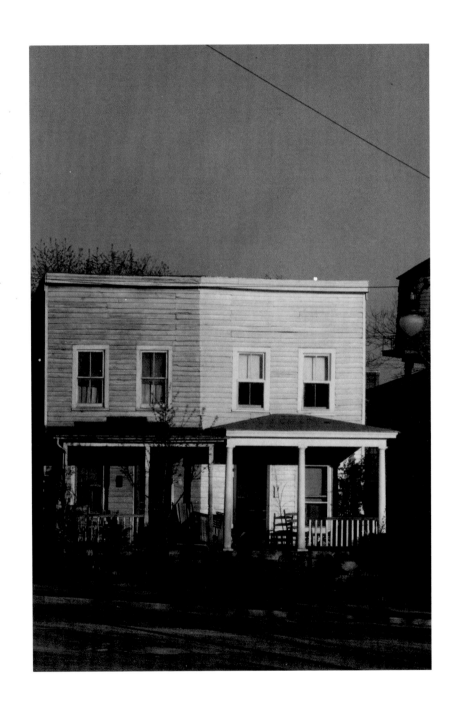

88 [ROW OF FRAME HOUSES, VIRGINIA], 1936

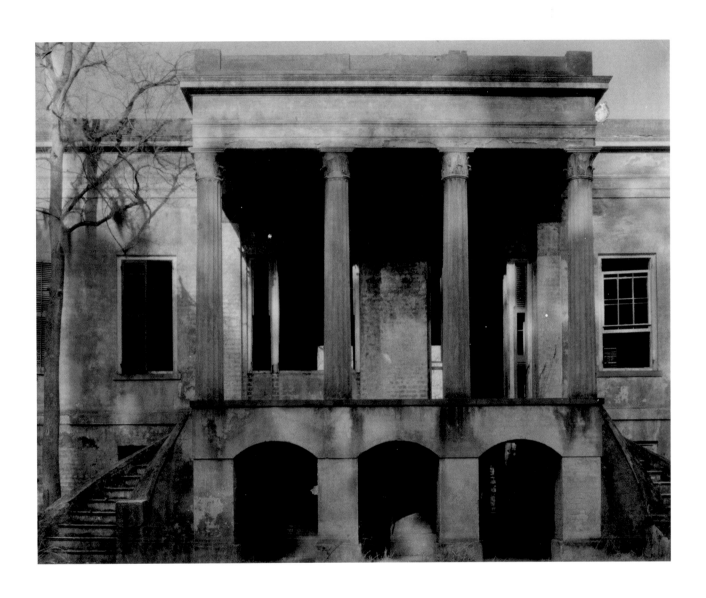

89 [FAÇADE DETAIL OF HERMITAGE PLANTATION HOUSE,
NEAR SAVANNAH, GEORGIA], February 5, 1935

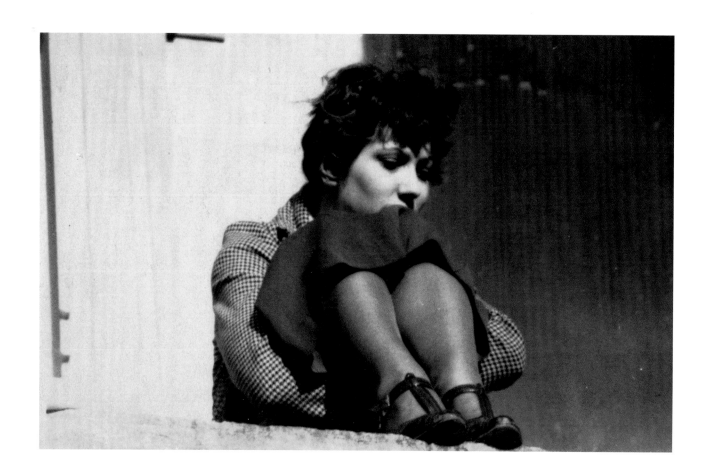

90 [JANE NINAS ON THE BALCONY OF BELLE GROVE PLANTATION,
WHITE CASTLE, LOUISIANA], February–March 1935

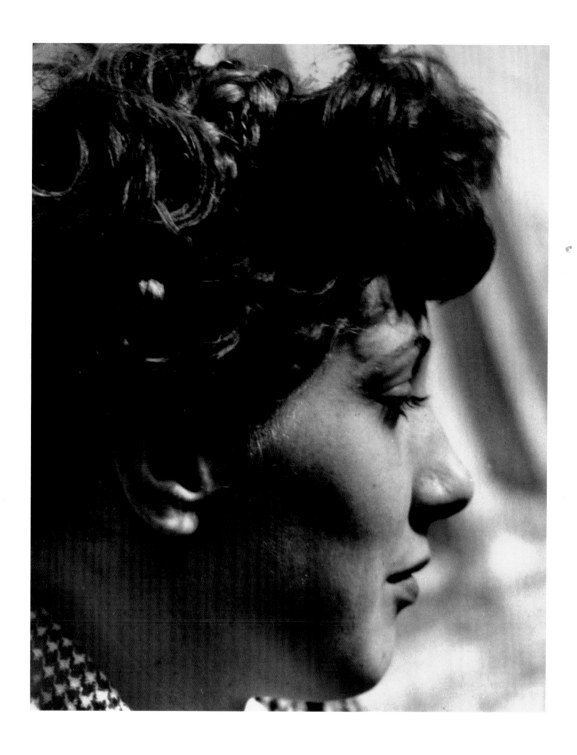

91 [JANE NINAS ON THE BALCONY OF BELLE GROVE PLANTATION,
WHITE CASTLE, LOUISIANA], February–March 1935

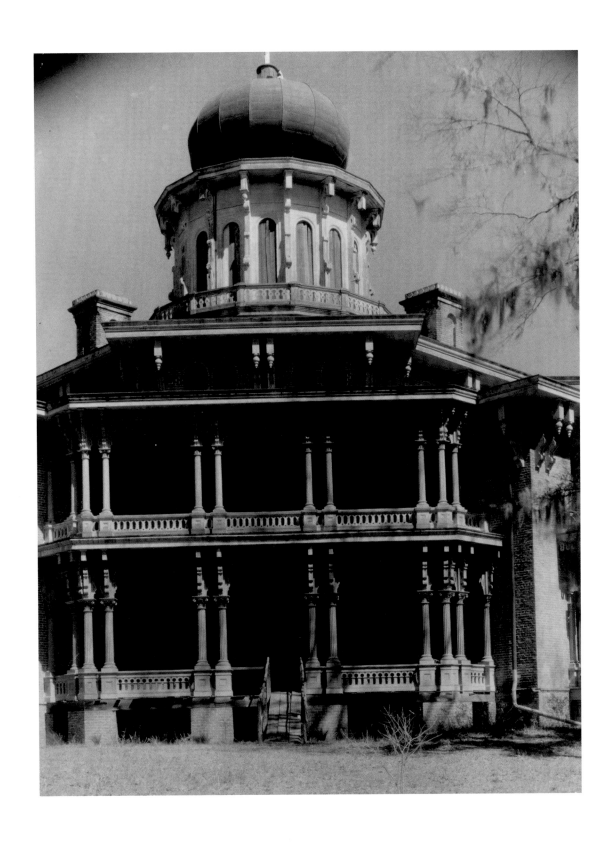

92 [CENTRAL FAÇADE OF LONGWOOD PLANTATION HOUSE,
NEAR NATCHEZ, MISSISSIPPI], March 1935

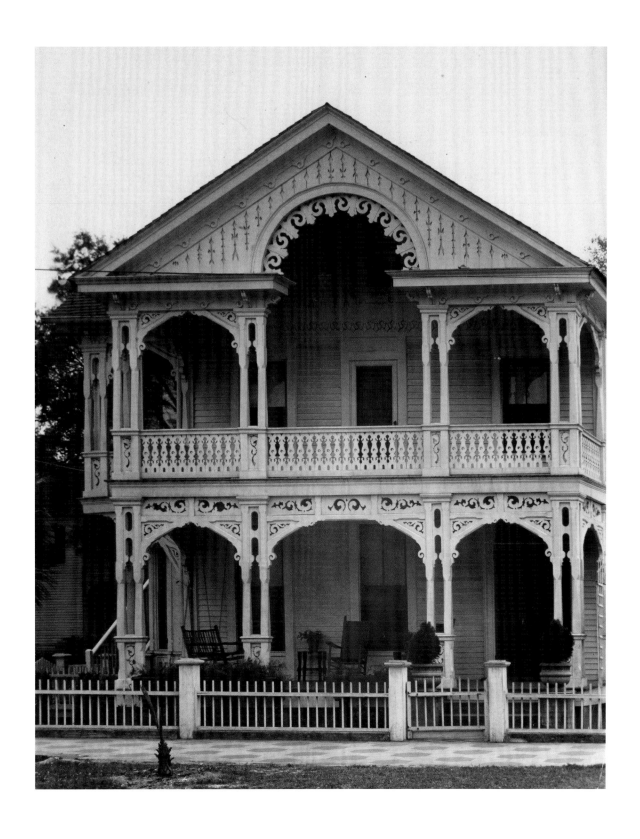

93 [FOLK VICTORIAN HOUSE WITH FRONT-GABLED ROOF,
FERNANDEZ, FLORIDA], 1935–36

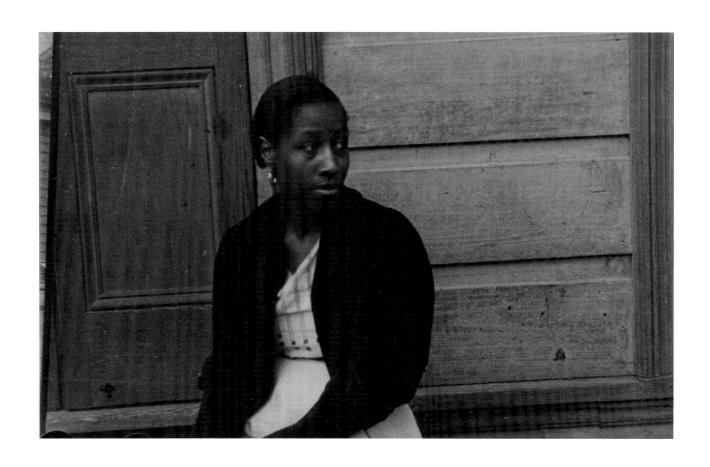

94 [WOMEN IN FRENCH QUARTER, NEW ORLEANS, LOUISIANA], February–March 1935

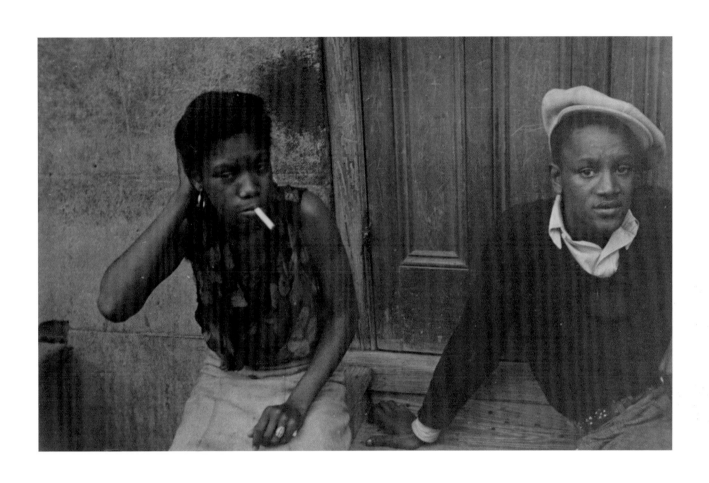

95 [MAN AND WOMAN SEATED ON STOOP IN FRENCH QUARTER,
NEW ORLEANS, LOUISIANA], February–March 1935

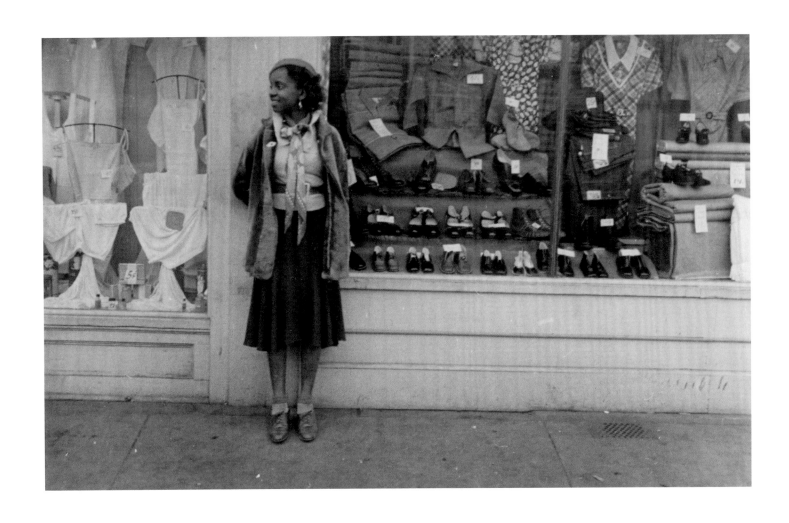

96 [YOUNG WOMAN OUTSIDE CLOTHING STORE, GEORGIA], 1934–35

97 [STREET SCENE, WEST VIRGINIA (?)], 1930s

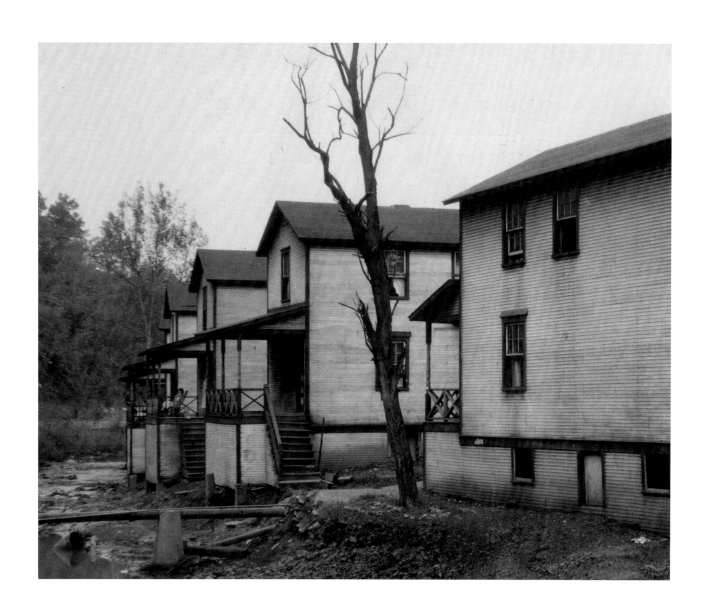

98 ROW OF CLAPBOARD "COMPANY" HOUSES FOR MINERS,
MORGANTOWN, ALONG CREEK, OSAGE, WEST VIRGINIA, June 1935

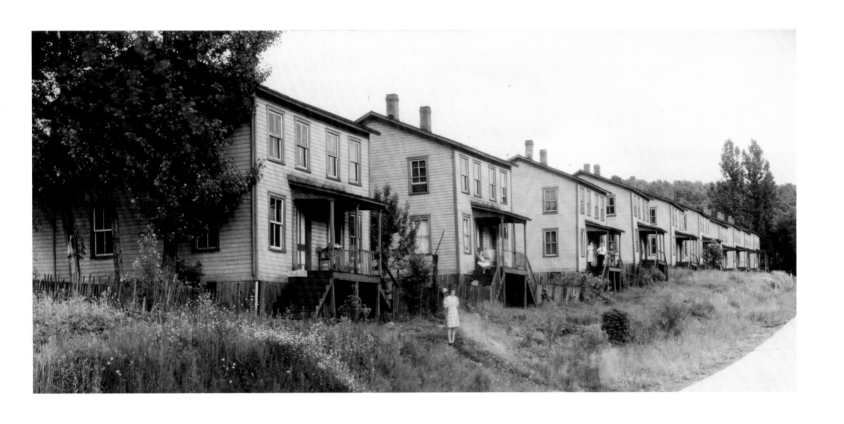

99 COMPANY HOUSES FOR TANNERY WORKS, GORMANIA,
WEST VIRGINIA, June 1935

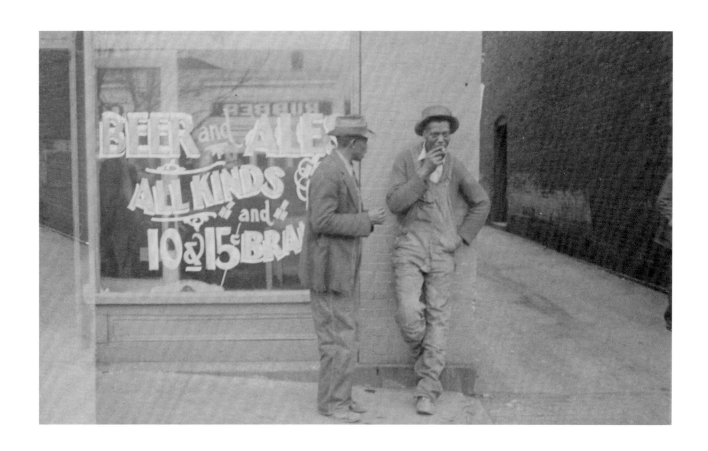

100 [TWO MEN IN FRONT OF LIQUOR STORE WINDOW,
GEORGIA], 1934–35

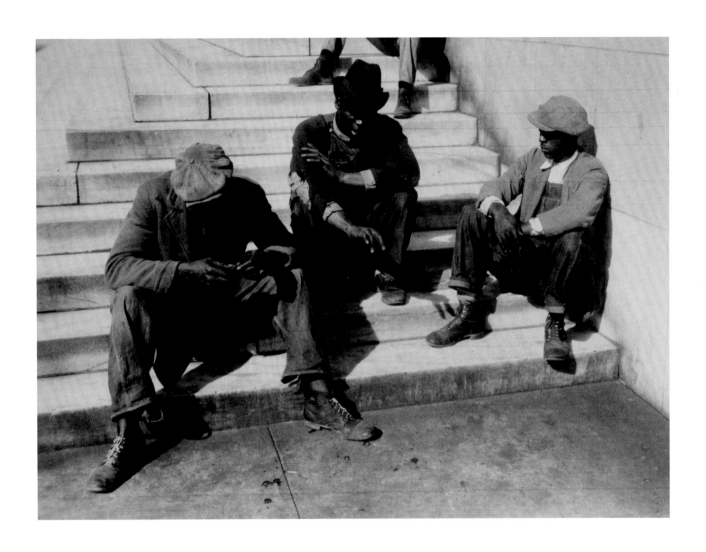

101 [MEN SEATED ON STEPS OF PUBLIC BUILDING,
SOUTHEASTERN UNITED STATES], 1934–35

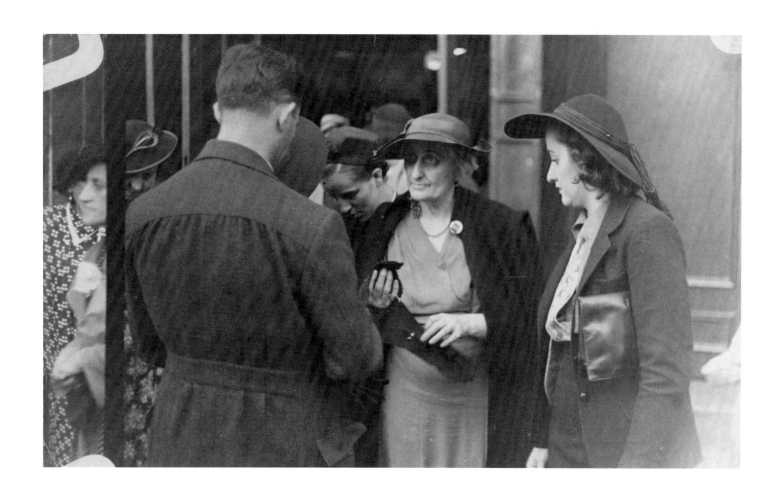

102 [BYSTANDERS OUTSIDE KLEIN'S DEPARTMENT STORE,
UNION SQUARE, NEW YORK CITY], September 1937

103 [BYSTANDERS OUTSIDE KLEIN'S DEPARTMENT STORE, UNION SQUARE, NEW YORK CITY], September 1937

105 [BEDROOM INTERIOR], 1930s

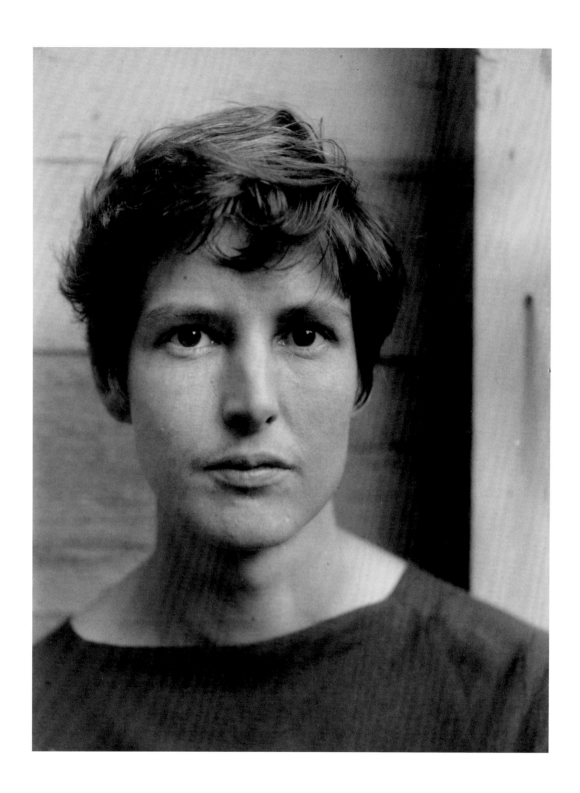

106 [HAZEL HAWTHORNE WERNER], 1930–34

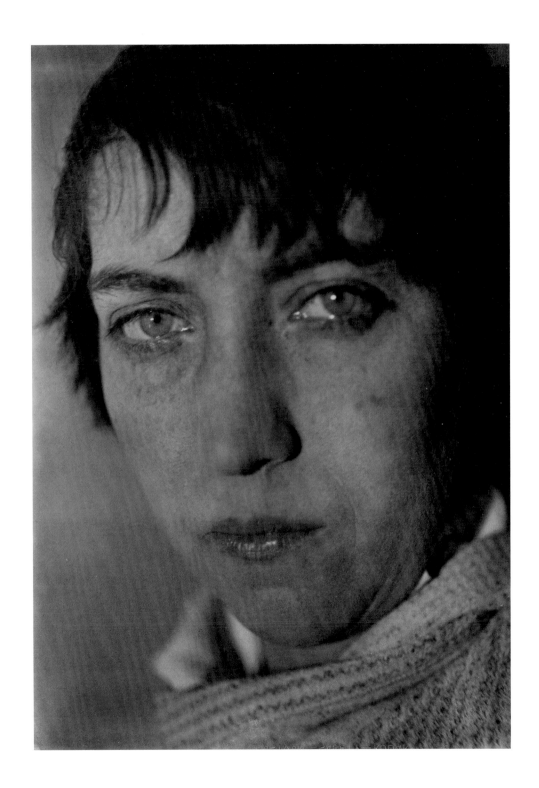

107 BERENICE ABBOTT, 1929–30

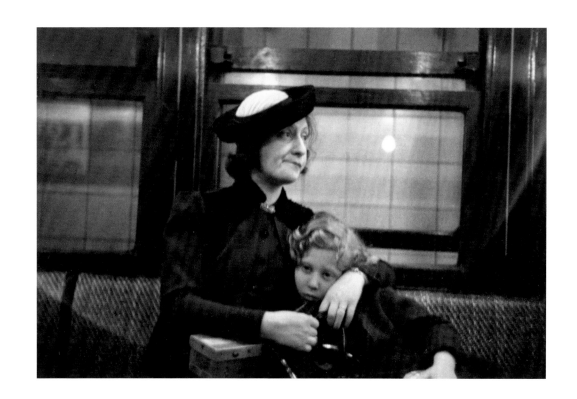

108 [SUBWAY PASSENGERS, NEW YORK CITY: WOMAN IN
VELVET COLLAR WITH ARM AROUND CHILD], May 5–8, 1938

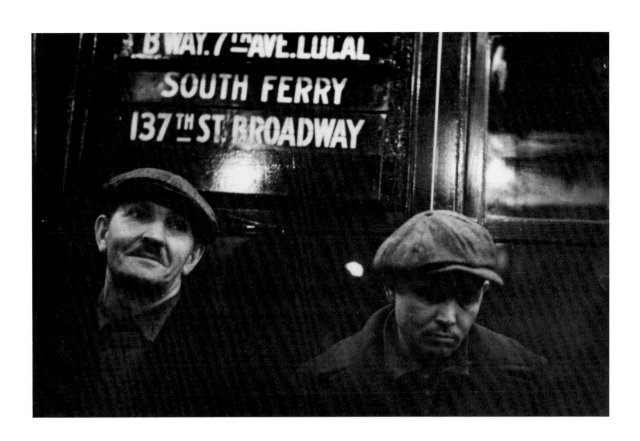

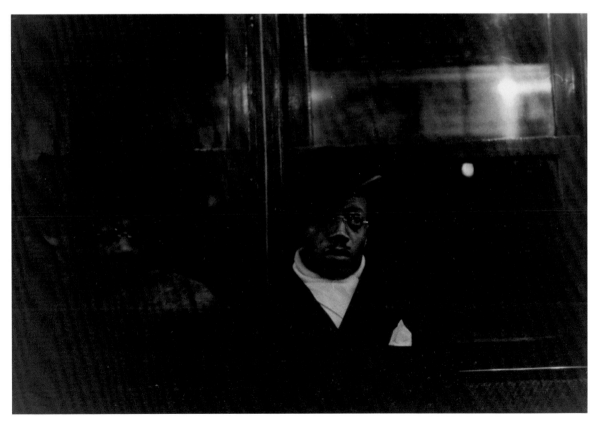

109 [SUBWAY PASSENGERS, NEW YORK CITY: TWO MEN IN CAPS BENEATH "7TH AVE LOCAL" SIGN], February 1938

110 [SUBWAY PASSENGER, NEW YORK CITY: MAN IN DERBY], January 13–21, 1941

THE FORTUNE YEARS AND BEYOND

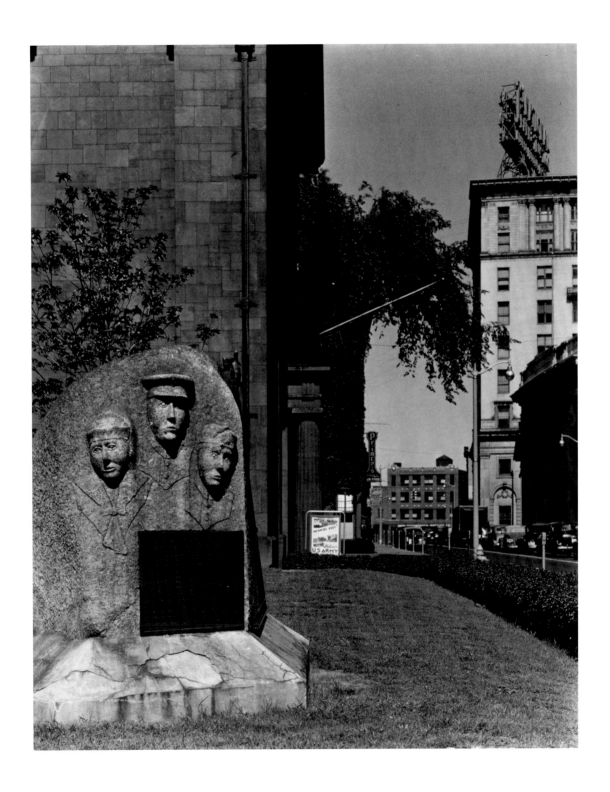

111 [VETERAN'S MONUMENT OUTSIDE CITY HALL, BRIDGEPORT, CONNECTICUT], May 18, 1941

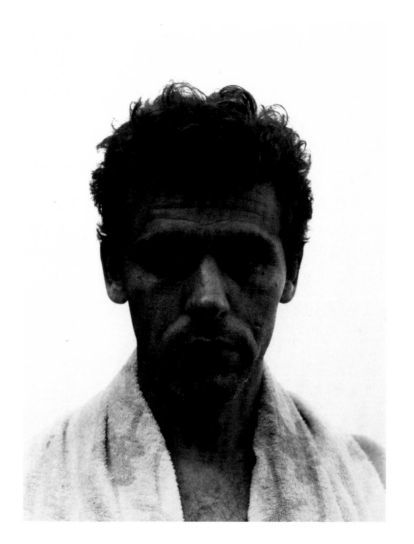

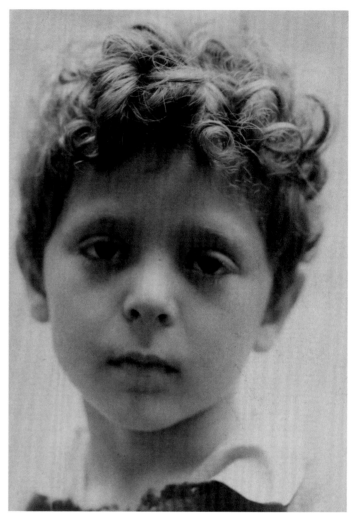

112 JAMES AGEE, 1937

113 [UNIDENTIFIED BOY], 1930s–40s

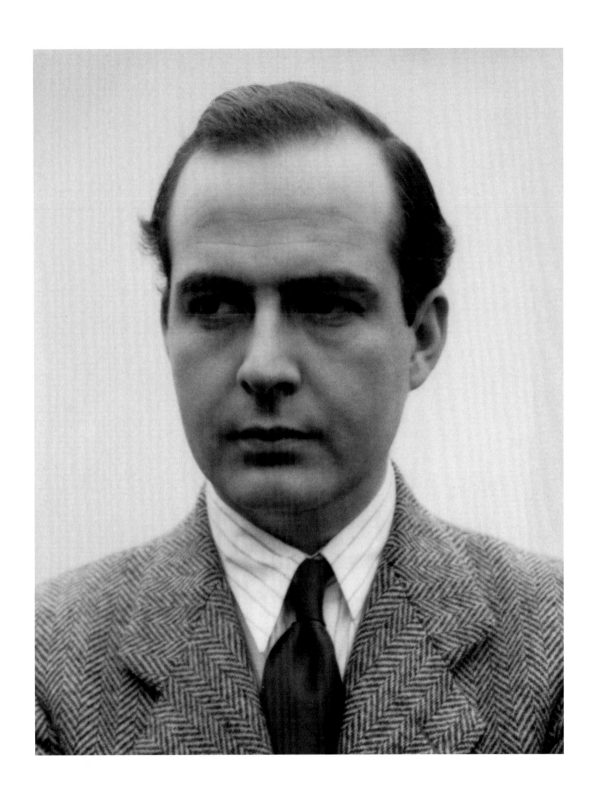

114 [SAMUEL BARBER, NEW YORK CITY], March 1, 1942

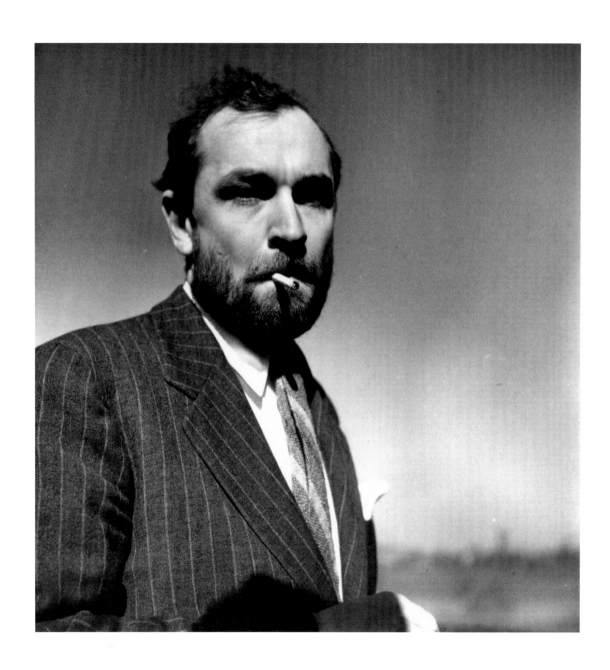

115 [ROBERT FITZGERALD, NEW YORK CITY], February 19, 1943

116 [ROBERT FITZGERALD], 1943

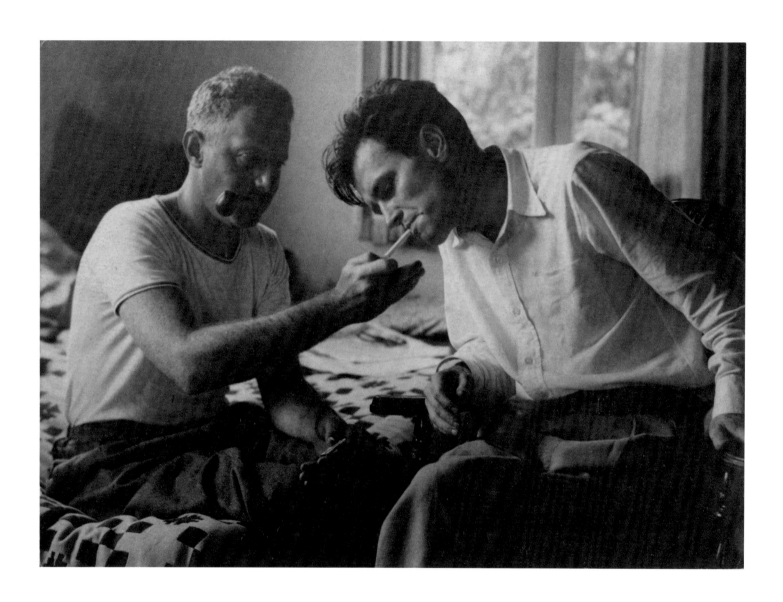

117 [HERBERT SOLOW LIGHTING JOHN MCDONALD'S
CIGARETTE, CROTON, NEW YORK], 1943

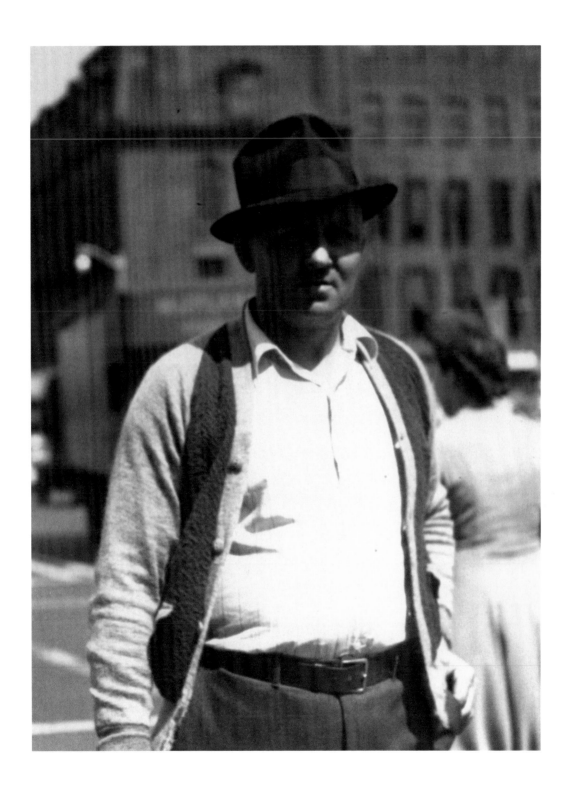

118 [PEDESTRIAN, BRIDGEPORT, CONNECTICUT], 1941

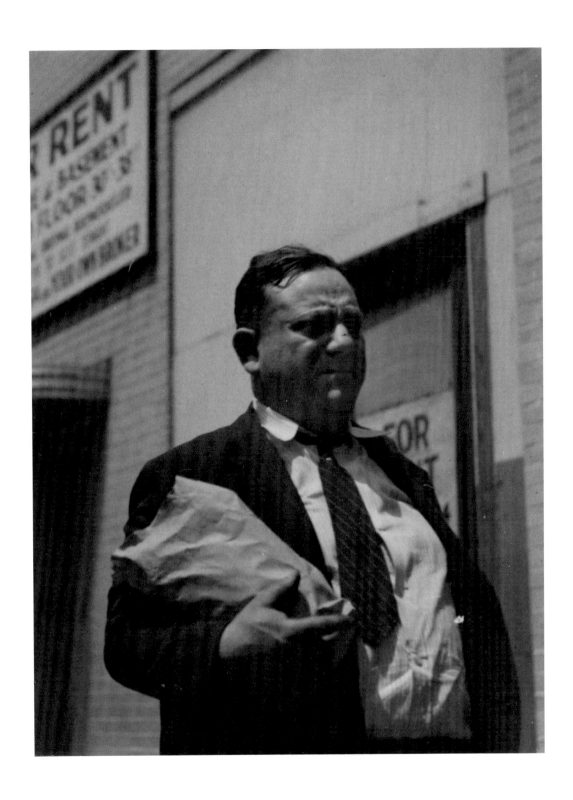

119 [PEDESTRIAN, BRIDGEPORT, CONNECTICUT], 1941

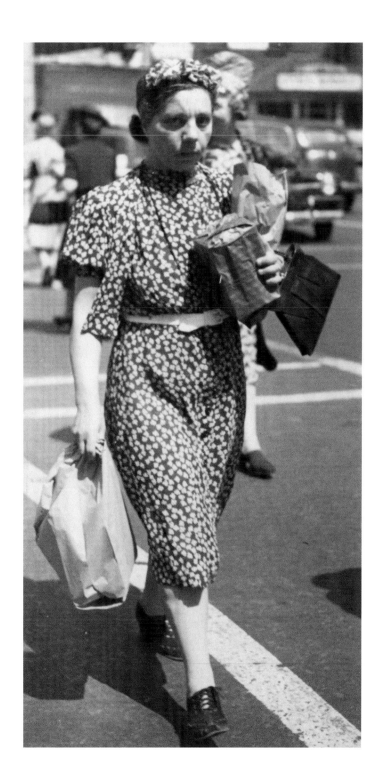

120 [WOMAN SHOPPER], 1939–41

121 [BEDROOM INTERIOR WITH RELIGIOUS AND FAMILY
PICTURES ON WALL, BILOXI, MISSISSIPPI], April 1945

122 [BEDROOM DRESSER, SHRIMP FISHERMAN'S HOUSE,
BILOXI, MISSISSIPPI], April 1945

123 [BEDROOM INTERIOR WITH RELIGIOUS AND FAMILY
PICTURES ON WALL, BILOXI, MISSISSIPPI], April 1945

124 [BEDROOM INTERIOR, SHRIMP FISHERMAN'S HOUSE,
BILOXI, MISSISSIPPI], April 1945

125 [BALLET THEATRE COMPANY, NEW YORK], October 1945

126 [BALLET THEATRE COMPANY, NEW YORK], October 1945

127 [BALLET THEATRE COMPANY, NEW YORK], October 1945

128 [BALLET THEATRE COMPANY, NEW YORK], October 1945

129 [BALLET THEATRE COMPANY, NEW YORK], October 1945

130 [CIRCUS TRAPEZE ACT, MADISON SQUARE GARDEN, NEW YORK CITY], 1940s

132 [CHICAGO THEATER, CHICAGO, ILLINOIS], 1946

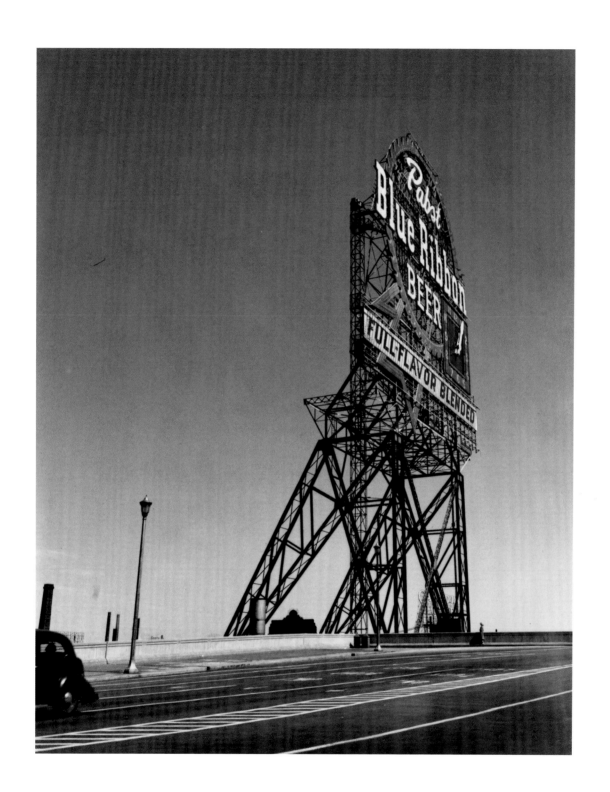

133 [PABST BLUE RIBBON SIGN, CHICAGO, ILLINOIS], 1946

134 [CHICAGO, ILLINOIS], 1946

135 [CHICAGO, ILLINOIS], 1946

136 [CHICAGO, ILLINOIS], 1946

137 [TRINI BARNES], 1940s

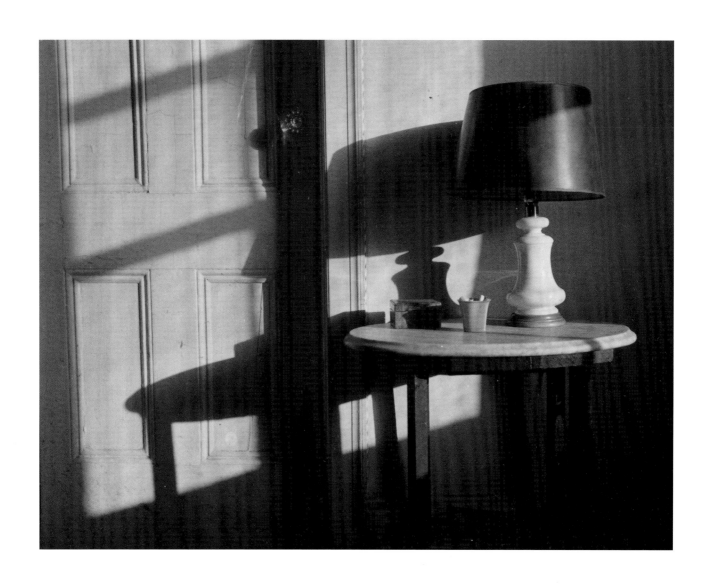

138 [LAMP ON TABLE IN WALKER EVANS'S APARTMENT,
441 EAST 92 STREET, NEW YORK CITY], 1946–47

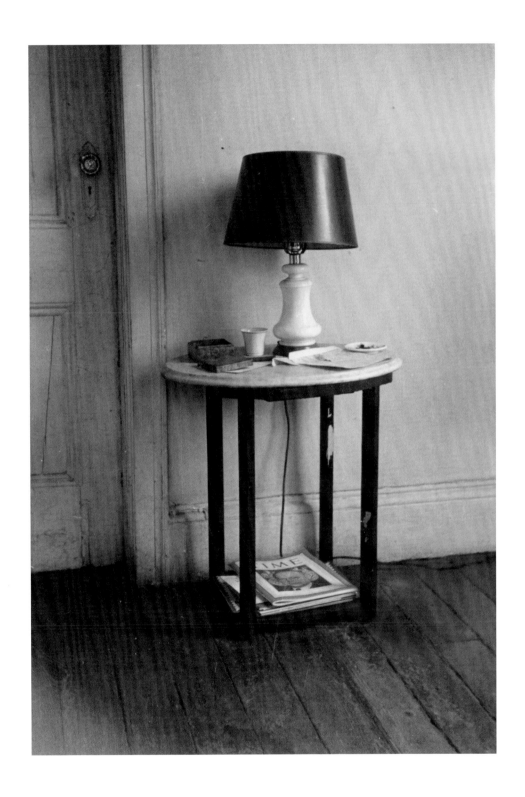

139 [LAMP ON TABLE IN WALKER EVANS'S APARTMENT, 441 EAST 92 STREET, NEW YORK CITY], 1946–47

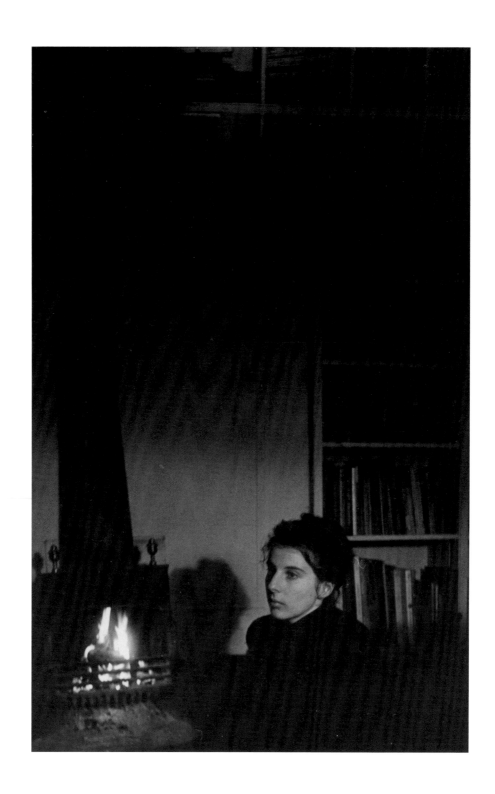

140 [MARY FRANK, NEW YORK CITY], January 1957

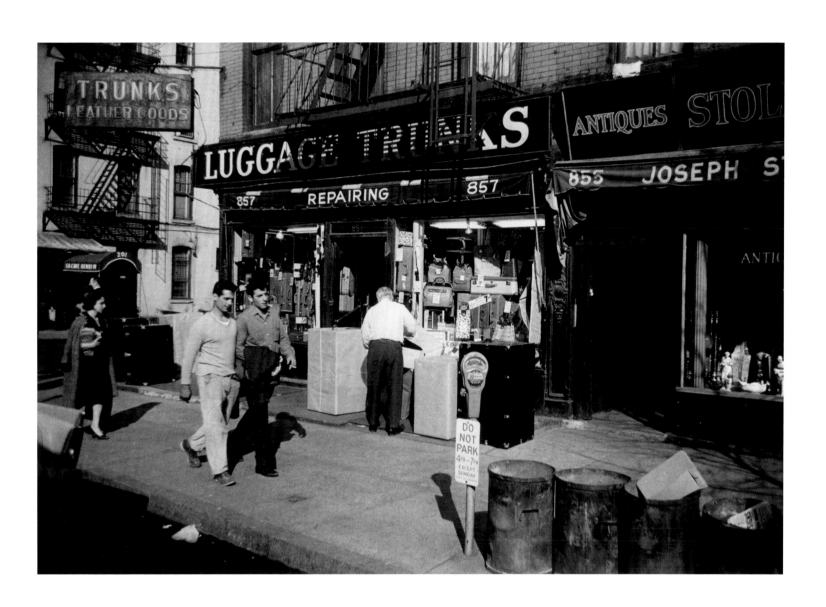

141 [THIRD AVENUE STOREFRONT], April–May 1959

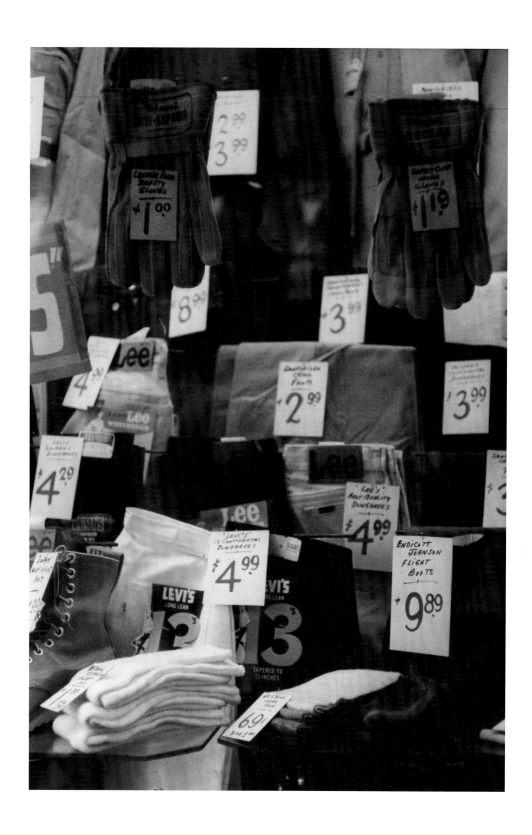

142 [SHOP WINDOW, NEAR CORTLANDT STREET, NEW YORK CITY], May 17, 1963

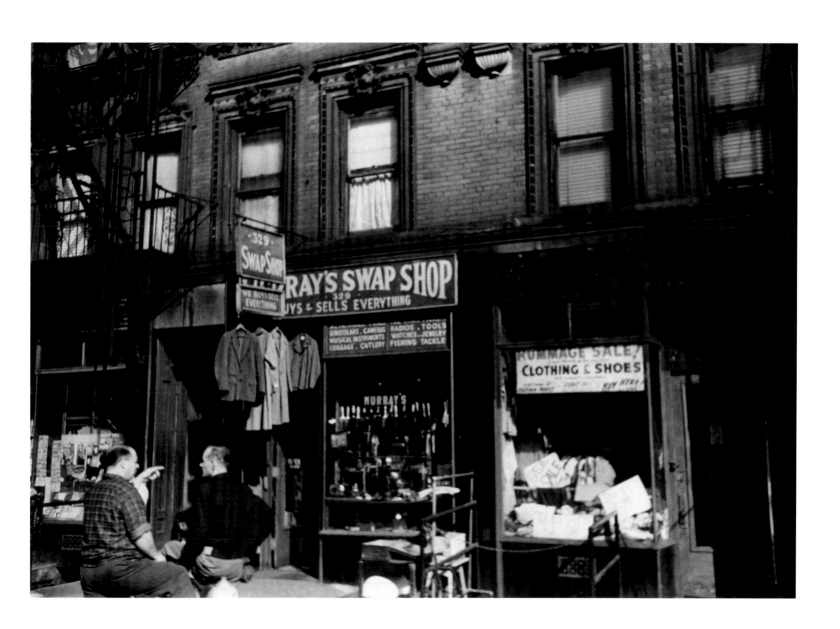

143 [THIRD AVENUE STOREFRONT], April–May 1959

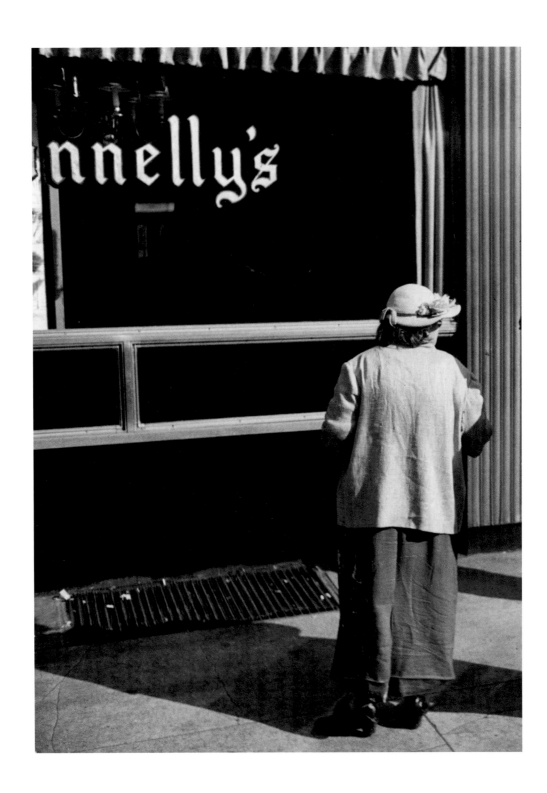

144 [THIRD AVENUE STOREFRONT], April–May 1959

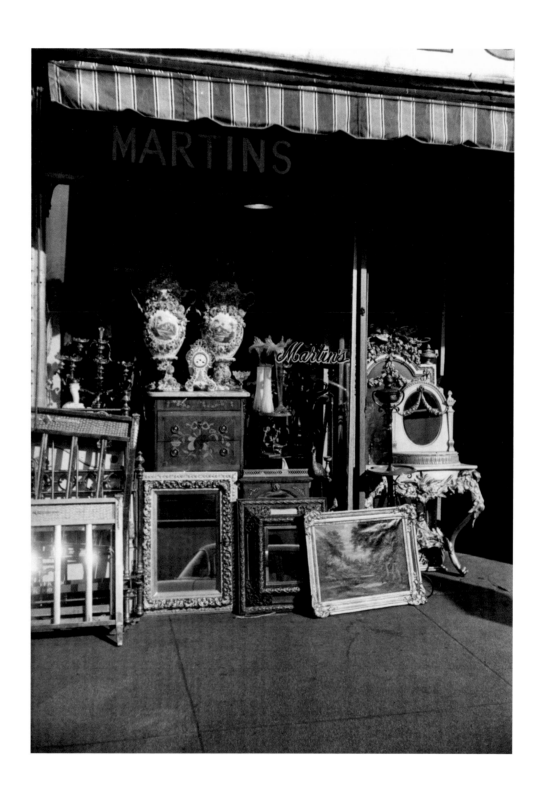

145 [THIRD AVENUE STOREFRONT], April–May 1959

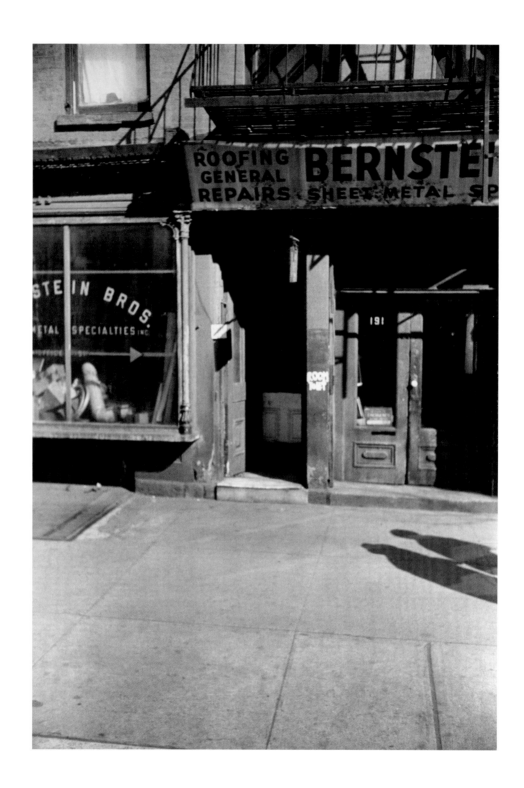

146 [THIRD AVENUE STOREFRONT], April–May 1959

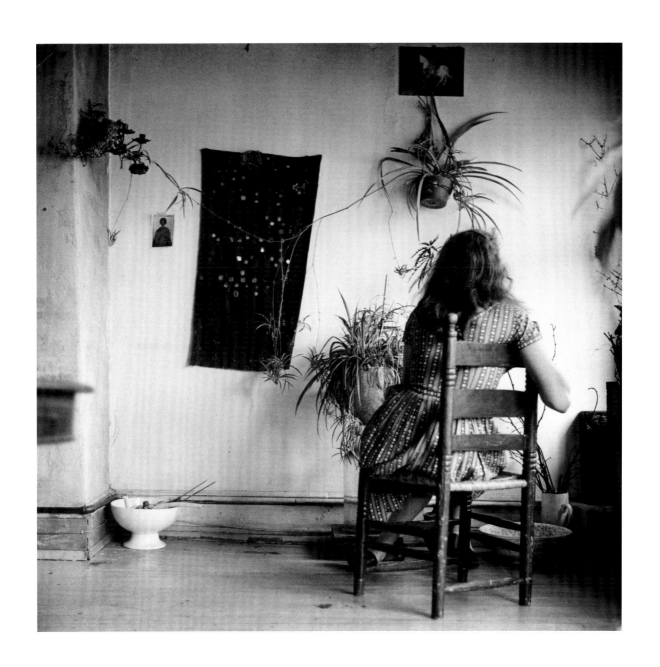

147 [MARY FRANK'S BEDROOM, NEW YORK CITY], 1959

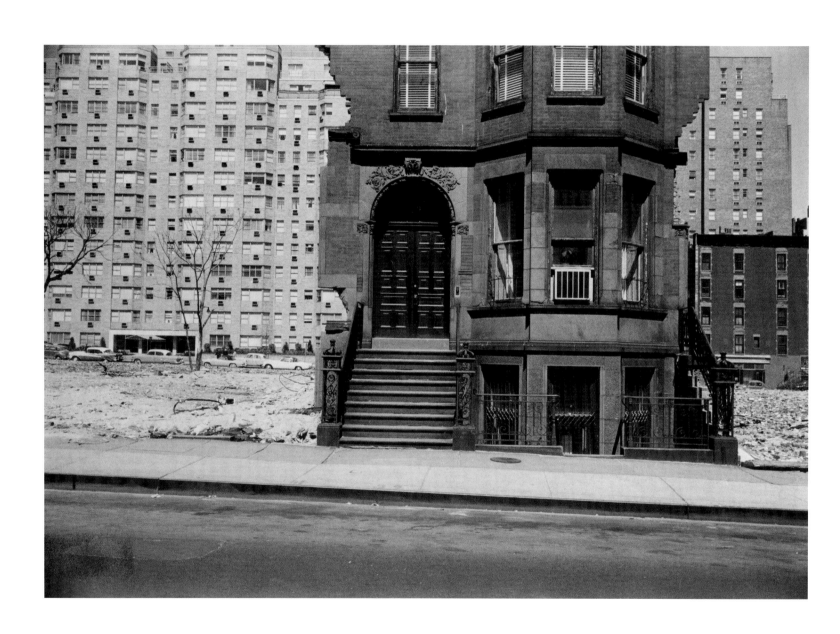

148 [URBAN CONSTRUCTION SITE], April–May 1959

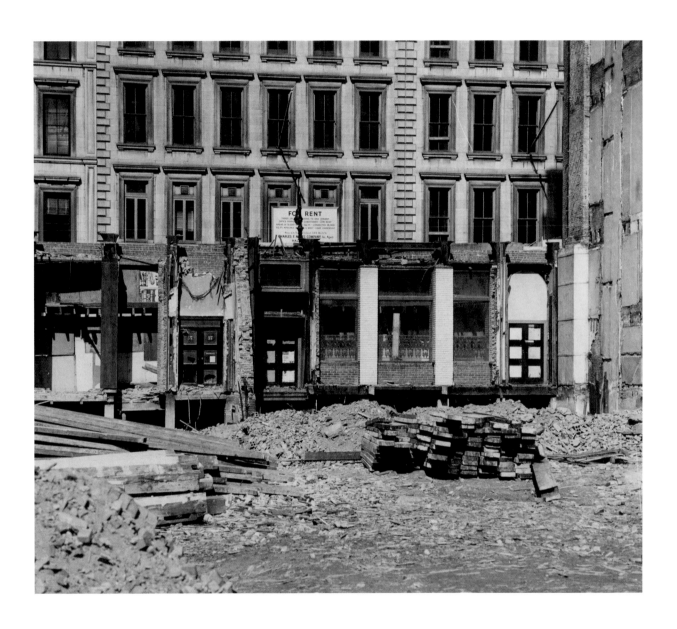

149 [VIEW OF NINETEENTH-CENTURY CAST-IRON WAREHOUSES
IN DOWNTOWN MANHATTAN, NEW YORK CITY], 1961–62

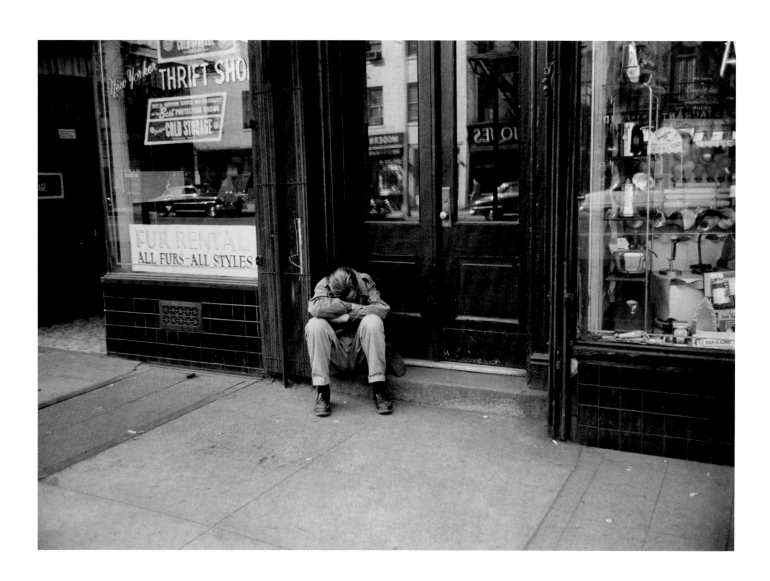

150 [NEW YORK], 1961

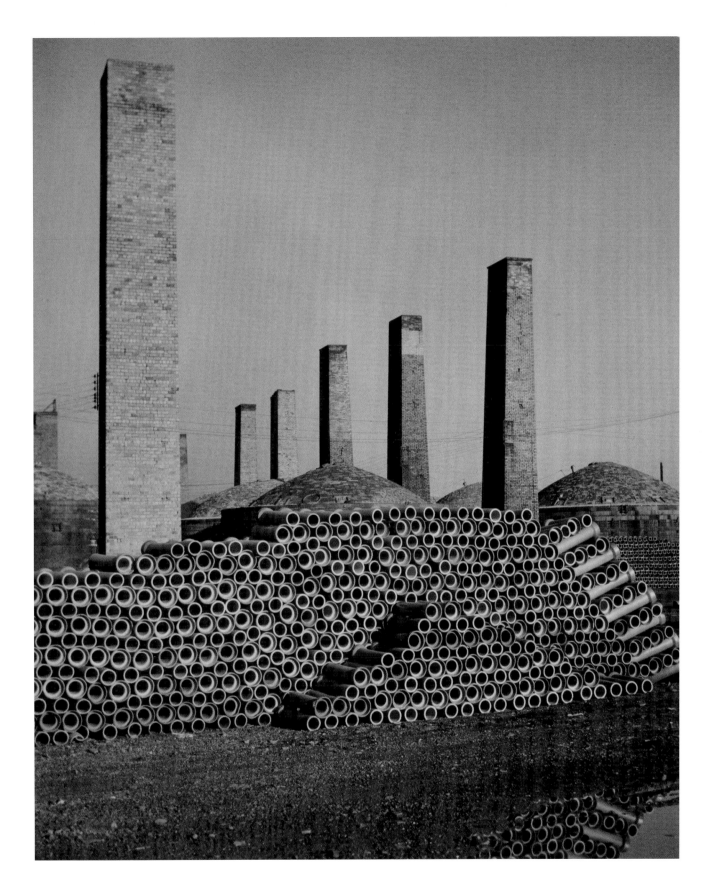

151 [STUDY OF OHIO CLAY PLANT], 1950

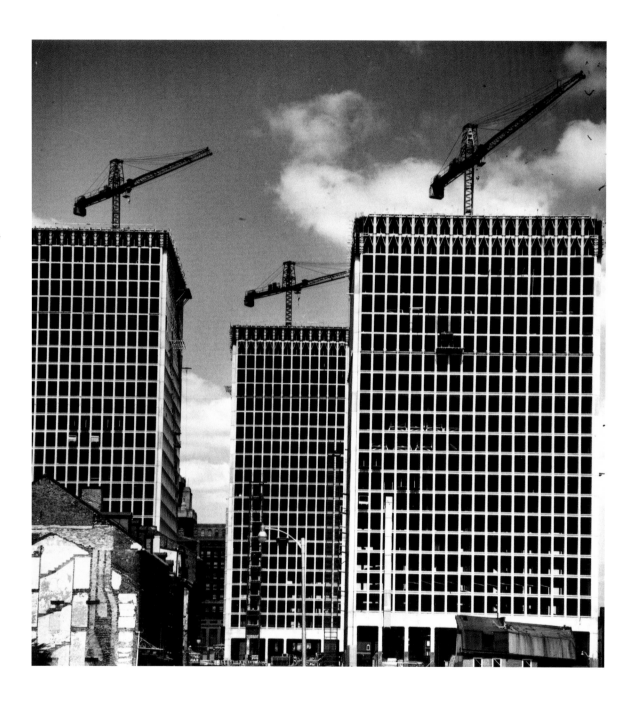

152 [VIEW OF BUILDING CONSTRUCTION FOR CONTAINER
CORPORATION COMMISSION], 1963

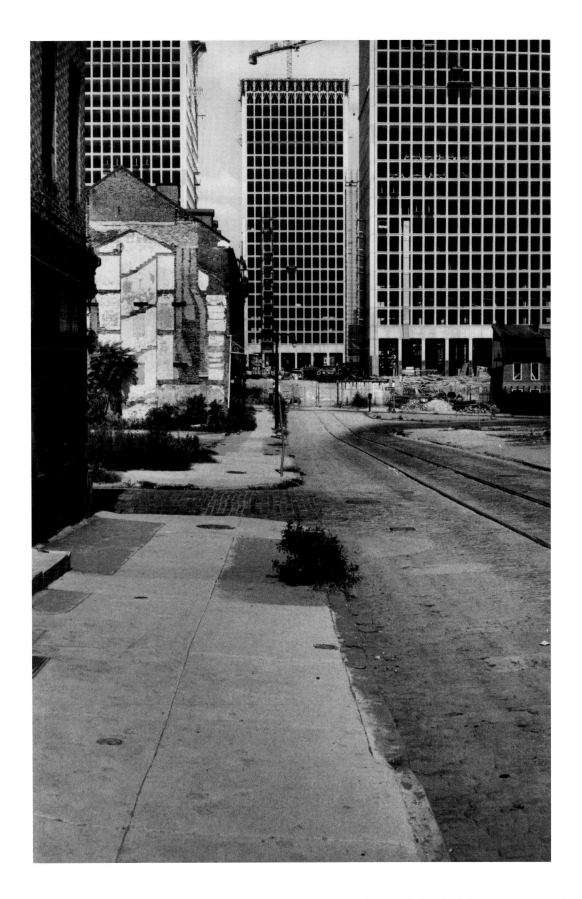

153 [VIEW OF BUILDING CONSTRUCTION FOR CONTAINER
CORPORATION COMMISSION], 1963

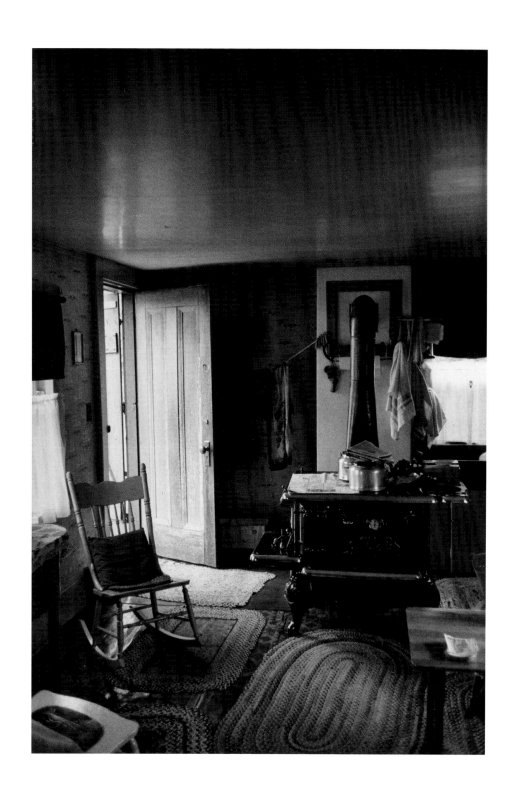

154 [INTERIOR OF THE HELIKER HOUSE,
CRANBERRY ISLAND, MAINE], July 29, 1962

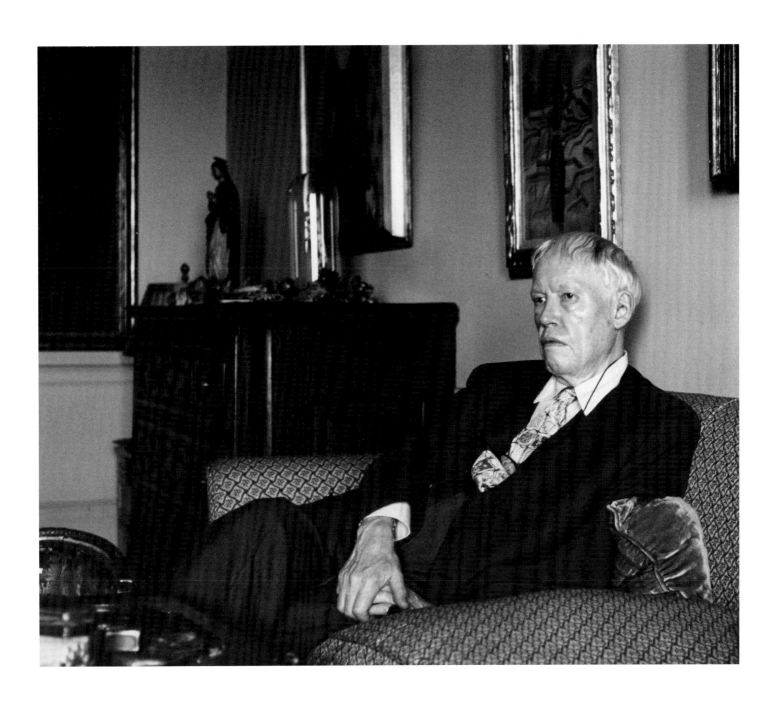

155 [CARL VAN VECHTEN AT HOME], May 3, 1962

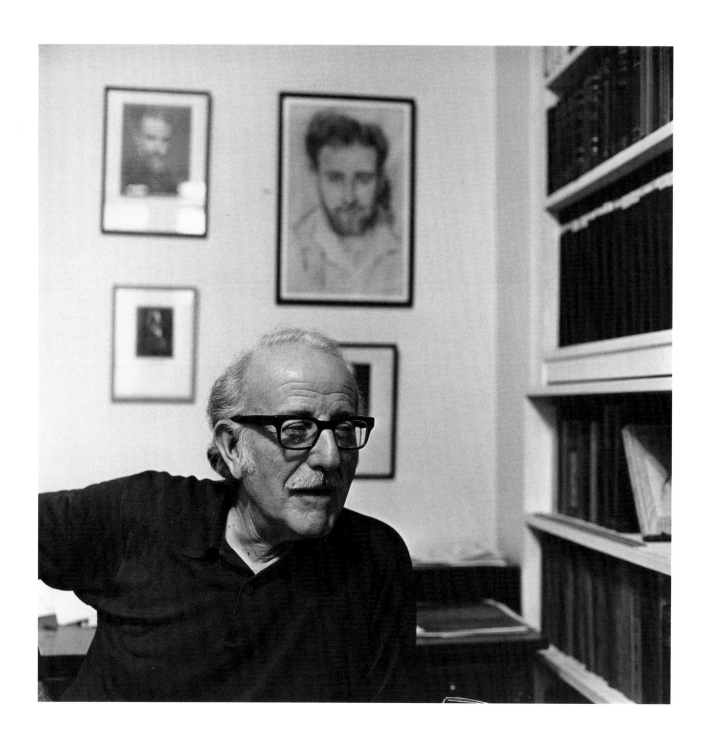

156 [PORTRAIT OF TENNESSEE WILLIAMS, NEW YORK], 1960s

157 [ISABELLE BOESCHENSTEIN EVANS, NEW YORK], October 21, 1960

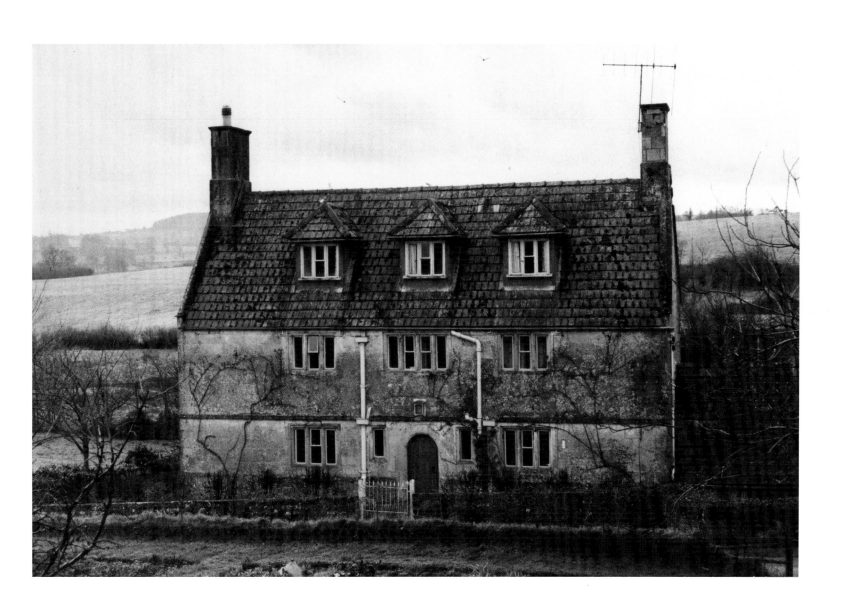

158 [BERNE, SWITZERLAND (BOESCHENSTEIN FAMILY RESIDENCE?)],
January 1967

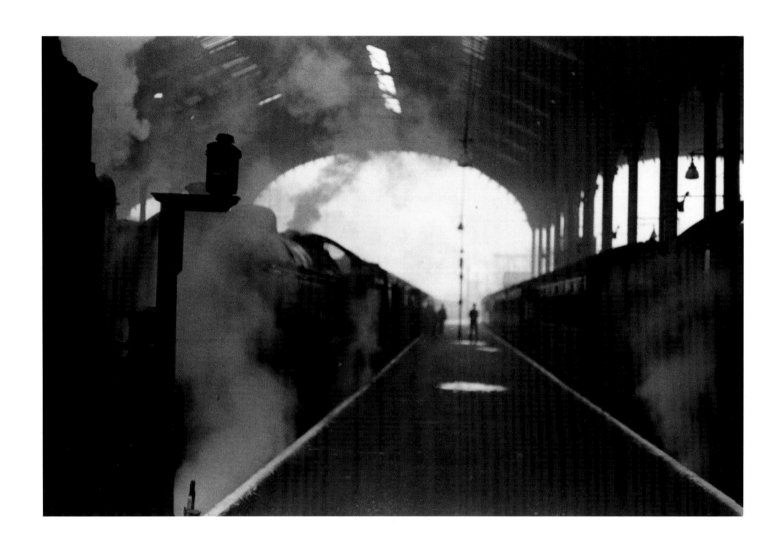

159 [LONDON], 1950s

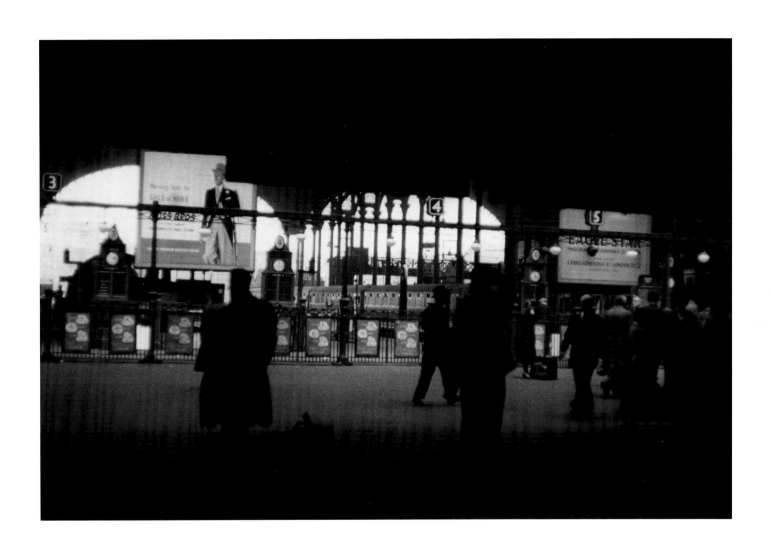

160 [LONDON], 1950s

161 [SKITTLE ALLEY IN PUB, LONDON], 1960s

162 [LONDON], 1950s

163 [LONDON], 1950s

164 [LONDON, TRAFALGAR SQUARE], 1950s

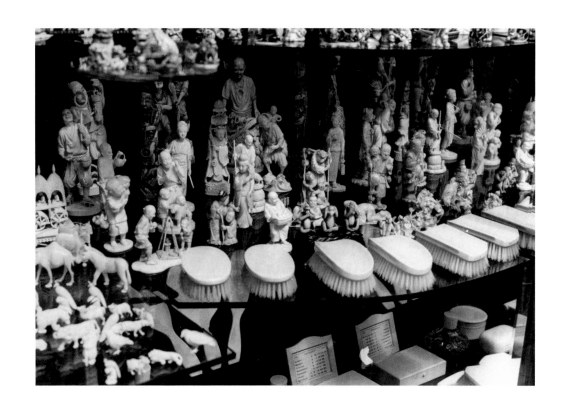

165 [SHOP WINDOW, LONDON], 1950s

166 [TAXIS, LONDON], 1950s

167 [LONDON], 1950s

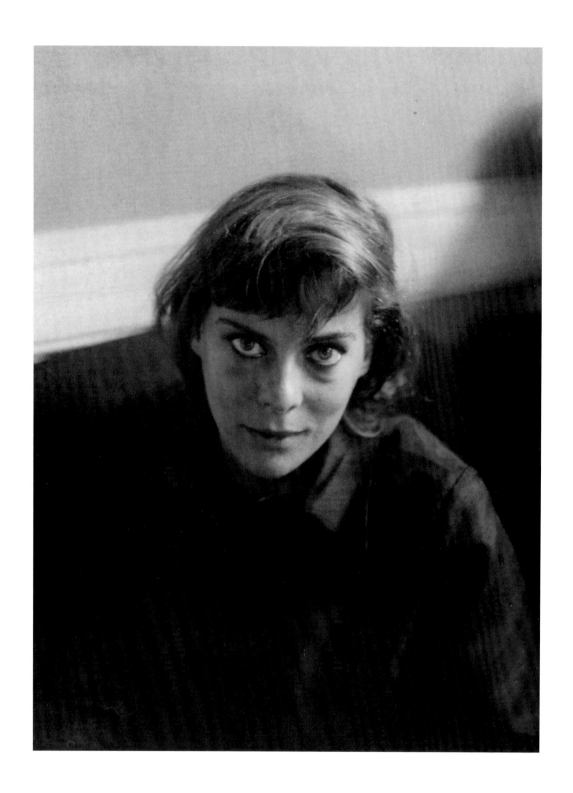

168 [CAROLINE BLACKWOOD], 1963 or later

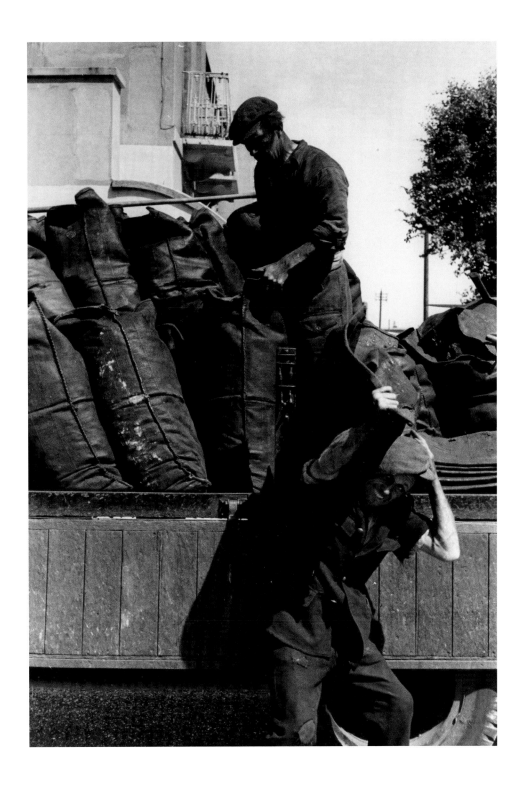

169 [LONDON], 1950s

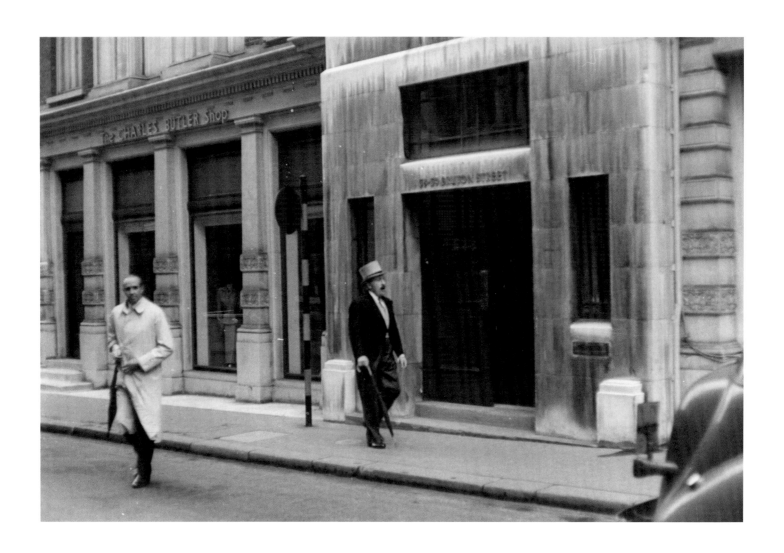

170 [BRUTON STREET, LONDON], 1950s

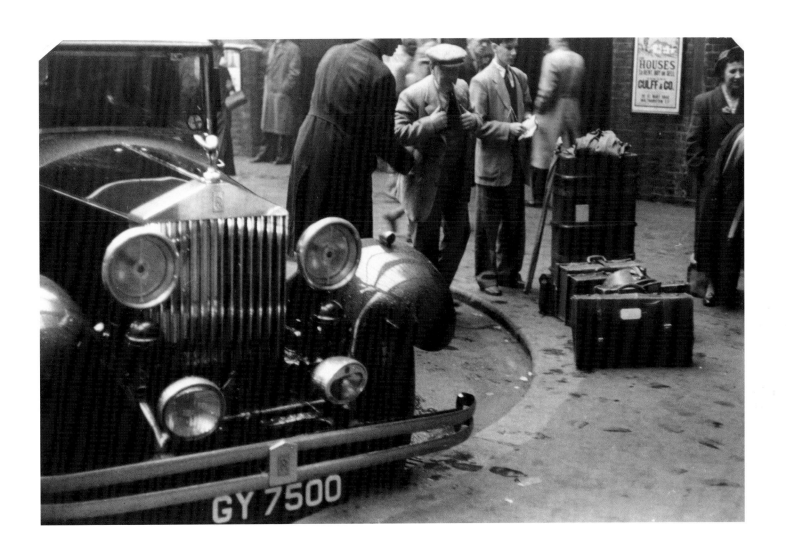

171 [LONDON], 1950s

172 [LONDON], 1973

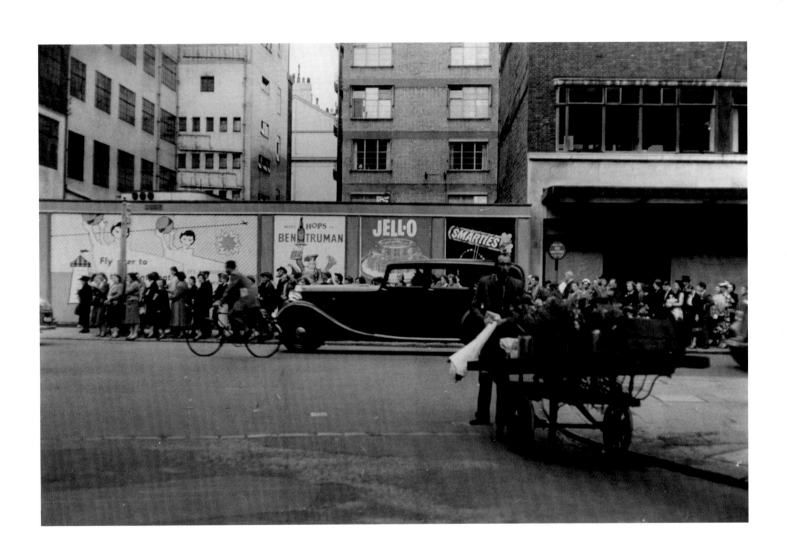

173 [LONDON], 1950s

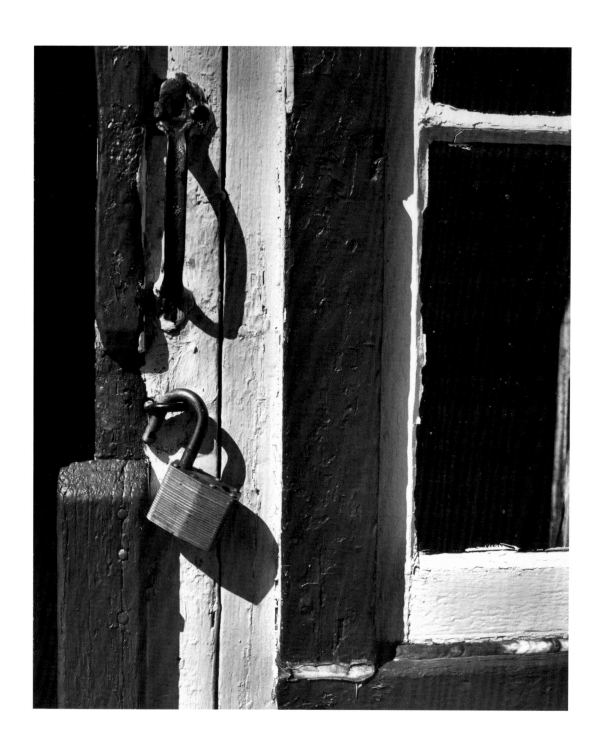

174 [BARN DETAIL, HEIGHTSTOWN, NEW JERSEY], 1963

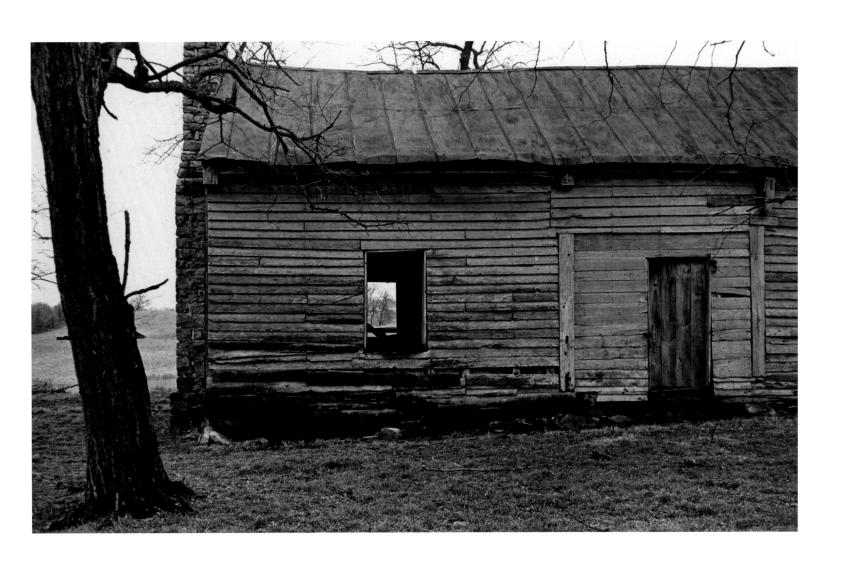

175 [BARN, KENTUCKY], 1961

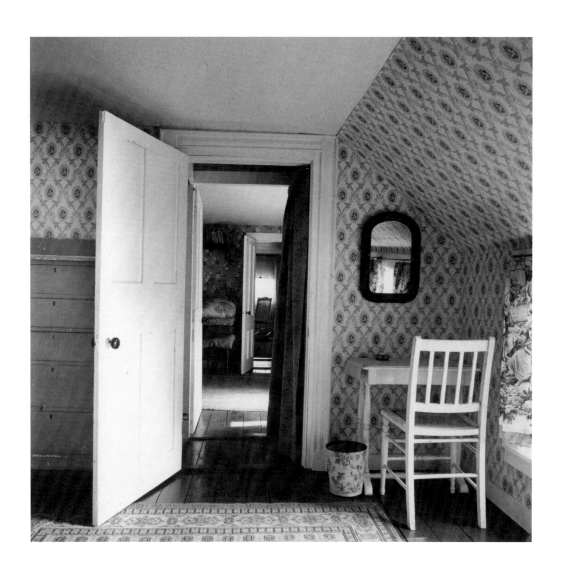

176 [INTERIOR VIEW OF HELIKER/LAHOTAN HOUSE, WALPOLE, MAINE], 1962

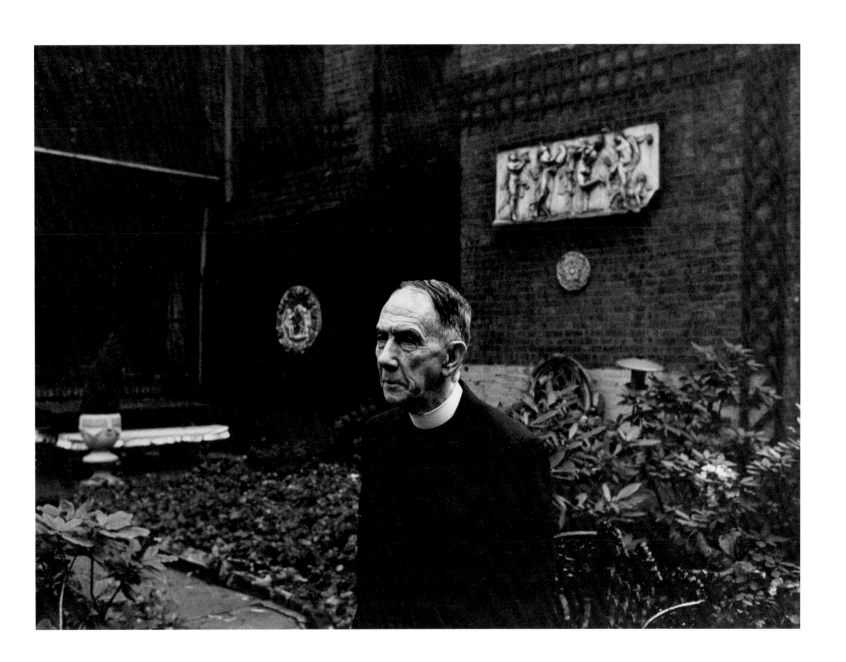

177 [FATHER JAMES FLYE], 1962

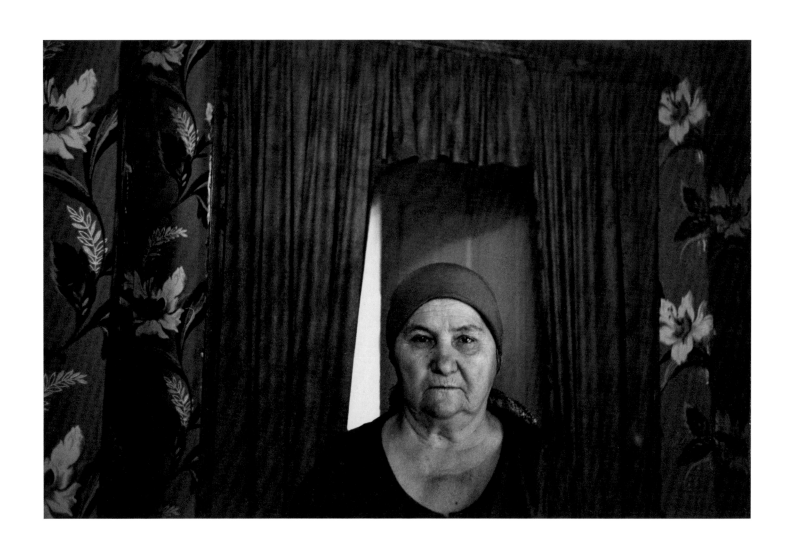

178 [PORTRAIT OF A HOUSEWIFE, ALLENTOWN PENNSYLVANIA], 1961

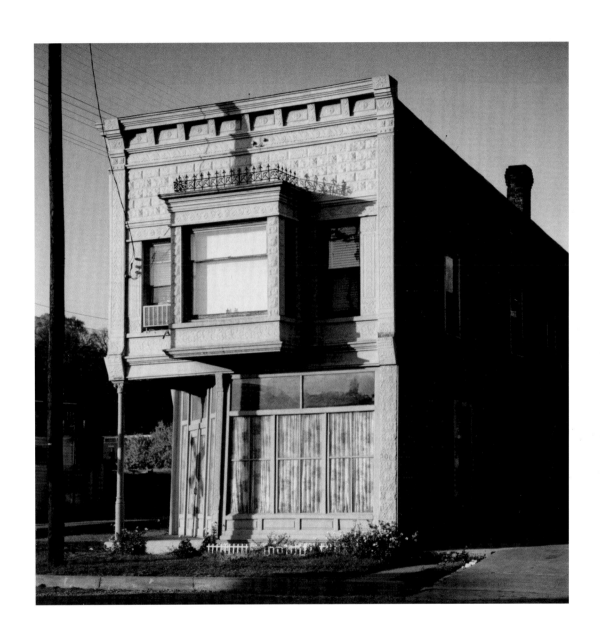

179 [RAILROAD DEPOT], October 1963

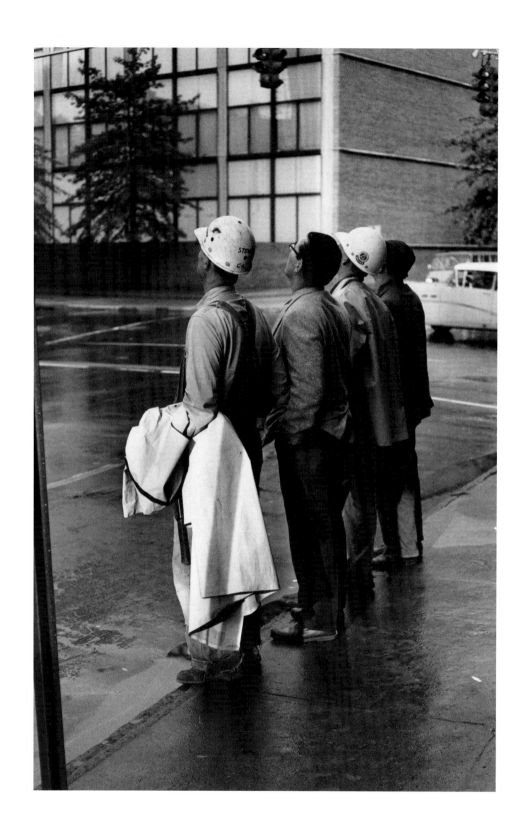

180 [MEN'S FASHION], March–June 1963

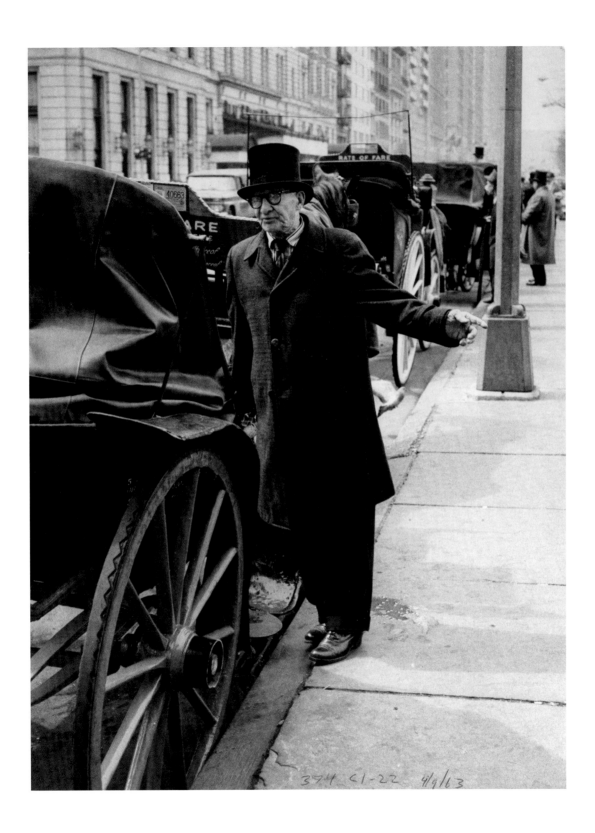

181 [MEN'S FASHION], March–June 1963

182 [VIEW OF FACTORY], 1960–65

183 [VIEW OF FACTORY], 1960–65

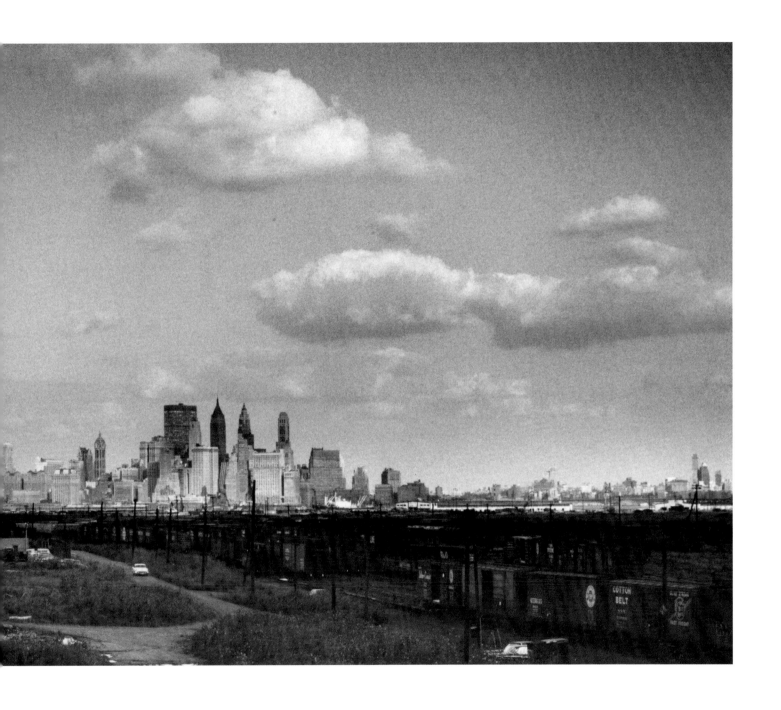

184 [MANHATTAN SKYLINE FOR CONTAINER CORPORATION COMMISSION], 1963

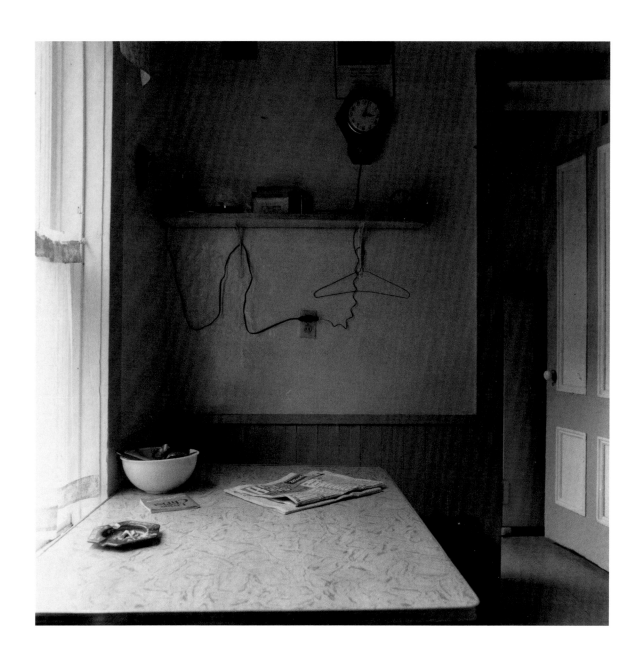

185 [KITCHEN INTERIOR, MAINE], 1969

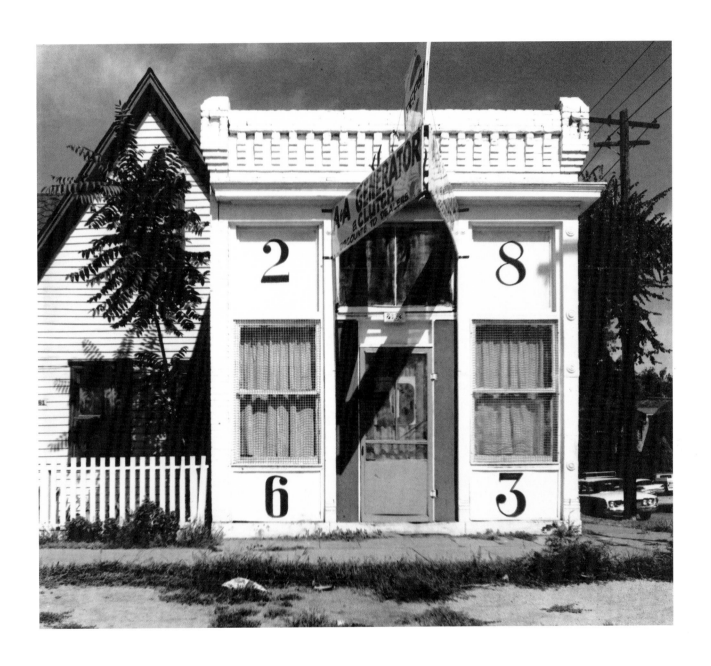

186 [FAÇADE OF HOUSE WITH LARGE NUMBERS, DENVER, COLORADO], August 1967

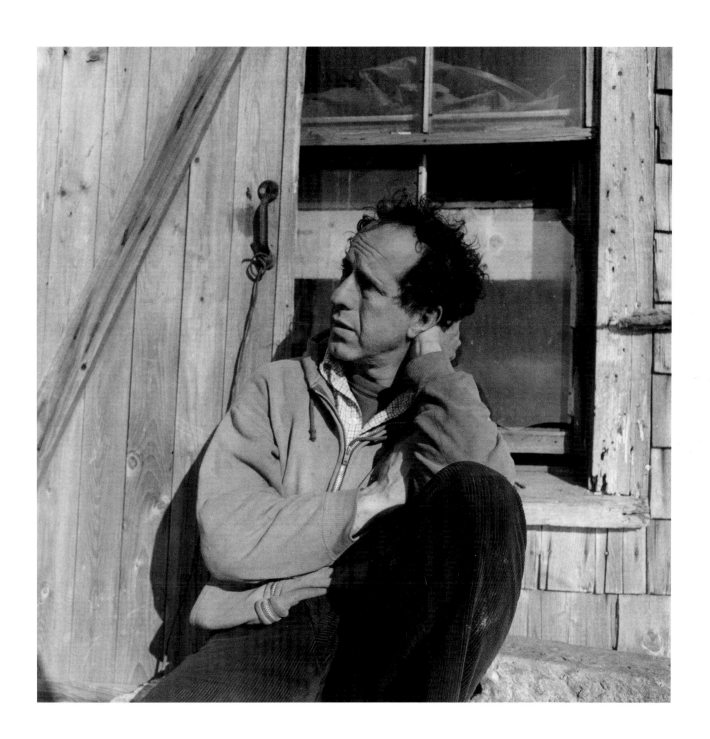

187 [ROBERT FRANK, NOVA SCOTIA], 1969–71

188 [INTERIOR VIEW OF ROBERT FRANK'S HOUSE,
NOVA SCOTIA], 1969–71

189 [ROBERT FRANK'S AND JUNE LEAF'S PROPERTY,
NOVA SCOTIA], 1969–71

 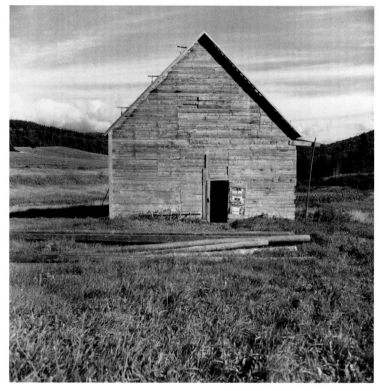

190 [BARN, NOVA SCOTIA], 1969–71

191 [BARN, NOVA SCOTIA], 1969–71

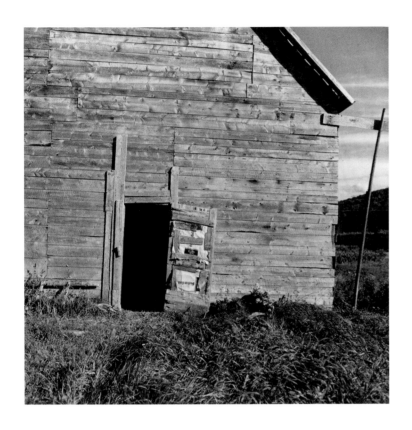

192 [BARN, NOVA SCOTIA], 1969–71

193 [BARN, NOVA SCOTIA], 1969–71

194 [JACK HELIKER, CRANBERRY ISLAND, MAINE], 1967–68

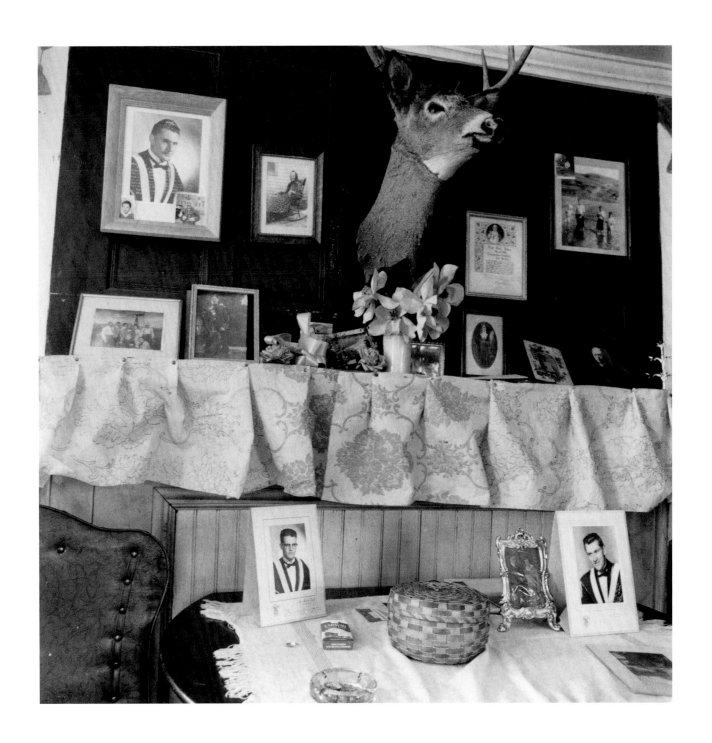

195 [INTERIOR VIEW OF A FISHERMAN'S HOUSE, NOVA SCOTIA], 1969–70

196 [INTERIOR VIEW OF A FISHERMAN'S HOUSE, NOVA SCOTIA], 1969–70

197 [HELIKER HOUSE, CRANBERRY ISLAND, MAINE], 1969

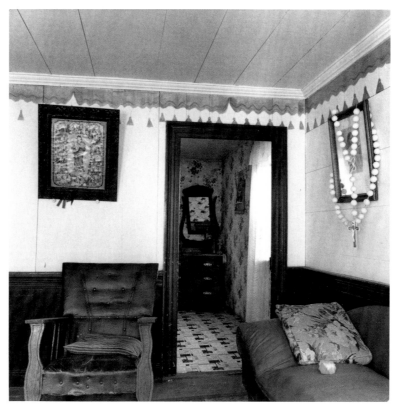

198 [INTERIOR VIEW OF A FISHERMAN'S HOUSE, NOVA SCOTIA], 1969–71

199 [INTERIOR VIEW OF A FISHERMAN'S HOUSE, NOVA SCOTIA], 1969–70

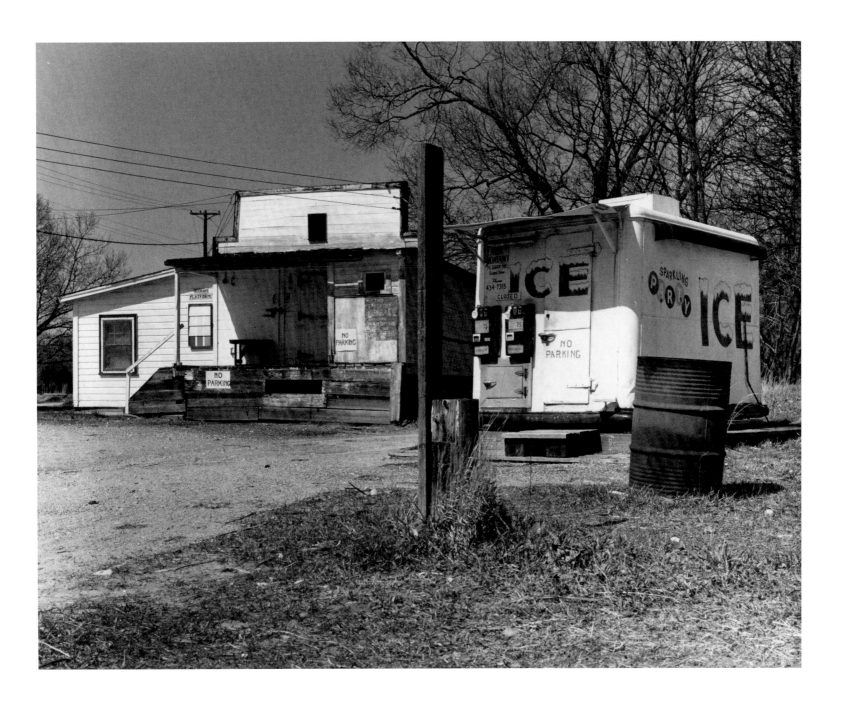

200 [SHACK AND ICE MACHINE, OLD LYME, CONNECTICUT], April 1973

LATE WORK: POLAROIDS

201–202 [UNTITLED], 1973–74

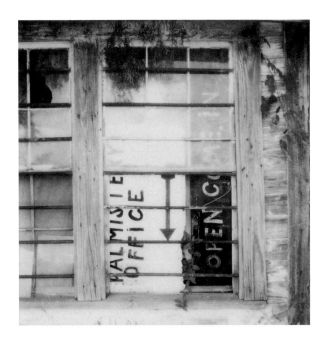

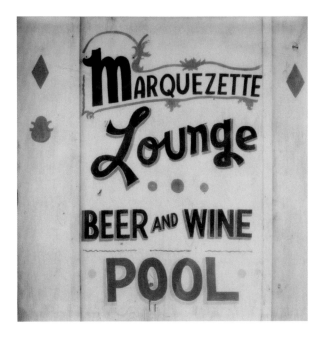

203-206 [UNTITLED], 1973-74

207–208 [UNTITLED], 1973–74

209 [UNTITLED], 1973–74

210–213 [UNTITLED], 1973–74

214 [UNTITLED], 1973–74

215–216 [UNTITLED], 1973–74

LIST OF WORKS

The photographs contained in the present exhibition share many of the idiosyncratic and inconsistent marks and inscriptions found on prints in other important collections of Evans's work. Wherever possible, for each work listed we have included the corresponding titling and dating recorded in the Walker Evans Archive, Metropolitan Museum of Art, New York. Bracketed titles [] for works are not actual titles, but rather descriptive ones and not to be confused with unbracketed titles of works that have been assigned by the artist or established by scholars. Regarding the Lunn Gallery stamp and the Walker Evans studio stamps found on the photographs in the present exhibition, see Keller 1995, pp. xvi–xvii. Unless noted otherwise, all works listed are gelatin silver prints.

1 [BUILDING FAÇADE DETAIL, NEW YORK CITY], 1928–30. 3¼ × 5 in. Lunn Gallery stamp (1975) XIV 27

2 [DETAIL OF SHIP MAST AND RIGGING, NEW YORK CITY], 1928–30. 5½ × 9½ in. Lunn Gallery stamp (1975) XVI 10

3 [SHIP RIGGING AND TACKLE DETAIL, MARKET DOCKS, NEW YORK], 1928. 7⅛ × 9¾ in. Lunn Gallery stamp (1975) IV 36

4 [DETAIL OF SHIP MAST AND RIGGING, NEW YORK CITY], 1928–30. 2¼ × 4 in. Lunn Gallery stamp (1975) XVI 1

5 [VIEW FROM ACROSS STREET OF EVANS'S APARTMENT HOUSE, 48 COLUMBIA HEIGHTS, BROOKLYN, NEW YORK], October 1928. 4¼ × 7⅜ in. Lunn Gallery stamp (1975) XIV right square empty

6 [HANNS SKOLLE ON ROOFTOP OF APARTMENT BUILDING AT 13 EAST 14TH STREET, NEW YORK CITY], 1928–30. 1⅜ × 2⅜ in. Lunn Gallery stamp (1975) IV 20

7 [TABLE SETTING AND THRONE CHAIR IN MURIEL DRAPER'S APARTMENT, NEW YORK CITY], May 29, 1934. 6⅛ × 8¼ in. Lunn Gallery stamp (1975) XIV 106v

8 [HANNS SKOLLE], 1928–30. 2 × 2⅝ in. Lunn Gallery stamp (1975) IV 20

9 [HANNS SKOLLE], 1928–30. 1¾ × 3¼ in. Lunn Gallery stamp (1975) IV 20

10 [HART CRANE], 1929–30. 5 × 7 in. Lunn Gallery stamp (1975) IV 3v

11 [HART CRANE], 1929–30. 5 × 7 in. Lunn Gallery stamp (1975) IV 3v

12 [HANNS SKOLLE], 1930–34. 5 × 7¼ in. Lunn Gallery stamp (1975) IV 20

13 [UNIDENTIFIED WOMAN LEANING ON FIREPLACE MANTLE], 1930s. 6 × 8 in. Lunn Gallery stamp (1975) both squares empty

14 [SHIP'S PROW AND RIGGING, NEW BEDFORD, MASSACHUSETTS], April 1931. 5¾ × 7 in. Lunn Gallery stamp (1975) II 27

15 [WATERFRONT BRICK BUILDINGS IN FULTON MARKET, NEW YORK CITY], 1933–34. 6 × 7¾ in. Lunn Gallery stamp (1975) II 67

16 [LINCOLN KIRSTEIN CUTTING RUBBER FUNNEL WITH SCISSORS], 1930–31. 5 × 7 in. Portfolio print, from *Walker Evans I* (Washington, D.C., 1974), numbered in ink below left edge of image "22/75." Blind stamp "Walker Evans Archive I"

17 [LINCOLN KIRSTEIN], 1931, 8 × 10 in. Lunn Gallery stamp (1975) IV 4x

18 [LINCOLN KIRSTEIN], 1931, 8 × 10 in. Lunn Gallery stamp (1975) IV 4

19 [BEN SHAHN AT 23 BETHUNE STREET APARTMENT, NEW YORK CITY], 1932–33. 4 × 5⅞ in. Lunn Gallery stamp (1975) IV 9

20 [CHARLES FULLER, BEDFORD, NEW YORK], 1931. 8⅛ × 6¼ in. Lunn Gallery stamp (1975) IV 2

21 [JANE AND JILL FULLER ON STAIRWELL, BEDFORD, NEW YORK], 1931. 6 × 8⅛ in. Lunn Gallery stamp (1975) IV 5

22 [JIGSAW ORNAMENT DETAIL OF FOLK VICTORIAN HOUSE AT OSSINING CAMP WOODS, NEW YORK], 1930–31. 6 × 7¼ in.

23 [COUNTRY CHURCH FAÇADE, OSSINING, NEW YORK], 1931. 6 × 8 in. Lunn Gallery stamp (1975) II 40. Evans stamp K (1966–75). Evans stamp C (not dated)

24 [LEFT WING FAÇADE OF QUEEN ANNE (?) HOUSE WITH PATTERNED MASONRY CHIMNEY, NEW YORK], 1931. 6³⁄₈ × 7³⁄₄ in. Lunn Gallery stamp (1975) IX 17

25 [GREEK REVIVAL HOUSE WITH PAIRED IONIC COLUMNS IN ENTRY PORCH, NORTHAMPTON, MASSACHUSETTS], 1930–31. 5 × 7 in. Lunn Gallery stamp (1975) IX 24

26 [GREEK REVIVAL HOUSE, GREENFIELD, MASSACHUSETTS], 1930–31. 5 × 7 in. Lunn Gallery stamp (1975) IX 30

27 [TWO GOTHIC REVIVAL HOUSES WITH DECORATIVE VERGE BOARDS IN GABLES, DORCHESTER, MASSACHUSETTS], 1930–31. 4⁵⁄₈ × 6⁵⁄₈ in. Lunn Gallery stamp (1975) IX 31

28 [GREEK REVIVAL HOUSE WITH HALF-LUNETTE WINDOW IN FULL-FAÇADE GABLE, CHERRY VALLEY, NEW YORK], November 1931. 6½ × 8 in. Lunn Gallery stamp (1975) IX II

29 [GOTHIC REVIVAL HOUSE, SOMERVILLE, MASSACHUSETTS], 1930–31. 6½ × 8 in. Lunn Gallery stamp (1975) IX right square empty

30 [GOTHIC REVIVAL HOUSE WITH IRON GATE, POUGHKEEPSIE, NEW YORK], 1930–31. 6 × 7½ in. Evans stamp F (1960–63). Evans stamp G (1963–65)

31 [SOUTH SEAS: MOUNTAINS AND SHORELINES], 1932. 6³⁄₈ × 8³⁄₈ in. Lunn Gallery stamp (1975) XVI 17

32 [CREW MEMBERS AT HELM OF CRESSIDA, SOUTH SEAS], 1932. 6¼ × 8½ in. Lunn Gallery stamp (1975) XVI II

33 [WOMAN WEARING SARONG, SOUTH SEAS], 1932. 6½ × 8⁷⁄₁₆ in. Lunn Gallery stamp XVI 27

34 [MALE PORTRAIT, SOUTH SEAS], 1932. 6¼ × 8 in. Lunn Gallery stamp (1975) XVI 25

35 [FEMALE PORTRAIT, SOUTH SEAS], 1932. 6⁵⁄₈ × 9½ in. Lunn Gallery stamp (1975) XVI 28

36 [FEMALE PORTRAIT, SOUTH SEAS], 1932. 6¼ × 8 in. Lunn Gallery stamp (1975) XVI 26

37 [PASSENGERS ON DECK OF CRESSIDA], 1932. 4¹³⁄₁₆ × 8 in. Lunn Gallery Stamp (1975) XVI 6

38 [SAILOR ON DECK OF CRESSIDA, SOUTH SEAS], 1932. 5 × 6³⁄₈ in. Lunn Gallery stamp (1975) XVI 8

39 [SOUTH SEAS, MAN WEARING GOGGLES], 1932. 6⅛ × 8⅛ in. Lunn Gallery stamp (1975) XVI 7

40 [STATUE AND OUTDOOR FAUCET IN COURTYARD, HAVANA], 1933. 6½ × 8½ in. Portfolio print, from *Walker Evans I* (Washington, D.C., 1974), numbered in ink below left edge of image "22/75." Blind stamp "Walker Evans Archive I"

41 [MAN ON DONKEY, CUBA], 1933. 8¼ × 6½ in. Lunn Gallery stamp (1975) XVIII 15

42 [TWO BAREFOOTED BOYS, HAVANA], 1933. 6 × 9½ in. Lunn Gallery stamp (1975) XVIII 23

43 [CHILD IN PROFILE BEFORE IRON GATE, HAVANA], 1933. 6³⁄₈ × 8½ in. Lunn Gallery stamp (1975) XVIII 17

44 [CHURCH INTERIOR WITH MADONNA AND CHILD STATUARY IN NICHE, CUBA], 1933. 6 × 6³⁄₄ in. Lunn Gallery stamp (1975) XVIII 4

45 [JOSE ANTONIO FERNANDEZ DE CASTRO, HAVANA], 1933. 5³⁄₈ × 7½ in. Lunn Gallery stamp (1975) XVIII 9

46 [GENERAL STORE WITH PEOPLE IN DOORWAY AND PONY TIED TO POST, HAVANA OUTSKIRTS], 1933. 6³⁄₁₆ × 8 in. Lunn Gallery stamp (1975) XVIII 14

47 [COUNTRY FAMILY ON STREET IN VEDADO DISTRICT, HAVANA], 1933. 6 15/16 × 12 in. Lunn Gallery stamp (1975) XV III 31

48 [STAND OF EIGHT MACHETES, HAVANA], 1933. 7 1/4 × 10 7/8 in. Lunn Gallery stamp (1975) both squares empty

49 [FOUR MUSICAL INSTRUMENTS, FRENCH CONGO, LOANGO (?)], 1935. 7 5/8 × 9 5/8 in. From *African Negro Art* portfolio, Museum of Modern Art, New York, 1935. Lunn Gallery stamp (1975) XX 424

50 [MASK REPRESENTING AN ANIMAL, FRENCH SUDAN, DOGON], 1935. 7 5/8 × 9 5/8 in. From *African Negro Art* portfolio. Lunn Gallery stamp (1975) XX 27

51 [TWO BOBBINS: IVORY COAST], 1935. 7 5/8 × 9 5/8 in. From *African Negro Art* portfolio, Museum of Modern Art, New York, 1935. Lunn Gallery stamp (1975) XX 135–41

52 [UNTITLED], 1935. 7 5/8 × 9 5/8 in. From *African Negro Art* portfolio, Museum of Modern Art, New York, 1935. Lunn Gallery stamp (1975) XX 282

53 [UNTITLED], 1935. 7 5/8 × 9 5/8 in. From *African Negro Art* portfolio, Museum of Modern Art, New York, 1935. Lunn Gallery stamp (1975) XX 252

54 [MASK], 1935. 7 5/8 × 9 5/8 in. From *African Negro Art* portfolio, Museum of Modern Art, New York, 1935. Lunn Gallery stamp (1975) XX 111

55 [UNTITLED], 1935. 7 5/8 × 9 5/8 in. From *African Negro Art* portfolio, Museum of Modern Art, New York, 1935. Lunn Gallery stamp (1975) XX 449

56 [UNTITLED], 1935. 7 5/8 × 9 5/8 in. From *African Negro Art* portfolio, Museum of Modern Art, New York, 1935. Lunn Gallery stamp (1975) XX 449

57 [EQUESTRIAN FIGURE, DAHOMEY, YORUBA], 1935. 7 5/8 × 9 5/8 in. From *African Negro Art* portfolio, Museum of Modern Art, New York, 1935. Lunn Gallery stamp (1975) XX 239

58 [BRICK BUILDING ON WATERFRONT, PAUL'S RESTAURANT, NEW YORK CITY], 1934. 6 1/4 × 8 1/4 in.

59 [GILDED PEDIMENT EAGLE, CHARLESTON, SOUTH CAROLINA], March 1936. 3 7/16 × 5 3/8 in.

60 [GREEK REVIVAL HOUSE, 329 ABERCORN STREET, LAFAYETTE WARD, SAVANNAH, GEORGIA], February–March 1935. 8 × 10 in. Lunn Gallery stamp (1975) X 37

61 [TWO WOMEN, FRENCH QUARTER, NEW ORLEANS, LOUISIANA (?)], February–March 1935. 6 1/8 × 8 5/8 in. Lunn Gallery Stamp (1975) III 501

62 [BOY AND WOMAN, FRENCH QUARTER, NEW ORLEANS, LOUISIANA (?)], February–March 1935. 6 1/4 × 9 7/16 in. Lunn Gallery stamp (1975) III 525

63 [MAN POSING FOR PICTURE IN FRONT OF WOODEN HOUSE], 1936. 8 × 9 5/8 in. Lunn Gallery stamp (1975) III 540

64 [WOODEN CHURCH (OR SCHOOLHOUSE ?)], 1936. 7 3/4 × 9 1/4 in. Lunn Gallery stamp (1975) III 563

65 [WOOD SHINGLE DETAIL, TRURO, MASSACHUSETTS], 1930–31. 5 × 7 in. Lunn Gallery stamp (1975) III 543

66 ROADSIDE GAS STATION WITH MINERS' HOUSES ACROSS STREET, LEWISBURG, ALABAMA, December 17, 1935. 7 1/2 × 9 1/2 in. Portfolio print, from *Walker Evans I* (Washington, D.C., 1974), numbered in ink below left edge of image "22/75." Blind stamp "Walker Evans Archive I"

67 [MINIATURE TOY ANIMALS NEAR ROADSIDE, WEST VIRGINIA (?)], 1930s. 3 1/8 × 4 3/8 in. Lunn Gallery stamp (1975) both squares empty

68 [MINIATURE TOY ANIMALS NEAR ROADSIDE, WEST VIRGINIA (?)], 1930s. 3 1/8 × 4 3/8 in. Lunn Gallery stamp (1975) both squares empty

69 [YOUNG BOY, WESTMORELAND COUNTY, PENNSYLVANIA], July 1935. 5 3/4 × 7 5/8 in. Lunn Gallery stamp (1975) III 44

70 "COMPANY" HOUSES FOR MINERS BY TRAIN TRACKS AND CREEK (WITH TOWN SIGN IN FOREGROUND), MASONTOWN, WEST VIRGINIA, June 1935. 7 3/4 × 9 3/4 in. Lunn Gallery stamp (1975) III 18

71 [STOREFRONT FAÇADE OF STAR PRESSING CLUB LAUNDRY, VICKSBURG, MISSISSIPPI], February–March 1936. 3 7/16 × 5 3/8 in.

72 [HOUSES IN NEGRO QUARTER, VICKSBURG, MISSISSIPPI], March 1936. 7 5/8 × 9 3/4 in. Lunn Gallery stamp (1975) III 559

73 [WOODEN HOUSES, RURAL SOUTH], 1930s. 7 3/4 × 9 5/8 in. Lunn Gallery stamp (1975) both squares empty

74 INDEPENDENCE DAY, TERRA ALTA, WEST VIRGINIA, July 4, 1935. 3 5/8 × 6 1/4 in. Lunn Gallery stamp (1975) III 23 v

75 INDEPENDENCE DAY, TERRA ALTA, WEST VIRGINIA, July 4, 1935. 6 1/4 × 9 in. Lunn Gallery stamp (1975) III 25

76 VIEW OF BETHLEHEM, PENNSYLVANIA, November 1935. 7 1/2 × 9 3/8 in. Lunn Gallery stamp (1975) III 57

77 [CROWD IN PUBLIC SQUARE], 1930s. 5 5/8 × 9 3/4 in. Lunn Gallery stamp (1975) both squares empty

78 [GREEK REVIVAL HOUSE, FROM ACROSS STREET, MACON, GEORGIA (?)], February 1935. 8 × 10 in. Lunn Gallery stamp (1975) X 43

79 [GIRL IN FRENCH QUARTER, NEW ORLEANS, LOUISIANA], February–March 1935. 4 5/8 × 7 in. Lunn Gallery stamp (1975) III 509

80 [BOY, RURAL SOUTH], 1930s. 5 5/8 × 8 in. Lunn Gallery stamp (1975) both squares empty

81 HOUSES AND GRAVEYARD, ROWLESBURG, WEST VIRGINIA, June 1935. 5 5/8 × 8 in. Lunn Gallery stamp (1975) III 22

82 VACUUM CLEANER FACTORY, ARTHURDALE SUBSISTENCE HOMESTEAD PROJECT, FSA, REEDSVILLE, WEST VIRGINIA, July 1935. 7 1/8 × 9 1/4 in. Lunn Gallery stamp (1975) III 39

83 BARNS ON FRANK TENGLE'S FARM, 1936. 8 × 10 in. Lunn Gallery stamp (1975) III 318

84 [TWO CHILDREN, RURAL SOUTH], 1930s. 5 3/4 × 8 3/8 in. Lunn Gallery stamp (1975) III 504

85 [WOMAN WITH FOUR CHILDREN ON HOUSE PORCH, RURAL SOUTH], 1930s. 7 7/8 × 9 3/8 in. Lunn Gallery stamp (1975) III 521a

86 [CHURCH INTERIOR WITH PUMP ORGAN, ALABAMA], 1936. 7 1/2 × 9 1/2 in. Portfolio print, from *Walker Evans I* (Washington, D.C., 1974), numbered in ink below left edge of image "22/75." Blind stamp "Walker Evans Archive I"

87 RESIDENTIAL AREA, MORGANTOWN, WEST VIRGINIA, June 1935. 7 3/4 × 9 1/2 in. Lunn Gallery stamp (1975) III 3

88 [ROW OF FRAME HOUSES, VIRGINIA], 1936. 2 1/2 × 3 13/16 in. Lunn Gallery stamp (1975) I 156v

89 [FAÇADE DETAIL OF HERMITAGE PLANTATION HOUSE, NEAR SAVANNAH, GEORGIA], February 5, 1935. 7 3/4 × 9 5/8 in. Lunn Gallery stamp (1975) X 40

90 [JANE NINAS ON THE BALCONY OF BELLE GROVE PLANTATION, WHITE CASTLE, LOUISIANA], February–March 1935. 4 5/8 × 7 1/2 in. Lunn Gallery stamp (1975) both squares empty

91 [JANE NINAS ON THE BALCONY OF BELLE GROVE PLANTATION, WHITE CASTLE, LOUISIANA], February–March 1935. Lunn Gallery stamp (1975) both squares empty 188

92 [CENTRAL FAÇADE OF LONGWOOD PLANTATION HOUSE, NEAR NATCHEZ, MISSISSIPPI], March 1935. Lunn Gallery stamp (1975) X 35

93 [FOLK VICTORIAN HOUSE WITH FRONT-GABLED ROOF, FERNANDEZ, FLORIDA], 1935–36. 7 5/16 × 9 1/4 in. Lunn Gallery stamp (1975) IX 105

94 [WOMEN IN FRENCH QUARTER, NEW ORLEANS, LOUISIANA], February–March 1935. 4 3/8 × 6 3/4 in. Lunn Gallery stamp (1975) III 505

95 [MAN AND WOMAN SEATED ON STOOP IN FRENCH QUARTER, NEW ORLEANS, LOUISIANA], February–March 1935. 4³⁄₈ × 7¹⁄₈ in. Lunn Gallery stamp (1975) III 512. Cheim & Read Gallery, New York, label #EV. 42

96 [YOUNG WOMAN OUTSIDE CLOTHING STORE, GEORGIA], 1934–35. 4¹⁄₂ × 7¹⁄₄ in. Lunn Gallery stamp (1975) III 500

97 [STREET SCENE, WEST VIRGINIA (?)], 1930s. 8 × 8 in. Lunn Gallery stamp (1975) both squares empty

98 ROW OF CLAPBOARD "COMPANY" HOUSES FOR MINERS, MORGANTOWN, ALONG CREEK, OSAGE, WEST VIRGINIA, June 1935. 4¹⁵⁄₁₆ × 6 in. Lunn Gallery stamp (1975) III 12v

99 COMPANY HOUSES FOR TANNERY WORKS, GORMANIA, WEST VIRGINIA, June 1935. 3⁵⁄₈ × 8¹⁄₂ in. Lunn Gallery stamp (1975) III 16

100 [TWO MEN IN FRONT OF LIQUOR STORE WINDOW, GEORGIA], 1934–35. 4¹⁄₈ × 6⁷⁄₈ in. Lunn Gallery stamp (1975) III 514.

101 [MEN SEATED ON STEPS OF PUBLIC BUILDING, SOUTHEASTERN UNITED STATES], 1934–35. 5³⁄₄ × 7³⁄₄ in. Lunn Gallery stamp (1975) III 523

102 [BYSTANDERS OUTSIDE KLEIN'S DEPARTMENT STORE, UNION SQUARE, NEW YORK CITY], September 1937. 6³⁄₄ × 9⁵⁄₈ in. Lunn Gallery stamp (1975) XIV 14

103 [BYSTANDERS OUTSIDE KLEIN'S DEPARTMENT STORE, UNION SQUARE, NEW YORK CITY], September 1937. 5¹⁄₂ × 6¹⁄₂ in. Walker Evans Archive, Metropolitan Museum of Art, New York, 1994.253.370.1. Lunn Gallery stamp (1975) XIV 19

104 ["THE GRAND MAN," ASTROLOGER'S SIGN, GEORGIA (?)], 1934–35. 4⁵⁄₈ × 7 in. Lunn Gallery stamp (1975) XXI 1

105 [BEDROOM INTERIOR], 1930s. 6³⁄₈ × 8 in. Lunn Gallery stamp (1975) XXI 26

106 [HAZEL HAWTHORNE WERNER], 1930–34. 6¹⁄₄ × 8¹⁄₄ in. Lunn Gallery stamp (1975) both squares empty

107 BERENICE ABBOTT, 1929–30. 5 × 7 in. Portfolio print, from *Walker Evans I* (Washington, D.C., 1974), numbered in ink below left edge of image "22/75." Blind stamp "Walker Evans Archive I"

108 [SUBWAY PASSENGERS, NEW YORK CITY: WOMAN IN VELVET COLLAR WITH ARM AROUND CHILD], May 5–8, 1938. 4³⁄₈ × 6¹⁄₂ in. Portfolio print, from *Walker Evans I* (Washington, D.C., 1974), numbered in ink below left edge of image "22/75." Blind stamp "Walker Evans Archive I"

109 [SUBWAY PASSENGERS, NEW YORK CITY: TWO MEN IN CAPS BENEATH "7TH AVE LOCAL" SIGN], February 1938. 4¹⁄₂ × 7 in. Lunn Gallery stamp (1975) XI 128

110 [SUBWAY PASSENGER, NEW YORK CITY: MAN IN DERBY], January 13–21, 1941. 5¹⁄₄ × 7⁵⁄₈ in. Lunn Gallery stamp (1975) VI 96

111 [VETERAN'S MONUMENT OUTSIDE CITY HALL, BRIDGEPORT, CONNECTICUT], May 18, 1941. 7⁷⁄₈ × 9¹⁄₂ in. Lunn Gallery stamp (1975) VIII 81

112 JAMES AGEE, 1937. 6 × 8 in. Lunn Gallery stamp (1975) both squares empty

113 [UNIDENTIFIED BOY], 1930s–40s. 2³⁄₄ × 4 in. Lunn Gallery stamp (1975) both squares empty

114 [SAMUEL BARBER, NEW YORK CITY], March 1, 1942. 7¹⁄₄ × 9³⁄₈ in. Lunn Gallery stamp (1975) IV 5

115 [ROBERT FITZGERALD, NEW YORK CITY], February 19, 1943. 5 × 5 in. Lunn Gallery stamp (1975) IV 7

116 [ROBERT FITZGERALD], 1943. 6³⁄₈ × 4¹⁄₄ in. Lunn Gallery stamp (1975) IV 7

117 [HERBERT SOLOW LIGHTING JOHN MCDONALD'S CIGARETTE, CROTON, NEW YORK], 1943. 3⁷⁄₁₆ × 4⁷⁄₁₆ in. Lunn Gallery stamp (1975) both squares empty

118 [PEDESTRIAN, BRIDGEPORT, CONNECTICUT], 1941. Commissioned by *Fortune* magazine for "In Bridgeport's War Factories," Published September 1941. 6¹⁄₂ × 8⁵⁄₈ in. Lunn Gallery stamp (1975) VIII 20

119 [PEDESTRIAN, BRIDGEPORT, CONNECTICUT], 1941. Commissioned by *Fortune* magazine for "In Bridgeport's War Factories," Published September 1941. 6½ × 8⅝ in. Lunn Gallery stamp (1975) VIII 8 L

120 [WOMAN SHOPPER], 1939–41. 3¾ × 7⅝ in. Commissioned by *Fortune* magazine for article "In Bridgeport's War Factories," Lunn Gallery stamp (1975) VIII 41

121 [BEDROOM INTERIOR WITH RELIGIOUS AND FAMILY PICTURES ON WALL, BILOXI, MISSISSIPPI], April 1945. 7⅜ × 9½ in. Lunn Gallery stamp (1975) XII 1

122 [BEDROOM DRESSER, SHRIMP FISHERMAN'S HOUSE, BILOXI, MISSISSIPPI], April 1945. 7⅜ × 9½ in. Lunn Gallery stamp (1975) XII 4

123 [BEDROOM INTERIOR WITH RELIGIOUS AND FAMILY PICTURES ON WALL, BILOXI, MISSISSIPPI], April 1945. 7⅜ × 9½ in. Lunn Gallery stamp (1975) XII 3

124 [BEDROOM INTERIOR, SHRIMP FISHERMAN'S HOUSE, BILOXI, MISSISSIPPI], April 1945. 7⅜ × 9½ in. Lunn Gallery stamp (1975) XII 2

125 [BALLET THEATRE COMPANY, NEW YORK], October 1945. Commissioned by *Fortune* magazine for article "The Boom in Ballet," Published December 1945. 7 × 9⅛ in. Lunn Gallery stamp (1975) XXI 49

126 [BALLET THEATRE COMPANY, NEW YORK], October 1945. Commissioned by *Fortune* magazine for article "The Boom in Ballet," Published December 1945. 7 × 9⅛ in. Lunn Gallery stamp (1975) XIX 55

127 [BALLET THEATRE COMPANY, NEW YORK], October 1945. Commissioned by *Fortune* magazine for article "The Boom in Ballet," Published December 1945. 7 × 9⅛ in. 1994.254.1370. Lunn Gallery stamp (1975) XIX 4

128 [BALLET THEATRE COMPANY, NEW YORK], October 1945. Commissioned by *Fortune* magazine for article "The Boom in Ballet," Published December 1945. 7 × 9⅛ in. Lunn Gallery stamp (1975) XIX 54

129 [BALLET THEATRE COMPANY, NEW YORK], October 1945. Commissioned by *Fortune* magazine for article "The Boom in Ballet," Published December 1945. 7 × 9⅛ in. Lunn Gallery stamp (1975) XIX 54

130 [CIRCUS TRAPEZE ACT, MADISON SQUARE GARDEN, NEW YORK CITY], 1940s. 6⅛ × 8¾ in. Lunn Gallery stamp (1975) both squares empty

131 [BASEBALL PLAYERS ROSTER BOARD(?)], 1946–47. 7¼ × 10 in. Lunn Gallery stamp (1975) both squares empty

132 [CHICAGO THEATER, CHICAGO, ILLINOIS], 1946. Commissioned by *Fortune* magazine for "Chicago: A Camera Exploration." Published February 1947. 10 × 10½ in. Lunn Gallery stamp (1975) XV 70

133 [PABST BLUE RIBBON SIGN, CHICAGO, ILLINOIS], 1946. Commissioned by *Fortune* magazine for "Chicago: A Camera Exploration." Published February 1947. 7⅜ × 9¼ in. Portfolio print, from *Walker Evans: Selected Photographs* (New York, 1974), numbered in ink below left edge of image "40/75." Blind stamp "Walker Evans Archive"

134 [CHICAGO, ILLINOIS], 1946. Commissioned by *Fortune* magazine for "Chicago: A Camera Exploration." Published February 1947. 3⅜ × 4⅜ in. Lunn Gallery stamp (1975) XV 91

135 [CHICAGO, ILLINOIS], 1946. Commissioned by *Fortune* magazine for "Chicago: A Camera Exploration." Published February 1947. 7¼ × 10⅛ in. Lunn Gallery stamp (1975) IV 23. Fortune editorial/copyright stamp "Chicago portfolio"

136 [CHICAGO, ILLINOIS], 1946. Commissioned by *Fortune* magazine for "Chicago: A Camera Exploration." Published February 1947. 7¼ × 10⅛ in. Lunn Gallery stamp XV 57. Evans stamp F (1960–63)

137 [TRINI BARNES], 1940s. 7½ × 7¾ in. Lunn Gallery stamp (1975) both squares empty

138 [LAMP ON TABLE IN WALKER EVANS'S APARTMENT, 441 EAST 92 STREET, NEW YORK CITY], 1946–47. 3¾ × 4¾ in. Lunn Gallery stamp (1975) XXI right square empty

139 [LAMP ON TABLE IN WALKER EVANS'S APARTMENT, 441 EAST 92 STREET, NEW YORK CITY], 1946–47. 4 1/2 × 6 1/4 in. Lunn Gallery stamp (1975) XXIV 3

140 [MARY FRANK, NEW YORK CITY], January 1957. 9 1/4 × 6 in. Walker Evans Archive, Metropolitan Museum of Art, New York, 1994.253.689.3. Lunn Gallery stamp (1975) IV 22

141 [THIRD AVENUE STOREFRONT], April–May 1959. Commissioned by *Fortune* magazine for unpublished portfolio. 9 1/2 × 13 1/2 in. Lunn Gallery stamp (1975) XIII 5. Fortune editorial/copyright stamp "Third Avenue"

142 [SHOP WINDOW, NEAR CORTLANDT STREET, NEW YORK CITY], May 17, 1963. 9 1/16 × 13 3/8 in. 1994.253.787.9. Lunn Gallery stamp (1975) XXIV right square empty

143 [THIRD AVENUE STOREFRONT], April–May 1959. Commissioned by *Fortune* magazine for unpublished portfolio. 9 1/2 × 13 1/2 in. Lunn Gallery stamp (1975) both squares empty

144 [THIRD AVENUE STOREFRONT], April–May 1959. Commissioned by *Fortune* magazine for unpublished portfolio. 6 3/8 × 9 in. Lunn Gallery stamp (1975). Evans stamp C (not dated)

145 [THIRD AVENUE STOREFRONT], April–May 1959. Commissioned by *Fortune* magazine for unpublished portfolio. 9 1/2 × 13 1/2 in. Lunn Gallery stamp (1975) both squares empty

146 [THIRD AVENUE STOREFRONT], April–May 1959. Commissioned by *Fortune* magazine for unpublished portfolio. 9 1/2 × 13 1/2 in. Lunn Gallery stamp (1975) XIII 10

147 [MARY FRANK'S BEDROOM, NEW YORK CITY], 1959. 10 × 10 in. Lunn Gallery stamp IV 21

148 [URBAN CONSTRUCTION SITE], April–May 1959. Commissioned by *Fortune* magazine for Unpublished Portfolio. 9 1/8 × 12 in. Fortune editorial/copyright stamp "Third Avenue"

149 [VIEW OF NINETEENTH-CENTURY CAST-IRON WAREHOUSES IN DOWNTOWN MANHATTAN, NEW YORK CITY], 1961–62. Commissioned by *Architectural Forum* magazine for "The American Warehouse," 1961–62. Published April 1962. 10 9/16 × 12 1/8 in. Lunn Gallery stamp (1975) XV II 30

150 [NEW YORK], 1961. Commissioned by *Fortune* magazine for "People and Places in Trouble." Published March 1961. 9 5/8 × 13 1/2 in. Lunn Gallery stamp VI (right square empty). *Fortune* editorial/copyright stamp "Poverty 3/61." Signed by Evans in pencil

151 [STUDY OF OHIO CLAY PLANT], 1950. Commissioned by *Fortune* magazine for article "Clay: The Commonest Industrial Raw Material," Published January 1951. 10 1/4 × 12 1/2 in. Lunn Gallery stamp (1975) V 1001. Evans stamp H (1941–c. 1963)

152 [VIEW OF BUILDING CONSTRUCTION FOR CONTAINER CORPORATION COMMISSION], 1963. 10 5/8 × 11 1/2 in. Lunn Gallery stamp (1975) VII 21

153 [VIEW OF BUILDING CONSTRUCTION FOR CONTAINER CORPORATION COMMISSION], 1963. 8 3/4 × 13 1/2 in. Lunn Gallery stamp (1975) VII 8. Evans stamp G (1963–65)

154 [INTERIOR OF THE HELIKER HOUSE, CRANBERRY ISLAND, MAINE], July 29, 1962. 9 × 13 3/8 in. Lunn Gallery stamp (1975) XXIII 89v

155 [CARL VAN VECHTEN AT HOME], May 3, 1962. 6 × 7 in. Lunn Gallery stamp (1975) IV right square empty. Evans stamp H (1941–c. 1963)

156 [PORTRAIT OF TENNESSEE WILLIAMS, NEW YORK], 1960s. 9 1/2 × 9 1/2 in. Lunn Gallery stamp (1975) both squares empty. Evans stamp "36 East 73rd St., New York, N.Y. 10021"

157 [ISABELLE BOESCHENSTEIN EVANS, NEW YORK], October 21, 1960. 4 9/16 × 6 5/8 in. Lunn Gallery stamp (1975) both squares empty. Signed below lower left edge of image by Walker Evans and dated "Oct. 21, 1960"

158 [BERNE, SWITZERLAND (BOESCHENSTEIN FAMILY RESIDENCE?)], January 1967. 6 1/4 × 9 3/8 in. Lunn Gallery stamp (1975) XXV 63

159 [LONDON], 1950s. 6¼ × 9½ in. Lunn Gallery stamp (1975)
XXV 43

160 [LONDON], 1950s. 6½ × 9⅝ in. Lunn Gallery stamp (1975)
XXV 41

161 [SKITTLE ALLEY IN PUB, LONDON], 1960s. 9 × 13¼ in.
Lunn Gallery stamp (1975) both squares empty

162 [LONDON], 1950s. 7³⁄₁₆ × 11¹⁄₁₆ in. Lunn Gallery stamp (1975)
XXV 36

163 [LONDON], 1950s. 9 × 13½ in. Lunn Gallery stamp (1975)
XXV 21

164 [LONDON, TRAFALGAR SQUARE], 1950s. 6⅜ × 9⅝ in.
Lunn Gallery stamp (1975) XXV 21

165 [SHOP WINDOW, LONDON], 1950s. 9⅛ x 13¼ in.
Lunn Gallery stamp (1975) XXV 44

166 [TAXIS, LONDON], 1950s. 7½ × 9⅝ in. Lunn Gallery stamp
(1975) XXV

167 [LONDON], 1950s, 7 × 9¼ in. Lunn Gallery stamp (1975) XXV 6

168 [CAROLINE BLACKWOOD], 1963 or later. 4½ × 6 in. Lunn
Gallery stamp (1975) both squares empty

169 [LONDON], 1950s. 9 × 13 in. Lunn Gallery stamp (1975)
XXV 24

170 [BRUTON STREET, LONDON], 1950s. 7¼ × 10⅞ in. Lunn
Gallery stamp (1975) XXV 34

171 [LONDON], 1950s. 7¾ × 11¼ in. Lunn Gallery stamp (1975)
XXV 12

172 [LONDON], 1973. 7½ × 7½ in. Lunn Gallery stamp (1975)
XXV 57

173 [LONDON], 1950s. 9 × 13½ in. Lunn Gallery stamp (1975)
XXV 25

174 [BARN DETAIL, HEIGHTSTOWN, NEW JERSEY], 1963.
10⅝ × 12⁹⁄₁₆ in. Lunn Gallery stamp (1975) XXI 19v. Evans stamp
H (1941–c. 1963)

175 [BARN, KENTUCKY], 1961. Commissioned by *Fortune* magazine
for article "People and Places in Trouble," Published March 1961.
7¹³⁄₁₆ × 12⅜ in. Lunn Gallery stamp (1975) VII 2. Evans stamp C
(not dated)

176 [INTERIOR VIEW OF HELIKER/LAHOTAN HOUSE, WALPOLE,
MAINE], 1962. 7¼ × 7¼ in. Walker Evans Archive, Metropolitan
Museum of Art, New York, 1994.252.113.1

177 [FATHER JAMES FLYE], 1962. Made for *Vogue* Magazine and
probably unpublished. 8⅞ × 11⅞ in. Lunn Gallery stamp (1975)
IV 16

178 [PORTRAIT OF A HOUSEWIFE, ALLENTOWN PENNSYLVANIA],
1961. Commissioned by *Fortune* magazine for article "People and
Places in Trouble," Published March 1961. 8½ × 13 in. Lunn Gallery
stamp (1975) V 106

179 [RAILROAD DEPOT], October 1963. 7½ × 7½ in. Lunn Gallery
stamp (1975) XI 5

180 [MEN'S FASHION], March–June 1963. Commissioned by
Fortune magazine for unpublished portfolio, "The Clothes: A Note on
Sartorial Actuality." 8 × 12¼ in. Lunn Gallery stamp (1975) XXIV 21.
Fortune editorial/copyright stamp "Dress"

181 [MEN'S FASHION], March–June 1963. Commissioned by
Fortune magazine for unpublished portfolio, "The Clothes: A Note
on Sartorial Actuality." 8⅜ × 10⅛ in. Lunn Gallery stamp (1975)
XXIV 37. Fortune editorial/copyright stamp "Dress"

182 [VIEW OF FACTORY], 1960–65. Possibly for *Fortune* magazine,
1960–65. 9½ × 9½ in. Lunn Gallery stamp (1975) V 125. Evans
stamp H (1941–c. 1963)

183 [VIEW OF FACTORY], 1960–65. Possibly for *Fortune* magazine,
1960–65. 9⅛ × 9⅛ in. Lunn Gallery stamp (1975) V 123. Evans
stamp H (1941–c. 1963)

184 [MANHATTAN SKYLINE FOR CONTAINER CORPORATION COMMISSION], 1963. $6^{1}/_{2}$ × $12^{1}/_{2}$ in. Lunn Gallery stamp (1975) VII 8

185 [KITCHEN INTERIOR, MAINE], 1969. $7^{5}/_{16}$ × $7^{5}/_{16}$ in. Lunn Gallery stamp XXIII 29

186 [FAÇADE OF HOUSE WITH LARGE NUMBERS, DENVER, COLORADO], August 1967. 10 × 10 in. Lunn Gallery stamp (1975) XXIII 100

187 [ROBERT FRANK, NOVA SCOTIA], 1969–71. $7^{5}/_{8}$ × $7^{5}/_{8}$. Lunn Gallery stamp (1975) XXIII 72v

188 [INTERIOR VIEW OF ROBERT FRANK'S HOUSE, NOVA SCOTIA], 1969–71. $7^{1}/_{8}$ × $7^{1}/_{8}$ in. Lunn Gallery stamp (1975) XXIII b3v

189 [ROBERT FRANK'S AND JUNE LEAF'S PROPERTY, NOVA SCOTIA], 1969–71. $7^{1}/_{8}$ × $7^{1}/_{8}$ in. Lunn Gallery stamp (1975) XXIII 76

190 [BARN, NOVA SCOTIA], 1969–71. $7^{1}/_{8}$ × $7^{1}/_{8}$ in. Lunn Gallery stamp (1975) XXIII 59a

191 [BARN, NOVA SCOTIA], 1969–71. $7^{1}/_{8}$ × $7^{1}/_{8}$ in. Lunn Gallery stamp (1975) XXIII 59b

192 [BARN, NOVA SCOTIA], 1969–71. $7^{1}/_{8}$ × $7^{1}/_{8}$ in. Lunn Gallery stamp (1975) XXIII 59

193 [BARN, NOVA SCOTIA], 1969–71. $7^{1}/_{8}$ × $7^{1}/_{8}$ in. Lunn Gallery stamp (1976) XXIII 58

194 [JACK HELIKER, CRANBERRY ISLAND, MAINE], 1967–68. 3 × $7^{1}/_{4}$ in. Lunn Gallery stamp (1975) XXIII 25

195 [INTERIOR VIEW OF A FISHERMAN'S HOUSE, NOVA SCOTIA], 1969–70. $7^{5}/_{16}$ × $7^{5}/_{16}$ in. Lunn Gallery stamp (1975) XXIII 57

196 [INTERIOR VIEW OF A FISHERMAN'S HOUSE, NOVA SCOTIA], 1969–70. $7^{5}/_{16}$ × $7^{5}/_{16}$ in. Lunn Gallery stamp (1975) XXIII 52

197 [HELIKER HOUSE, CRANBERRY ISLAND, MAINE], 1969. $9^{7}/_{8}$ × 10 in. Lunn Gallery stamp (1975) XXIII 21

198 [INTERIOR VIEW OF A FISHERMAN'S HOUSE, NOVA SCOTIA], 1969–71. $7^{3}/_{8}$ × $7^{1}/_{4}$ in. Lunn Gallery stamp (1975) XXIII 51

199 [INTERIOR VIEW OF A FISHERMAN'S HOUSE, NOVA SCOTIA], 1969–70. $7^{5}/_{16}$ × $7^{5}/_{16}$ in. Lunn Gallery stamp (1975) XXIII 55

200 [SHACK AND ICE MACHINE, OLD LYME, CONNECTICUT], April 1973. 8 × 10 in. 1994.252.151.1. Lunn Gallery stamp (1975) both squares empty

201 [UNTITLED], 1973–74. Color Polaroid photograph. 4 × 3 in.

202 [UNTITLED], 1973–74. Color Polaroid photograph. 4 × 3 in.

203 [UNTITLED], 1973–74. Color Polaroid photograph. 4 × 3 in.

204 [UNTITLED], 1973–74. Color Polaroid photograph. 4 × 3 in.

205 [UNTITLED], 1973–74. Color Polaroid photograph. 4 × 3 in.

206 [UNTITLED], 1973–74. Color Polaroid photograph. 4 × 3 in.

207 [UNTITLED], 1973–74. Color Polaroid photograph. 4 × 3 in.

208 [UNTITLED], 1973–74. Color Polaroid photograph. 4 × 3 in.

209 [UNTITLED], 1973–74. Color Polaroid photograph. 4 × 3 in.

210 [UNTITLED], 1973–74. Color Polaroid photograph. 4 × 3 in.

211 [UNTITLED], 1973–74. Color Polaroid photograph. 4 × 3 in.

212 [UNTITLED], 1973–74. Color Polaroid photograph. 4 × 3 in.

213 [UNTITLED], 1973–74. Color Polaroid photograph. 4 × 3 in.

214 [UNTITLED], 1973–74. Color Polaroid photograph. 4 × 3 in.

215 [UNTITLED], 1973–74. Color Polaroid photograph. 4 × 3 in.

216 [UNTITLED], 1973–74. Color Polaroid photograph. 4 × 3 in.

SOURCES AND FURTHER READING

PRIMARY SOURCES

The Museum of Modern Art Archives, New York.
The Walker Evans Archive, The Metropolitan Museum of Art,
New York.

FURTHER READING

James Agee and Walker Evans. *Let Us Now Praise Famous Men: Three Tenant Families.* Boston: Houghton Mifflin, 1941; 2d enlarged ed., 1960.

Lesley K. Baier. *Walker Evans at Fortune 1945–1965.* Wellesley, MA: Wellesley College Museum, 1978.

Walker Evans. *American Photographs.* Essay by Lincoln Kirstein. Exhibition catalogue. New York: Museum of Modern Art, 1938; 2d ed., 1962; fiftieth-anniversary ed., 1988.

_____. *Message from the Interior.* Essay by John Szarkowski. New York: Eakins Press, 1966.

_____. *Many Are Called.* Essay by James Agee. Boston: Houghton Mifflin, 1966. 2d enlarged ed., 2004.

Sarah Greenough. *Walker Evans: Subways and Streets.* Washington: National Gallery of Art, 1991.

Maria Morris Hamburg, Jeff L. Rosenheim, Douglas Eklund, and Mia Fineman. *Walker Evans.* New York and Princeton: Metropolitan Museum of Art and Princeton University Press, 2000.

John T. Hill, Heinz Liesbrock, and Alan Trachtenberg. *Walker Evans: Lyric Documentary.* Gottingen: Steidl, 2006.

Judith Keller. *Walker Evans: The Getty Museum Collection.* Malibu: J. Paul Getty Museum, 1995.

Rodger Kingston. *Walker Evans in Print: The Rodger Kingston Collection; Books, Periodicals & Ephemera by or about Walker Evans.* Belmont, MA: P.R. Kingston Photographs, 1995.

Lincoln Kirstein. *Mosaic: Memoirs.* New York: Farrar, Straus & Giroux, 1994.

James R. Mellow. *Walker Evans.* New York: Basic Books, 1999.

Gilles Mora and John T. Hill. *Walker Evans: The Hungry Eye.* New York: Abrams, 2004.

_____. *Walker Evans: Havana 1933.* New York and London: Pantheon and Thames & Hudson, 1989.

Sandra S. Phillips, Neil Selkirk, Elizabeth Sussman, Doon Arbus, and Jeff L. Rosenheim. *Diane Arbus: Revelations.* New York: Random House, 2003.

Anotole Pohorilenko and James Crump. *When We Were Three: The Travel Albums of George Platt Lynes, Monroe Wheeler and Glenway Wescott.* Santa Fe: Arena Editions, 1998.

Belinda Rathbone. *Walker Evans: A Biography.* New York: Houghton Mifflin Company, 2000.

Jeff L. Rosenheim. *Walker Evans: Polaroids.* New York and Zurich: Scalo, 2001.

Jeff L. Rosenheim, Jordan Bear, Chema González, and Vicente Todolí. *Walker Evans.* Madrid: Fundación Mapfre, 2009.

Jeff L. Rosenheim, Douglas Eklund, and Alexis Schwarzenbach. *Untitled: A Walker Evans Anthology.* New York and Zurich: Scalo, 2000.

Agnès Sire and Jean-François Chevrier. *Henri Cartier-Bresson and Walker Evans: Photographing America 1929–1947.* London: Thames & Hudson, 2009.

John Tagg. *The Burden of Representation: Essays on Photographies and Histories.* Minneapolis: University of Minnesota Press, 1993.

Alan Trachtenberg. *Reading American Photographs: Images as History, Mathew Brady to Walker Evans.* New York: Hill and Wang, 1989.

William Stott. *Documentary Expression and Thirties America,* New York: Oxford University Press, 1974.

John Szarkowski, *Walker Evans.* Exhibition catalogue. New York: The Museum of Modern Art, 1971.

_____. *The Photographer's Eye.* New York: The Museum of Modern Art, 1966.

_____. *The Face of Minnesota.* Minneapolis: University of Minnesota Press, 1958.

_____. *The Idea of Louis Sullivan.* Minneapolis: University of Minnesota Press, 1956.

Jerry L. Thompson. *Walker Evans at Work: 745 Photographs Together with Documents Selected from Letters, Memoranda, Interviews, Notes.* New York: Harper & Row, 1982.

Virginia-Lee Webb. *Perfect Documents: Walker Evans and African Art, 1935.* New York: Metropolitan Museum of Art, 2000.

Clark Worswick and Belinda Rathbone. *Walker Evans: The Lost Work.* Santa Fe, Arena Editions, 2000.

ACKNOWLEDGMENTS

I wish to extend special thanks to Clark and Joan Worswick who, on numerous occasions over the previous two years, allowed me to visit their large collection of vintage Walker Evans photographs. Throughout the editing and selection process for the exhibition and book, Clark and Joan were incredibly generous. I shall always remember the times we spent together, discussing Evans and sundry other mutual passions in the visual arts.

Special thanks also go to the following: Aaron Betsky, director, Cincinnati Art Museum, for his early and continued support of my concepts and ideas for this Evans exhibition and publication; Dr. Eugenia Parry and John Wood, for their invaluable critical feedback on my texts; Mary Christian, New York, for her expert copyediting; Arnold Crane, Chicago, for generously sharing his recollections of Walker Evans in the 1960s and 1970s; Cassandra Taylor, my trusted assistant, for helping marshall this project forward in an ordered fashion.

The following individuals and organizations were generous in their cooperation and assistance:
MacKenzie Bennett, assistant archivist, and Thomas Grischkowsy, The Museum of Modern Art Archives, New York; Whitney Gaylord, cataloguer, and Megan Feingold, assistant, Department of Photography, The Museum of Modern Art, New York; Eileen Sullivan, The Walker Evans Archive, Image Library, The Metropolitan Museum of Art, New York; Jennifer Belt, associate permissions director and Tim McCarthy, Art Resource, New York; Laura McCall, senior director, Teneille Haggard, artist liaison and exhibition coordinator, and Laurel Jensen, head registrar, Andrea Rosen Gallery, New York; Lauren Panzo, director, and Kaelen Kleber, Pace / MacGill Gallery, New York; Markus Hartmann, international publishing director / special projects, Tas Skorupa, editor in chief, English publications, Angelika Hartmann, production, Hatje Cantz Verlag GmbH, Ostfildern, Germany; John Pelosi, Estate of Diane Arbus, New York; Hanna Nelson and Ophélie Leboeuf, Agence Photographique de la RMN, Paris; Brian Rose, New York; Rodger Kingston, Boston.

The many talented staff at the Cincinnati Art Museum were instrumental in ways too numerous to describe. A special thank you goes to the following:
Stephen Jaycox, deputy director, presentation
Susan Hudson, exhibition coordinator
Jay Pattison, registrar
Scott Hisey, head of photographic services
Chris Williams, chief preparator
Everage King, preparator

For their constant support and encouragement: Elena Dorfman and Mr. and Mrs. Thomas Crump

NOTE ON THE PLATES

In choosing to print Evans's images in the four-color offset process, we have deviated from most books available about this artist's work. The industry standard over the years has been to reproduce Evans's black-and-white gelatin silver prints with duotone or tritone processes, which limit the tonal range by the use of only one or two inks in addition to the standard process black. The present volume faithfully reproduces Evans's original vintage works even when there are obvious shortcomings in the artist's darkroom practices. In this attempt to reproduce the photographs more accurately, the plates not only complement the book's texts, they also allow for the best understanding of Evans's material choices and his working process over five decades.

This catalogue is published in conjunction with the exhibition
Walker Evans: Decade by Decade

Cincinnati Art Museum
June 12, 2010 – September 5, 2010

COPYEDITING
Mary Christian

GRAPHIC DESIGN AND TYPESETTING
Atelier Sternstein | Johannes Sternstein, Maren Witthoeft

TYPEFACE
Adobe Garamond Pro and Super Grotesk

PRODUCTION
Angelika Hartmann, Hatje Cantz

REPRODUCTIONS AND PRINTING
Dr. Cantz'sche Druckerei, Ostfildern

PAPER
LuxoSamtoffset, 150 g/m²

BINDING
Conzella Verlagsbuchbinderei Urban Meister, Aschheim-Dornach

© 2010 Hatje Cantz Verlag, Ostfildern, and authors

All photographs by Walker Evans are © Walker Evans Archive,
The Metropolitan Museum of Art, New York
© 2010 the artists, photographers, and their legal successors

PUBLISHED BY
Hatje Cantz Verlag
Zeppelinstrasse 32
73760 Ostfildern
Germany
Tel. +49 711 4405-200
Fax +49 711 4405-220
www.hatjecantz.com

Hatje Cantz books are available internationally at selected bookstores.
For more information about our distribution partners, please visit our
homepage at www.hatjecantz.com.

ISBN 978-3-7757-2491-3
A paperback edition is available in the museum only.

Printed in Germany

COVER ILLUSTRATIONS
Front cover: [*Pabst Blue Ribbon Sign, Chicago, Illinois*], 1946
(see page 167)
Back cover, clockwise from upper left: [*Façade of House with Large
Numbers, Denver, Colorado*], August 1967 (see page 221); [*Chicago,
Illinois*], 1946 (see page 170); [*Untitled*], 1973–74 (see page 236);
[*Chicago Theater, Chicago, Illinois*], 1946 (see page 166)

FRONTISPIECE
Arnold Crane, *Walker Evans,* 1969